Ruth Bernhard

Ruth Bernhard

Between Art & Life

by Margaretta K. Mitchell

CHRONICLE BOOKS

SAN FRANCISCO

Published by Chronicle Books LLC
85 Second Street
San Francisco, CA 94105
www.chroniclebooks.com

Distributed in Canada by Raincoast Books
9050 Shaughnessy Street
Vancouver, BC V6P 6E5

10 9 8 7 6 5 4 3 2 1

Printed in Hong Kong

Library of Congress Cataloging-in-Publication Data available.

ISBN: 0-8118-2191-9

contents

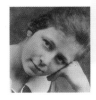
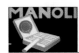

foreword

"'Yes' is the most dangerous word in the dictionary and the most important word in my life."

LIFE IS A MATTER OF PASSION. To be in love with the world is to be open and fearless, to welcome adventure and to be a person who says yes to what comes. "Yes" is the most dangerous word in the dictionary and the most important word in my life. Despite everything, I am optimistic, not fearful. As a child in boarding school, I was the one who would be sent out into the dark to look for the bear. It took courage to reinvent myself over and over, and to turn out to be this person with this life. However, I wouldn't want to be anyone else. I often say that if I were not me, I would envy myself! Because I am completely my authentic self, I am content with life. This is what I want to inspire in my students: the courage to become themselves, to make the most of their lives by falling in love with life.

It is vital to live fully every day. Today is the day! The minute something has happened, it is gone. It is memory: a story. We invent and reinvent ourselves, turning events of our lives into the story of our life. If in creating ourselves we have to throw in extras to amuse others, so much the better. All is illusion. Such is the work of the artist who lives with a full imagination. Maybe life is itself the ultimate work of art.

Because I am deeply empathic with nature, I am aware that I am no more nor less than a tree. In fact, as I have often explained to students, I become a tree when I photograph a tree. I feel the invisible experience that a tree is: the roots, the core, the insects who live inside, the birds and their nests in the branches. The wholeness of the experience is in my photograph. That is why I take photography seriously, and why I take my students seriously. I have respect for them and love for their striving selves, as I do for myself. My students are not learning how to make photographs, but rather how to express themselves with their camera.

I have tried to tell the truth of my life here in these pages. As I tell it, I realize that the truth of life is elusive. What we remember is true and yet is only what we remember. So it can never be the whole truth. Looking back over a life of almost ninety-five years, I am amazed that I remember so many details. When it comes to recalling the narrative of my life, my mind is like Swiss cheese. Maybe it is better not to remember everything. It is impossible to fit all of those years in a tiny capsule like a book. But this is an attempt to weave the story of my life into the pattern of my life work in photography.

For a photographer, light is the real teacher. But it is more than that. Light is the reason for my photographing at all. It is a language that speaks to me. It reveals the subject and becomes an experience that matches my feelings. In that fusion I sense the life force there in the subject and in myself. In that glow, I am in love, madly in love with the world.

Photographs come to me in the way a poem comes into being. I use my intuition and experience. I never go out to look for a photograph. I never plan deliberately. My intellect is not allowed to interfere. It is a completely natural process. I am always surprised when the essence of something finds me. Like drops of water on the screen door in my photograph *The Apple Tree*. The house where I was visiting was quiet that morning. All at once the apple-tree shape behind the screen door came alive with the droplets of water. Fantastic! In a flash, I rushed to get my camera.

Each time I make a photograph I celebrate the life I love and the beauty I know and the happiness I have experienced. All my photographs are made like that—responding to my intuition.

When I am working on a still life, it might be days before I make an exposure, and then it will be one negative. I see the image in my mind's eye. When the image in the camera matches it, I keep it on the negative. A photograph is a new event, a new illusion of space and time. My hope is that some of my photographs have given people visual experiences close to poetry.

After all these years, I am still motivated by the radiance that light creates when it transforms an object into something magical. What the eye sees is an illusion of what is real. The black-and-white image is yet another transformation. What exactly exists, we may never know.

Today, my greatest regret is that I no longer photograph. But I see life around me as a photographer and am affected by it all the time. I am fortunate to be able to still look forward with excitement to every day. I always have several exhibitions in my future, and each one brings new people into my life. I have found a new family from my work as a teacher, which has increasingly been my creative focus over the last forty years. The intense pleasure of seeing is now something I try to give others. I see death as a part of life and feel grateful to still be able to stay independent and to enjoy each day. The language of light and shadow that we call photography brings me closer to understanding this ageless mystery called life.

Ruth Bernhard

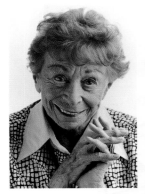

introduction

L ike a great wine, Ruth Bernhard is aged enough to be considered vintage. With her photographs in collections all over the world, and her role as teacher almost eclipsing her artistic achievements, she has arrived at that point in her life when people treat her as an icon. With an easy eloquence, she stands on the stage, her slides flickering on the screen behind her as she spins out the thread of her life, carefully illuminating each of her photographs with stories, as they appear. Like an actress who perfects her part by playing it over and over, Ruth has refined the story of her life to serve her work until, together, they have become a ritual dialogue between art and life.

Wanting to tell the story of this life, willing and eager biographers approached Ruth, but she was not sure a biography mattered to her. Initially she was uncomfortable with the fact that our end-of-the-century audience is no longer satisfied with the public face the artist chooses to display. We demand the dark passage in order to appreciate the open pool of light. We yearn for integration of light and dark, for psychological individuation. We long to know the truth, and we crave any detail that will bring our heroes back to the human scale. With her age now in the mid-nineties and her students' interest in her philosophy increasing, Ruth was alerted to the idea that her real life is as important a medium as her work in photography, which has generated five books so far.

If she were going to share her personal history, however, she wanted to find the right person. Ruth and I had worked together before, and she called me. She spoke about her discomfort with the idea of a biography: "It never occurred to me to have a biography. My interest has always been in books of my photographs. They are important, but me and my life—why, I always thought that should wait until I 'fly with the angels.'" Now that she had begun to consider telling her story, she said she would like to have me write the book. "I trust you." She said, "You are the right person because you did such a conscientious job on *Recollections: Ten Women of Photography*. You let us speak for ourselves and you respected us."

I had interviewed ten older women, Ruth included, for *Recollections*, over twenty years ago. Indeed, I had been a pioneer in the effort to make older women photographers better known, while they were still alive and could tell their stories. I know the challenge of boiling down the intensity of a long artistic life to the pages of a book that satisfies the artist as well as the audience. As the author of two texts on Ruth, I knew her well. But the focus of all her previous books was her photography. The facts of her life were somewhat obscure, and what was known served the understanding of her work; I assumed that she wanted to keep it that way.

Even after Ruth began trying to convince me that I was the author she wanted to work with, I hesitated. I knew how seriously this commitment would affect my life and my own work as a

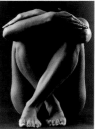

photographer. Then, I realized that if I were to write about Ruth, I wanted the satisfaction of telling her story *with* her, in her voice, rather than at the distance that many years of research without her would require. At last I agreed to write. We sat down on a rainy California winter afternoon and started to open boxes and boxes of letters and photos, remembering details of Ruth's early years. I was immediately hooked. I imagined that over time I could complete a story and illustrate it, like a scrapbook and a family album all in one. I envisioned a delectable mélange of art and life in words, artifacts, and pictures: a collage of Ruth's life.

Ruth's and my connection goes back to around the year 1970. Her remarkable body of work was already known to me before we met, as it was to most younger photographers in the San Francisco Bay Area, where she and I both live. In fact we lived only a few blocks from each other in San Francisco when I arrived at her studio on Clay Street to attend a workshop called *Seeing and Awareness*. Ruth handed out a photograph, one copy for each student, that we were instructed to study and describe. What was in the picture? What did the photograph say? There was a sharp intensity to her voice and to her manner as she scrutinized us and waited for each observation to emerge from our effort to see on all levels at once. I gained enough from that one visual exercise to convince me of Ruth's value as an insightful teacher, even though the class was filled and I could not remain in her studio.

Famous as she is today, in the 1970s Ruth was well known only to her small coterie of students, collectors, and curators. I realized then that she and her generation of women photographers had essentially been left out of the written history of American photography. Finally, in 1975, they were shown in a historical survey exhibition of women photographers curated by Margery Mann and Anne Noggle at the San Francisco Museum of Modern Art. In 1976 I began working on the book *Recollections: Ten Women of Photography*, a chronicle of the oldest major American women photographers still living at that time. I asked Ruth to be one of the ten women. Curious as it sounds today, at the time people could not understand why I was excited about doing a book on creative old women. They were simply not visible. I was way ahead of the wave, but it had long been obvious to me that it was essential to rewrite photo history to include women. The exhibition accompanying the book traveled to sixteen American museums and broke attendance records at the International Center of Photography in New York, astounding museum curators all over the country with its record crowds of old and young, male and female.

My knowledge of Ruth's work and aesthetic motivations was formulated in the course of producing *Recollections*, and again in the 1980s, when she was putting together her photographs of nudes for the book *The Eternal Body*. For that project I was asked to write the text: an essay on her photographs of the female nude. I welcomed the formidable task of being the first person to place Ruth's work in the larger stream of art history, because I felt strongly about her presence as a woman artist in that male-dominated field. Indeed, she was a pioneer, working before the contemporary freedom of expression about the body. Her work stands apart from others' in the human dignity she evokes, the reverence for the experience of being a woman that is filtered through her use of pho-

tography to express her ideals. Her approach with light is that of a sculptor modeling with clay.

As a portrait photographer I am fascinated by the mystery of personality. Interpreting a person in words is, for me, a far more daunting task than capturing a person on film. In both media, however, the challenge is to extract the essence of the person, letting the subject be as authentic as possible. Of course, a great portrait is a dialogue of sorts, so writing a memoir in Ruth's voice has me behind another kind of lens, listening instead of looking.

Ruth Bernhard: Between Art and Life was intended to be a modest scrapbook drawn from a series of straightforward interviews with Ruth. Gradually the concept grew into a memoir written in the first person with other voices contributing a counterpoint that balances the single voice. Thus the book has both the immediacy of a monologue and the complication of a play with subplots and supporting characters.

I have worked for the past two years tracking the heart and soul of this deeply complex personality as she looks back over a life that is now in its ninety-fifth year. Even today, she commands a devoted following of students, friends, and lovers. Here is a woman who, through the courage of commitment to her own intuition, has lived a life more rich and dark in nuance than she projects in her illustrated lectures. Ruth will not be the suffering artist. She identifies with the ideal, burying the pain and strain, smoothing out the memories, much as she diffuses the surfaces of rough flesh of her nudes.

Until now she has presented the story of her life as performance, much as a ballet dancer creates the illusion of ease as she seems to become weightless on her pointed toe. We, in the audience, are transported to an ideal state, as we identify with such a marbleized beauty. But there is another way to see the dancer move, to identify with the sweat and strength and musculature that express the power of the jump. In that view we experience the movement; we see the effort the dancer must exert to thrill us. We are given a view of more than the perfect moment. We live the dance.

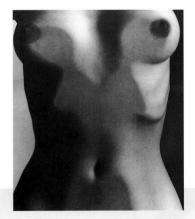

Ruth not only photographs perfect moments, she creates them. Through her imagery she lives from perfect moment to perfect moment. In life she says yes to the next impulse so that, in the telling, life becomes art, a life illuminated, glorified against the dark of the auditorium space, where her audience sits transfixed, ready to enter into the distilled emotion of a flawless, permanent, eternal place where the gods play, where the artist seeks harmony and solace from the

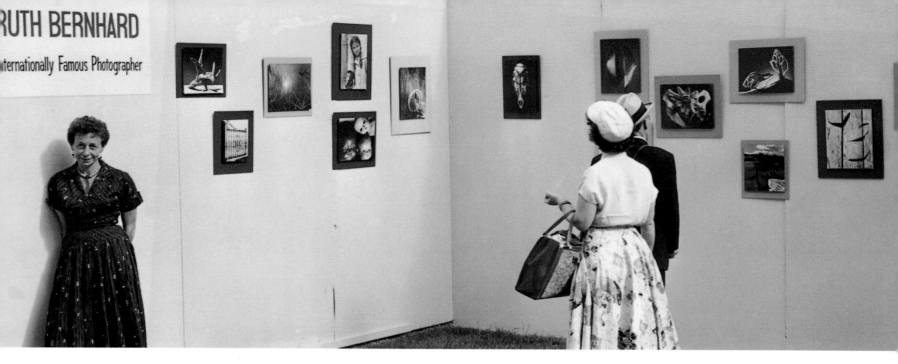

chaos of the dark, from the fundamental loss of control in real life over time.

From her youngest years, Ruth idealized her father, perhaps even more than most children, because he was such an elusive personality. The appeal she made to grown-ups to notice and appreciate and, if possible, to love her must certainly have masked the agony of a parentless childhood. Yet, solitude became the great gift of her lonely early life, a gift that put a love of nature above all other loves, and opened up the imagination to a creative life in which she could triumph over the grief of those deprivations. When she speaks of her childhood today, she tells the story as if it were a script. We will have to imagine her pain from her desire to stay in the playful world of the child. Or from such statements as, "Dolls represent caring. I never had a desire to be married or to have children, but I have always cared about dolls." Her photography of dolls carries that emotion from her childhood self. Her relationship to light in her adult imagery retains for her the consolation she felt as a child when she held grasses up to the sunlight, instructed by her teachers to examine the stem in a brighter light. The role of light in photography is the medium of revelation, as it is in life. Ruth's own "writing with light" became the source of comfort, joy, and belief.

In the balance of light and shadow and the chemical alchemy of the darkroom, Ruth found a way to transform her life experience into metaphor. The muse lives in the moment and that moment in art is beautiful. A photograph becomes a way to create a perfect world, a place where time stops and we linger in the forever. But in our daily life we cannot live in two dimensions, or in the abstract of black and white. We stumble. In her real life Ruth picks herself up, laughs and cries and laughs again. The full story of an artist's life lights the way for others who seek the creative life. We experience the effort to produce and not consume. We see a life lived for artistic expression in the human dimension. It is no longer a mythic tale, but a real-life story that we can treasure all the more for its gift of wholeness.

Ruth's childhood has sweet surfaces stuffed with sadness, providing us with scenes that

could be from a Victorian novel, a childhood out of a story like the little princess who lived with her parrot in the attic room, dreaming of her distant father. From her point of view, Ruth was an orphan. She was abandoned by her mother when she was less than two years old. Estranged from her self-centered, distant, and aristocratic father, Lucian Bernhard, who was rapidly rising as a star in the emerging new world of German design and advertising, Ruth lived her childhood in her imagination, where she could discover an ideal vision, one that real life cannot touch.

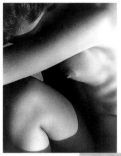

Eventually, Ruth emerged from her lonely, frustrating, but privileged childhood, dominated by her yearning for recognition by her father. Lucian Bernhard was a brilliant artist, but for Ruth he was a benevolent but critical and distant figure. However, as a young woman, Ruth criticized his real behavior. She did not approve of the way he treated his young models, posing them in suggestive ways, and she could never compete with the pretty girls of his fantasy. There is no doubt that Lucian respected his daughter; he was instrumental to her security as a young and emerging artist, and Ruth learned from her father how to be an artist. From her youngest years she watched him in his studio, where he was most at home. All clues suggested to Ruth that work was the most important thing in his life. With unusual confidence she adopted that stance in her own life and easily fell into the role of the working artist. In her artistic training she followed a traditional curriculum—based on the classical harmonies, serious study, and the great masters of European art.

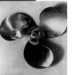

As a young woman, Ruth followed her father from Berlin to New York. There, the freshly minted photographer found a new style in the dictum "form follows function" and, with her camera, documented the stripped-down industrial design dominating the 1930s scene. Her father and his industrial-design friends were well connected in New York, and the circle of modernist design and its new museum, The Museum of Modern Art, placed Ruth at the fulcrum of the emerging cultural style. Though her father launched her into a career in photography and succeeded in acknowledging her feelings when she fell in love, it was too late for a true bond between father and daughter to develop. She respected her father, but she could never find herself in the image he held of women.

She found her style on her own, in the spare urban aesthetic of modernism, lighting objects with the drama of light and shadow. Her understanding of classical ideals, drawn unconsciously from her classic German education, combined with the example of Bernhard style that had been around her as she grew up, set the stage. Once she arrived in New York, she was ready to perform. The city was a visual feast. She responded to the pulse of the street traffic, the treasures at the five-and-ten-cents store, and the magic chiaroscuro of the movies. It was in New York that she discovered the surrealist movement in photography, which she had not encountered anywhere in her development as an art student. But it was not until she met Edward Weston that Ruth found her soul.

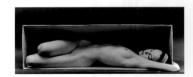

This book publishes the personal correspondence between Ruth and Weston for the first time. The meeting with Edward Weston was a powerful, transforming, emotional experience

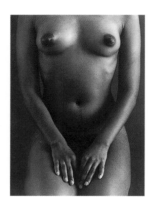

that turned Ruth into a serious photographer. She approached her craft with a passion to express her feelings. She was ready, at age twenty-nine, for commitment, to Weston and, more important, to herself. In Weston she found the guide for her life's path as an adult and as a photographer. In the expressive example of his photographs, she discovered images that made poetry. A man of charismatic power in his relationships, Weston drew people to him, especially women, who adored him and who served his art as model and muse. In his photographs there was a perfect harmony of vision and craft. His living was pared down to a monkish, spartan simplicity so he could devote himself to his work. Thus he treated the making of a photograph with high seriousness. Ruth was attracted to the timeless quality she found in Weston's simplicity and she strengthened her resolve to reinvent herself as an artist. Weston's meditative style and his sensuous seeing suited her perfectly. During Weston's lifetime, Ruth participated in his devotion to photography as a willing disciple and glowed in the warmth of his approval. Beyond words and concepts, she let her intuition rule, following his example, to live her life dedicated to pure seeing as she experienced it in photography. As a teacher, also, Ruth has acknowledged a debt to Weston. She focuses on one student at a time, distilling the creative process from an intense scrutiny of the image, then redirecting the student to another level of awareness.

While her childhood loneliness threw Ruth into her imagination and the experiences of her family life turned her against marriage, the nurturing she received from her early teachers gave her the kind of love and fulfillment that she craved. This would come to her later as a daughter-lover to Weston, and mother-teacher to her students. Her life was full of romantic entanglements, but it is her success in connecting with people as an educator that has brought her the family she now calls her "entourage."

The modern world conceives education to be concerned with skills and information, not with feeling and imagination. Ruth communicates a different vision when she teaches photography: "creative realization through the 'third eye'—the camera lens." She promises that students can explore their uniqueness, and she urges them to challenge limitations. From the beginning she wants students to find the place photography can hold in their lives, echoing the way she used photography as a therapeutic language to reinvent herself, over and over again. When Ruth says to pay serious attention to your work, it is really a way to say one must feed the soul to keep it alive. Photography provides a way to bring the outer and inner experience deep within us into focus: life and soul merge.

Ruth's work found recognition from the very start. Her photography appeared in print in the early thirties and by the time she was published in *U.S. Camera*, No. 4, the June 1939 issue, she was the "American Aces" cover story. Already she had produced work in all her subject areas: children, shells, animals, toys, dolls, all sorts of still-life subjects, and nudes. The main illustration of the article was a figure featuring wet drapery on the raised breast of a mannequin. The text recommends that she obtain a Guggenheim (as the foremost student of Weston) and spend her year on the subject of the female form. In that early article her future seemed set in motion.

Ironically, the projections fit perfectly with her eventual success as a photographer, except for one fact: Ruth never received a Guggenheim fellowship despite several applications.

If I think about Ruth's life as a fairy tale, the 1930s would become the scene of her awakening. From the house of her stepmother she goes out into the world to find her father, and instead Prince Edward appears. He acknowledges the beauty of her soul, awakening the life force of her creative self as photographer.

Until she settled in San Francisco, Ruth never stayed very long in one place. She lived in New York and Los Angeles, visited frequently in Florida, and moved from one romance to another. The place that kept her interest consistently was her own imagination. Through her photography, often practiced as late-night meditations, she found her expressive medium. As she had sought a refuge from disappointment and loneliness in her childhood through her imaginative play with dolls and animals, she focused on objects with the same intensity, feeling, and singleness of purpose, turning everything she loved, including naked bodies, into an expression of her self.

In the strategy of avoiding the dark, Ruth also found that she could survive by being good. She forged a strong spirit, deep knowledge, and a relentless curiosity that has kept her forever young at heart. Despite her direct and forthcoming nature, it is hard for Ruth to discuss her life when it touches emotional pain. She is not unwilling; she simply smooths it over. A photograph has the great attraction that it can transform the chaos of life into an image where we can live forever, in spirit. Photographs carry Ruth Bernhard's emotional life. There, in the language of light and symbol, she molds her feelings into art, controlling time and space. Over and over again in conversation about her life, the details are visual. There are no narrative, no dates, no time: the image is everything.

She wants to give illumination to the inner story of her heart's path as a message of hope to youth. As an older woman who is a sage, so much of what she represents is the power of authenticity, the value of working to know yourself, the intensity of learning to express yourself. In relationships the question is perennial; Ruth as a child asked herself, "What is love? How do I find love?" Ultimately, for her, "Love is the answer." Over and over we see her try, following her intuition all the way. By the example of her real life she asks, "By loving nature, do we also feel loved?" and answers by teaching that each of us as a human being is a part of nature. If we can feel that deeply, we can trust our intuition, take our risks and say yes to life, to love, to adventure, to solitude, to an ideal harmony; say no to hypocrisy, dishonesty, and possession.

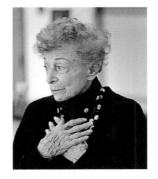

In my almost daily conversations with Ruth I encountered different voices: the eloquent, sophisticated, deep-thinking philosopher and observer of the world; the sensible practitioner of photography; the impatient, curious, self-absorbed, endearing child; the lover of art, music, and theater; and the charming, fun-loving, caring friend.

To draw these voices together to establish the narrative of her life, to bring other players onto the stage with her, and to capture her personality on paper has been a great challenge. About art and seeing and living, Ruth is consistently and remarkably clear and deep and embracing in her

expression. About her pattern of living and feeling and doing, she is partially vague and strangely uninterested. I discovered that her interest lies in the moments, not the narrative, unless it serves an understanding of her work. What shows matters: the perfection of the image. The blood, sweat, and tears are hidden, but we feel them. Were this not a memoir in the style of an autobiography, I would have followed her lead and dropped the narrative. Who cares when or how it happened exactly? As Ruth herself says, "I don't do much with everyday life. I would rather focus on the plum tree out front that I planted years ago when it was twenty-four inches tall."

Ruth lives in the moment. People move in and out of her life, but in some basic way they are not her primary connection: "I surround myself with things I love. I consider them all part of my creative life. It doesn't make any difference who I am with. I can never lose the connection I have with these wonderful things. I don't dust them often. It is wonderful to know where everything is." These "things" are her collections of nature's tiniest shells and bones, grasses and flowers, as well as small ceramic or wood sculptures of animals—all extensions of her own vision and perfect conversation starters. I have seen the moment many times. A visitor arrives. Greetings are exchanged. The hallway to the living room is lined with shelves that support her treasures. One is picked up and shown to the visitor with great ritual dignity, and a long discussion follows that will stay with the visitor and be retold later as a magic moment meant just for him or her. It's another lesson in seeing and awareness, effortlessly received and naturally given—lessons from a life constantly energized by imagination.

"If you get married, you make life comfortable for the other person. You pave the way." In her era, marriage seemed to be one-sided, the woman making it comfortable for the man to present himself to the world. Ruth had such a poor example in her father that she did not want any part of that way of life. Besides, she wanted to *be* her father, the artist. She had great impatience with her old school friend in Germany who had married and who proudly showed Ruth her linens and silver. Ruth's response was clear dismissal of any value for her in the trappings of married middle-class life. In her generation the choices were so separate, with a chasm in between. Ruth made a decision to be independent.

In her ninety-five years, although she has had deep relationships, she has remained her own person. In this time she has moved beyond artistic ego, beyond the creation of actual images on paper, to become a teacher of creativity, a guide to the inner life that integrates heart and soul, art and life. No greater gift could she have shared now than this walk through her past. We take comfort in the message that art and life are one and the same if lived deeply, intuitively, and with a commitment to a goal beyond individual achievement. Now Ruth has achieved the position of

icon herself, with an almost mythic capacity for survival. It is clear to everyone who knows her that to be an articulate, eloquent, witty, and passionate person at her age, available to people in youthful enthusiasm, is a remarkable achievement, perhaps greater even than any one of her photographs.

Ruth has transcended the circumstances of her origins and family life by integrating the pain of the past. Finally, after years of reinventing herself, she inspires all whom she meets to see more and do more than they think possible by trusting in their intuition as she has trusted in hers.

As an intuitive person, Ruth demonstrates her sense of the world in detail. If she receives a plant and it grows a new shoot, it is cause for celebration. At Walgreens, hunting for a cosmetic item becomes a quest. Whatever she turns to notice is the topic of that moment. She is paying full attention to you, too. When I called recently to say that I was leaving my house to get in the traffic and cross the bridge, hoping to be on time for our visit, she said, "It is best to rattle before you strike!" In the two-year process of preparing this book, Ruth and I were often seated at the kitchen table, sharing a light supper featuring her favorite plum wine, some cheese and bread, some chicken and salad, and, always, coffee ice cream or applesauce with a cup of her excellent strong, dark coffee, which Ruth laces with heavy cream. "Margaretta [always my whole name, savoring each syllable], you did not put enough butter on the bread! I love the bread that you brought: crusty, Berkeley bread. But it must have lots of sweet butter."

We were meeting one evening to go over photographs, and we were examining the proof sheets of black-and-white negatives of photographs I made at Princeton University in October 1996, when it was officially announced that Princeton would house the archive of Ruth's life work in photography. Her head was down, loupe against her eye, as she focused intensely on the individual images, scenes of her at the Princeton Art Museum opening, lecturing at the podium, greeting the president and his wife, and receiving a lovely gift at the president's dinner. Up popped her head. She sighed, "Oh, I am not my type at all!"

When we were getting underway in early 1998, Ruth's schedule was inundated with interviews to give, honors to accept, and workshops to plan; with people wanting to meet her, galleries exhibiting her work, and dentist's and doctor's appointments. There seemed to be no time available to consider her legacy. The details of the past held small interest next to the delight of an afternoon excursion with a friend. I was working. I was on the phone and trying to visit with Ruth. I was frantic. One day at Ruth's I heard that she was going to Whidbey Island, Washington, to conduct her last workshop. She had given a "final" workshop a year before and I had missed it. So I said with great forcefulness, "I am going with you to document the workshop. If I am working on this book, I have to be a part of everything you do." It was evident that Ruth was still not clear then that this book would happen and that its completion was dependent on her.

So I went to Coupeville, Washington, with Ruth and Mary Ann, Ruth's right hand, also known as lady in waiting to Ruth as queen. We were driven north the long way from Seattle "so that Ruth could see the tulip fields." Queen and lady in waiting took over the second floor of a

"Ruth inspires all whom she meets to see more and do more than they think possible by trusting in their intuition as she has trusted in hers."

Victorian bed-and-breakfast with every appointment necessary for a visiting dignitary and her entourage. Ruth always had the queen's high-ceilinged bedroom, and she took a stately breakfast surrounded by silver and fine linen and china, with a proper plate for everything.

In a teaching career of almost forty years, Ruth has reached international audiences. Mixing anecdotes from her life with the occasional pungent comment, she covers the familiar ground of her belief in the power of the universal order that connects us all with nature: a stone on the beach, a cloud in the sky, the body as seedpod containing the past, present, and future. In her lexicon, beauty is a spiritual expression hidden inside a leaf or a face, revealed in the curve of a hip or the bark of a tree. Seeking spirit in matter demands our full attention, or even our devotion. A found object of everyday life, or an ordinary body, can, with heightened awareness, become a sacred, transmuted object of veneration. An image exposed in light and shadow, captured on a slim piece of photographic paper, can become a way to dig deeper than words, heal wounds of the heart, and embrace the world. At a recent lecture one of her friends, a former student, whispered in my ear, "When I hear Ruth speak, I am in church."

Ruth would see herself more simply: "You can't tell a person what to do. You can help guide him to find his motivation. Then, he becomes free to express himself. As a teacher I weed the garden and fertilize the plant. What comes out is what was hidden inside all the time."

I think that it was about the time of this last workshop that Ruth understood my commitment to the book and my loyalty to her. Ruth engenders such loyalty in her friends. She collects people, finding them much as she instinctively spots the crushed teapot in the street or the shell on the beach. Soon, she finds ways for these friends to participate in her life and her work.

Much of the text that follows comes from conversations with Ruth, either formal interviews or casual visits. Once I put the anecdotes on paper I realized that there were abrupt endings, holes in the stories, and that somehow I had to reach deeper for detail, for the pictures that were missing. Often the anecdote she told me was not quite the same as the one I read in an earlier interview article. I had to figure it out. So every night on the phone I had a list of questions I called "clarifications." "Are you in bed, Ruth?"

"Yes, I am horizontalizing. Isn't that a perfect word for what I am doing?"

"Remember that story about Marlene Dietrich? It doesn't sound right. Something is missing. . . . Oh! It wasn't Dietrich who gave you the tickets, it was the character actress on the stage with her? You'd better start at the beginning. I will read it to you when I rewrite it." So, another night at the computer until two in the morning. Finally, I spent several afternoons that extended into the evening reading the final text aloud to Ruth for corrections. It was a good idea. I had several names wrong. Ruth made suggestions for changes in the most subtle details. But most of all, she said, "You have a very good ear." Then I asked her how she felt now about doing the book. She thought a minute and replied, "I chose well. You are the author because you really care about me."

Ruth has an active life for a person in her ninety-fifth year. She has exhibitions and goes to

others' openings, as well as to the symphony and theater. She tells me that she never falls asleep in the theater, which I find hard to believe, but the point is that in her later years she has become a success all around and has enjoyed the results of years of teaching, lecturing, and producing photographs. She is a personage now, and in her old age her life has expanded in an unusual way, bringing her financial as well as personal good fortune. In 1999, at her opening at the Fong-Heimerdinger gallery, I was chatting with a well-dressed youngish man in the dark suit and tie of a businessman on the go. He worked at a brokerage office, and I imagined that he handled her account. "Do you realize?" he exclaimed, waving his hands at the prints on the wall, "Ruth is a working woman. She is doing all of this at her age—on current income!"

Ruth's family grows and grows. People are always bringing their work for her advice. Former students fly in to visit for the afternoon, from as far off as Florida. They call frequently from Portugal or Texas, and her brothers are on the phone at least weekly, keeping in close touch. She receives letters from admirers. When I am there for a visit in the afternoon (Ruth does not receive visitors in the morning, she is a night person), there is always the ritual of looking at the mail, gifts, cards, notes from her admirers. There is always a card from Shedrich Williames, the friend who sends her a message every single day—sometimes twice a day—a card sometimes perfumed, always with a blessing. And you naturally imagine that all these guardian spirits from around the world wishing Ruth well may be one reason she has lived so long. Her life has expanded and continues to expand, including more and more people and more and more love.

When we speak of this coterie of faithful friends, Ruth shakes her head with a chuckle, wondering aloud what it is that magnetizes her. "Perhaps," she muses, "it is because I never gave up the childhood excitement about a new day every day. If you add maturity to a young enthusiasm, you can be highly vitalized. I still seek that acknowledgment that I sought as a child."

"Also," I add, "it is because everyone has mentioned your loyalty, your steadfast capacity for friendship. You have spoken of your hunger for appreciation and I know a lot about your high expectation of devotion in return." We laugh.

For her birthday party in October 1999, I had arranged for her favorite photograph, *Creation,* to be digitalized in frosting on her cake. Thirty-three of us crowded into my dining room to sing "Happy Birthday" and to watch her surprise when she saw the cake. The room was darkened, the candles lit. Ruth spotted her photographic image. "Perfect! My favorite! Fantastic! How did you do it? And I see that you remembered to put my copyright. Wonderful!" She lifted a glass. "To my last birthday." As everyone groaned and protested, "No, Ruth, no," she continued without hesitation, ". . . of the twentieth century!"

When asked that night how she would like to be remembered, Ruth said simply, "There was a woman who loved life to the very last day."

Margaretta

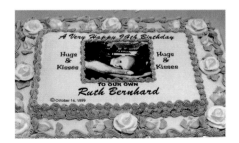

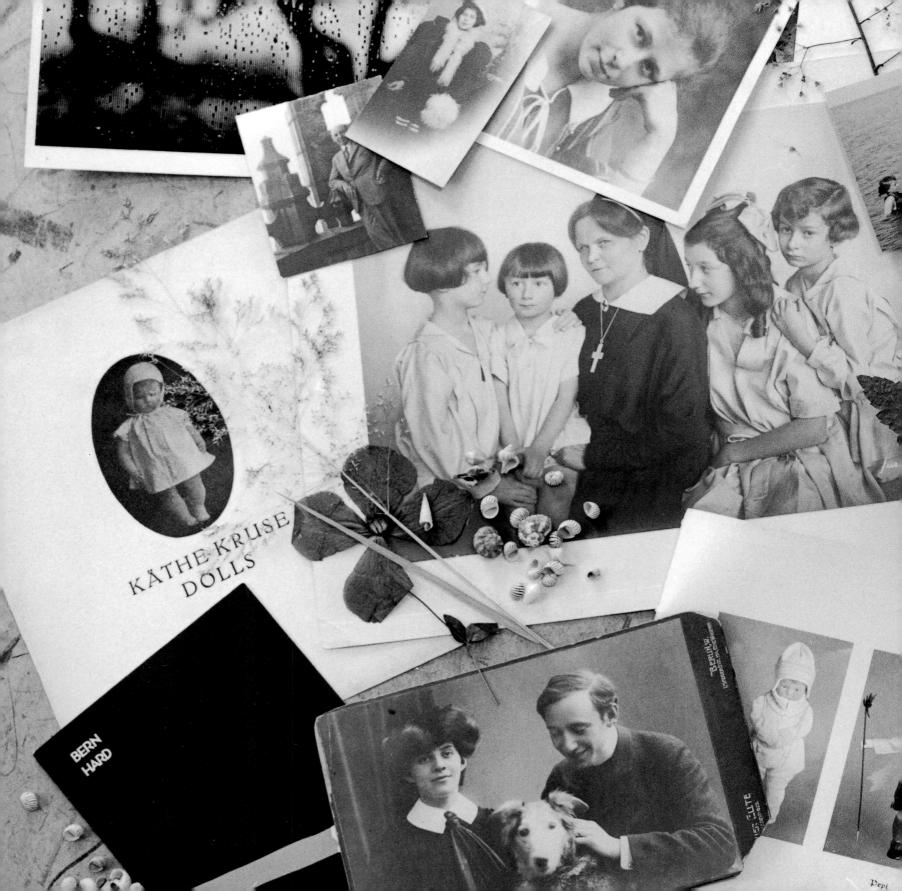

My Life

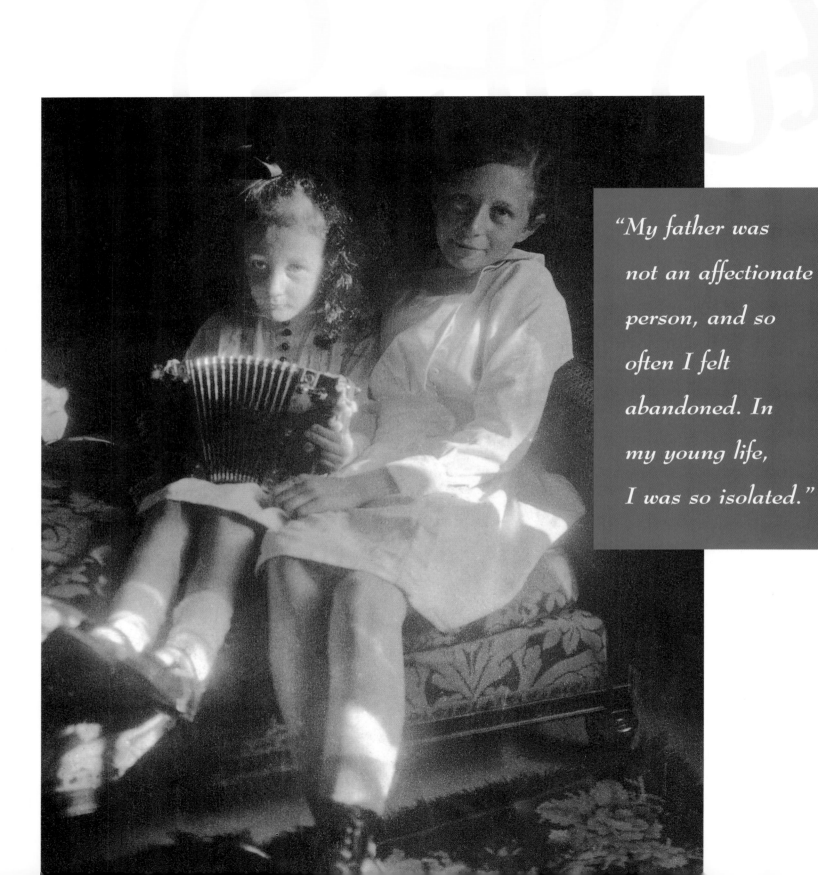

"My father was not an affectionate person, and so often I felt abandoned. In my young life, I was so isolated."

childhood

MY FATHER

MY FIRST MEMORY places my father, Lucian Bernhard, at center stage, where he remained for all of my young life. When I was five years old I was very ill with scarlet fever. The scene is in the hospital. I am wrapped up in a blanket and carried to the window. I remember being held up to see my father, who was not allowed to come inside and visit me. I scream when I see that there is a woman with him. She is not my mother, of course, and I must have known it. I cry because I expected him to be alone. The nurses put me in a bath to calm me, but I keep on screaming. The entire hospital heard me.

Aloneness was what scared me so much, not the sickness itself. I don't remember what it was like to have scarlet fever. All I remember was waving to him and feeling extremely jealous of that woman. I hated her, whoever she was. I never met her. I never even could tell my father about my reaction, but I have never forgotten it. Someone else was in my father's life and I wasn't.

My father was not an affectionate person, and so often I felt abandoned. In my young life I was so isolated. I was never sure what it is to love. I asked myself over and over, "Would I be able to do that, to love someone?" My entire childhood held the questions, "If love exists, what is it? How do you get it?" Later, when I was a teenager, I always asked myself, "Do I have enough to offer? Am I giving enough to get what I need?" Perhaps that is why I love things of beauty so much. I love plants and trees and shells and animals because I know how I feel about them. And they don't have to feel about me—so I have no expectations. What I get back is what I put in. Perhaps that is why I loved my dogs so much. And it may be the reason why I never wanted children.

I know that I was born in Werder, near Berlin and was named Ruth-Maria, but I cannot begin my story earlier than my first memory because my father never spoke about his family, never mentioned aunts or uncles or cousins. None of my family knows anything about his past because whenever he talked about his childhood, he changed the story. I often say that he was born on a lily pad.

From all his different tales of origin, I know my father was born in 1883. But from his stories, he could have been born once in Switzerland and once in Stuttgart, Germany. He frequently told us the story that as a youth in Stuttgart, he saw an exhibition of art nouveau and was so inspired that he painted the furniture and walls of the family house with the new, vibrant colors.

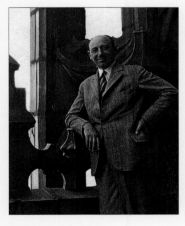

Facing page: Ruth with half-sister Lucienne, 1915. Above: Ruth's father, Lucian Bernhard.

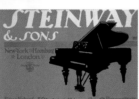

When his parents arrived home from vacation and saw what he had done, they ordered him to leave. And he did. I think that he invented this story as creatively as he did his pictures. But it is true that he went to Berlin at a young age. There, in 1906, in the year following my birth on October 14, 1905, he won a poster contest. A printing company, Hollerbaum and Schmidt, held a competition, sponsored by the Priester Match Company. Lucian Bernhard submitted a modernist design of twin red- and yellow-tipped wooden matches and the brand name "Priester" in block letters against a dark background. The composition was stark and graphic, a stunning concept. So dramatically different was this new reductive design that my father won the contest. His career was launched.

He was a very talented man and a perfectionist. From the beginning Lucian displayed a fantastic color sense. His success coincided with the tremendous popularity of posters, an advertising trend lasting from 1906 to 1921. His early posters were the beginning of visuals in advertising. The poster was extremely important in the first twenty years of the century in Germany. It was the only color work that the printing industry could produce. All the rest of the magazines and newspapers were still printed in black and white.

In his lifetime my father was called "The Father of the German Poster"; he was really what we would call today a graphic artist. German poster art can be compared in popularity to television in the fifties, and it gave my father international respect as a pioneer of the primary medium for advertising for so many years. His work was published in the first poster magazine, *Das Plakat,* which was founded by Hans Josef Sachs, a dentist and collector of posters. This journal promoted my father, and he immediately became famous in Germany. My favorite posters were "Kaffee Hag," a strong design with a snake, and "Stiller," an advertisement for shoes. In my opinion, his real contribution as an artist was in the design of typefaces. Bernhard typefaces remain popular today and I always use them in my books. It is my inheritance!

My father worked for the German government of the Kaiser, making designs for notes of money. He designed many posters in script that told people, "Give your gold to the fatherland." That must have been during the First World War. I remember a book that my father designed for the Kaiser, which was made to honor the wartime soup kitchens and as a kind of thank you to the German women who staffed them.

When I was a baby my father had just become well known and his posters were all over town. He married my mother when they both were very young; he was twenty-one and she was seventeen. When she became slightly visible with me, the marriage was arranged quickly. They certainly never had much of a life together. When they met, my father was a young artist; my mother was a teenager. She must have wanted her childhood back, because she left the family and went to America when I was two years old. They were, of course, divorced.

He was not like a father. He was an admired, faraway person who couldn't do anything wrong. I once gave him a wallet on which I had embroidered little acorns and leaves on a piece of olive-green fine wool. "A wallet, eh?" is all he said upon receiving my gift.

Facing page: Posters designed by Lucian Bernhard. Priester Match Company, 1903. Steinway & Sons, 1910. Left: Lucian Bernhard. Below: Kaffee Hag poster designed by Lucian Bernhard, 1914.

Kaffee Hag
Coffeinfreier Bohnenkaffee

In my childhood I never spent much time with him. He had his own studio and spent much of his time there. You could see the Elephant Gate of the Berlin Zoo across the street, and below, where I would meet him for coffee when I was older, was Das Romanische Café, a favorite destination for all kinds of artistic people.

Once as a young child I must have spent a night at his studio, because I have a memory of lying on pillows there. I could not sleep, but was too afraid to awaken him to tell him. I spent the strange night hours trying to decide what to do.

Our family house faced an old-fashioned, wide boulevard with large trees on either side. The address was Podbielskialle 3, in Dahlem, a suburb in the Grunewald section of Berlin. The houses were impressively large. I guess it was the most distinguished residential area of the city. In the middle section of each boulevard was a dirt equestrian path with a bicycle lane. The sidewalk in front of the house, which we called by the French name, *trottoir,* was made up of a stone mosaic paving typical of Berlin.

My father's influence was everywhere in the house, beginning with the wide front entrance, where he designed and had his initials, LB, carved in wood to fit the semicircular space above the door. He had these painted in dusty colors in a flowing Bernhard script design that might be considered art nouveau in style. When I returned to Germany recently, my brother Alex and I went to the house. We didn't go inside, but I saw that the carving was still there.

Everything inside—rugs, furniture, walls—was in the Bernhard style, which was always beautiful, with subtle grays, simple lines, furniture made to order and painted in many layers to create a glasslike lacquered finish. His style was his own: simple, elegant, with curving lines— never angular. Father was a collector also. I recall painted Japanese screens all across one wall in the room with the spinet. And another wall of Japanese drawings. I am sure that I absorbed my love of Japan from these early objects in the family home.

As a girl, whenever I saw my father, I was spellbound. He was such a distant figure, so unattainable. In my memories of childhood in Germany, I see him as a dandy. He was meticulous

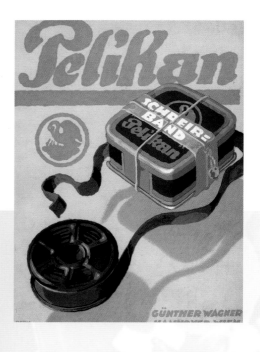

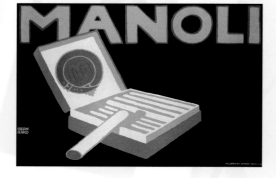

**Posters designed by
Lucian Bernhard.
Left: Pelikan, 1920.
Right: Manoli, 1911.
Facing page: Stiller, 1908.**

about his clothes. Beautifully groomed, he wore bow ties to set off his made-to-order suits. His spats were always crisp. He changed clothes more than once a day and was never seen in less than impeccable dress. In fact, I never saw him in his bathrobe. Really, I don't think that he had any leisure clothes until he came to America. I have inherited a love of fashion and style from him. I have never worn blue jeans, and I do not like leisure clothes at all.

My father also created quite an aristocratic impression by using a monocle on a black cord hanging around his neck, instead of the more bourgeois look of eyeglasses. While sophisticated, the monocle was actually a practical idea, helping with the one eye of his that was not as good as the other.

His quarters seemed very special. I remember that he had his own room and bath at one end of the floor. There was a specially designed closet he had built just for his ties. If raindrops fell on his shoes, my father would be upset. To polish his shoes and care for his clothes, he employed a valet, Mr. Christman, whose wife served the household as cook.

We also had a chauffeur, named Philip, who was proud of his job. Cars were very special in those days early in the century. I remember seeing Philip driving without his cap on, probably so he could look like the owner and not the chauffeur. My father never drove himself. Later in America he tried, but he had an accident, hitting the back wall of the garage. He actually drove in the front door and created another in the back! But in Germany before the war it was logical to have a chauffeur to take care of the car, which was treated very well, polished as much as the family silver.

From my father I observed at close hand the life of an artist. Lucian Bernhard was the most important person in my life until I met the photographer Edward Weston. I know that I was an

Ruth and her brother Alex at the doorway of their childhood home in Berlin, photographed by Alex's wife, Audrey, in 1995. The initials L. B., located above the door, were carved from a design by Lucian Bernhard.

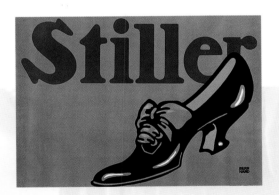

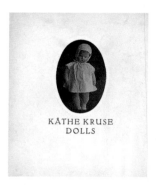

These dolls, with their handmade clothes, were much like Ruth's cherished doll, Peter. Booklet on Käthe Kruse dolls, courtesy of Ruth Bernhard.

KÄTHE KRUSE DOLLS

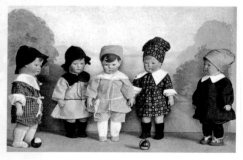

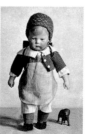

unexpected sketch in my father's life, but it must be said that no matter how distant he was, he never shirked his responsibility for supporting me. This was true when he placed me with the Lotz family at the age of two, when I later went to boarding school, and when, in my early twenties, he invited me to join him in New York. Especially then, he supported me, introducing me to his designer friends and encouraging my photography. He admired my style as a person. But as a girl, I always felt ugly. He did not appreciate me as a woman. In a sense, he treated me like a son, which he wanted more than he ever wanted a daughter.

All through my youth I saw little of my father, and when I lived in boarding school, I saw him only on holidays. Not until I was grown up and living in New York did I really know my father; nevertheless, I always wanted to please him.

MY TEACHERS

After my mother left, my father was so busy with his newfound fame that he could not manage to care for his child on his own. His solution was to place me with a pair of sisters in their forties and their mother, who were my "family" until I was seven years old and I returned to Berlin to live with my father and his new wife. Katarina and Helene Lotz were teachers. They lived in Hamburg with their mother, who was a really grandmotherly woman. They ran some sort of institution for young women (perhaps what we used to call "fallen" women). We lived in an apartment in a huge house at 21 Nordestrasse. I think that the young women actually lived in another part of the building, but I never saw them. More important to me were the horses I saw in the building across the street. I remember a horse going up the driveway, being forced by some men up the cobblestones. It made me cry when I heard the men talk to the horse in a rough manner.

The Lotz sisters, whom I have always called my teachers, taught me to read before I was four, and I was encouraged to spend time in that other world of imagination. I was alone a lot, in a huge room that was often used for a social hall. There, I had all kinds of dolls. Lots of them were tiny, about two inches high. My dolls were real to me. Without other children in my life, they were my little friends. In Germany at that time there was a very special doll created by Käthe Kruse, who was a friend of the Lotz family. In fact, she was the original connection between my father and the Lotzes. Her husband was a painter and a friend of my father's. Käthe Kruse doll faces had simple, straightforward expressions, not overly sweet like so many other dolls. They looked like real children. Grandmother Lotz made clothes for both boy and girl Kruse dolls. I fondly remember my boy doll, Peter, best of all. I cared for him as if he were my own baby brother. He had a head that moved so I had to hold him carefully, like a real baby. At first he wore baby clothes and as I grew so did he, into more childlike clothing.

The Lotzes had a big kitchen and there was always something to do. At Christmastime I learned how to make a gingerbread house made of *lebkuchen*—delicious! There was a fence all around it and the windows were made of red gelatin that came in sheets. With candles inside I

could see the light coming through. The Lotz sisters paid special attention to what I liked to eat. I recall participating in making things, especially desserts. There was a special dish we called a porcupine cake. It was made with chocolate and biscuit dough and had almonds stuck in it to look like the needles of a porcupine. I was always entertained in that house. I also cooked for my doll, Peter, every day. If I ate, he ate, too.

My father sent books, and many were fairy tales. They had a big influence on me and I would made up dolls into characters who lived in many countries, which I placed in the corners of the hall. One fairy tale that I remember well was about two young girls who wanted to go out to make their fortune. It was called *Gold Maria and Pitch Maria.* The first sister left home and came to an apple tree, which called out to her, "Shake me!" She did, and apples fell into her apron. She came to an oven and it spoke to her, saying, "I am ready." And she had bread from the oven to eat. Then she saw an old woman in a window shaking out bedding and she offered to help her. So she swept the floor and helped the woman with her housework and when she left to go home, she was showered with gifts. Her sister saw the gifts and decided to go the same way. She met the apple tree and did not do as she was asked, nor did she obey the bread in the oven. And then she pretended to want to help the old woman, but she was lazy. So she did not do the right thing at all, and life did not reward her. From that day forward I believed that life will reward you if you pay attention to the world around you, are helpful, and do the right thing. My life was influenced by that tale and others like it. I learned to be responsible for myself and to be open to the world.

My teachers also read to me from books about nature, and we looked up whatever I wanted to learn about. I was encouraged to ask questions. No subject was taboo. The sisters told me everything in a most natural way: the role of fathers, where babies came from. That I also learned firsthand from all the animals in my care. I had no surprises and there was nothing to whisper about when I was older, in boarding school. My teachers taught me to tell the truth, or at least not to lie. They always asked me questions, encouraging me to explain and respond. That gave me confidence. They wanted me to express myself, to be aware of nature, to see beauty. It was a perfect life for a child with intuition, being allowed free rein.

I particularly remember a picnic to the Lüneburger Heide, where I saw my first heath briar, *erica,* which was a few inches high. I picked it and one of my teachers said, "Hold it up to the light so that you can see it better." My training to see light began in that moment. It was part of my education to collect and organize my treasures from nature. I learned to press flowers in a special book with absorbent pages. I remember a little garden I had in a window box. I loved planting the seeds and watching the little green sprouts appear. It was natural when on vacation to the North Sea that I would come home with stones and shells and plants, like tiny pink wild roses and beautiful feathery grasses, as I was already a most ardent collector of the secret wonders of nature. On these excursions I wore strapped over my shoulder a little tube-shaped purse made of tin, painted green with pictures printed on it. I put the grasses and flowers and insects,

> "My dolls were real to me. Without other children in my life, they were my little friends."

especially frogs, that I collected in the field in that purse until I got back to the house. To this day my living room table is covered with treasures: seedpods, leaves, shells, bones, and all manner of miniature animals in clay and metal and fabric. I continue to find new books to keep flowers, leaves, and grasses pressed.

Nature gave me a grasp of a natural order to all ways of life. I feel immense consolation when I see sunlight illuminate a blade of grass. It is this awe that I feel when I photograph. Such experiences helped me to be a serious observer.

I also always have had a love of animals. As a small child I wanted to be a veterinarian, so great was my rapport with the animal world. When I was a baby, my father had a Russian wolfhound named Sasha who wore a purple bow five inches wide, very elegant. My biological mother favored dachshunds and, later, as a grown-up, I did too. During my teenage years at boarding school there were snakes and insects and family terriers waiting at home. Even to this day I have great feeling for animals in the zoo. On my visits there we look into each other's eyes for a long time. Perhaps I turned to animals and the natural world out of my solitude. That is the wellspring of my artistic expression; all my life I have been close to that child and her view of the world.

Animals and people are all one and the same to me. I was crazy about horses and had horse statues of wood, miniatures of all kinds, and pictures of horses, too. I was responsible for a little garden and many animals: two guinea pigs, two rabbits, and dancing white mice. There were thirty-six canaries in cages to care for. I loved checking the nests for new babies. I was always bringing creatures like salamanders into the house in my pocket.

THE NEW FAMILY AT HOME IN BERLIN

In 1911, the year that my father married my stepmother, I was six years old. She was an American who had come to Germany with her family because her sister needed medical treatment for infantile paralysis. They lived in Germany for a long time and ran a silkworm factory. I was not in contact with my father at that time and had no idea that I had a new family. I moved to their apartment in Berlin when I was nine years old. This was the first family home that I knew. It was on one floor, with a long garden along the side. During that first year I had tutors to prepare me for public school, which I attended for a year or so. When I arrived into the family I already had a baby sister, Lucienne, or Tootsie, as she was called. It was a complete shock for me suddenly to become an older sister and a daughter, since I had spent those early years without a traditional family.

My stepmother's name was Margaret and I called her Mother. She was not easy for me to like. I was somehow caught in competition with her for my father's attention. She often had headaches and stayed in her room all day, so my sister and I were really cared for by the servants. We went into Mother's room every night to kiss her good night—on the hand. She was jealous of me from the beginning. My father paid more attention to me than to the new baby. I

Above: Ruth's parents' dog, Sasha (detail). Below: Ruth with friend at the San Francisco Zoo; photograph by Robert Gibson, 1959.

think that he liked being with me more because the baby could not laugh at his jokes yet. Really, he didn't like children at all. But I was—at least I tried to be—a good child for him, even if I was difficult for my stepmother. My father came home only a few times a week and he would sneak upstairs to say good night to me.

Mother was elegant. Her clothes were always in the latest fashion, *très chic*, so new that she influenced what others wore. Our clothes were designed by her over the years, and she always had a seamstress available to make them. Mother was drawn by fashion artists. I remember a marvelous hat that had a veil covering her face. I think that my father fell in love with her looks, loving her as a beautiful decoration, not a person. Margaret and her stylish looks went with his designs perfectly.

Father was in love with style over substance and did not spend much time at home. His relationship with his wife was distant. When they spoke, they argued. She would burst into tears and leave the dinner table. She became a hysterical woman, most unpleasant to be around. My father wanted to go out tango dancing; she would stay home. Never did I see my father kiss his wife, not even a peck. So my time at home on holiday from school was filled with tension. Oddly enough, nothing was ever said, nor did my father ever speak about the discord. No doubt, he did not know how to make a woman happy, and as his wife Mother was disappointed with her life.

In 1914, war broke out during our summer holiday. I was with Margaret and her mother on a ship in the North Sea. We saw the warships and were told to go home. My father was sent to Belgium with the Fourth Army. Even though he was a private, he looked incredibly dapper in his uniform, which was made especially for him by the Kaiser's tailor. He was assigned to the

Below: Ruth's mother, Gertrude. Left: Ruth, Karl, Manfred, and Lucienne at the edge of the North Sea with Ruth's stepmother, Margaret.

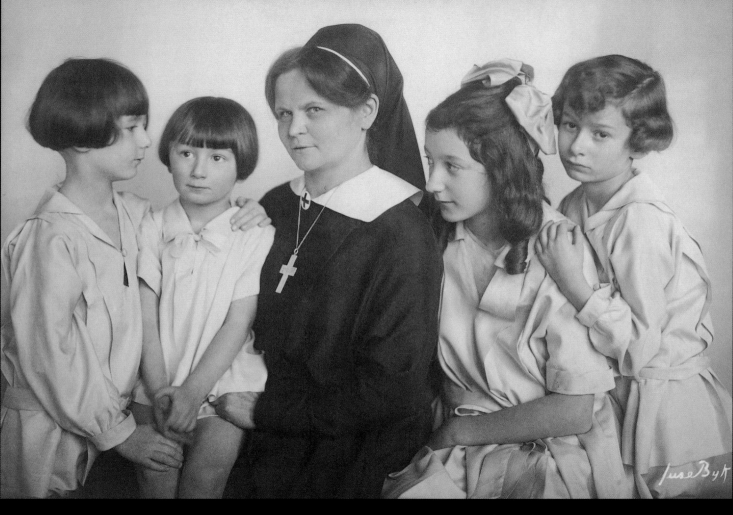

Manfred, Alex,
Schwester Marga

balloon defense. There were cables hanging from the balloons so that airplanes could not fly through. He made the camouflage for the balloon hangars and did layout and design for the Fourth Army newspaper.

During the war, in 1915, my brother Karl was born. I had not known that a baby was coming. I heard things said like, "Mother is big," but I was completely unaware of her pregnancy. She was gardening a lot and wore loose smocks. One Sunday morning I heard a commotion down the hall from my room. Afterward I saw the baby and I knew my father was very excited and proud. He already had two daughters, Lucienne and me, and now, at last, he had a son. So Karl was wanted and appreciated by my father. Later in life he did not complain about his father as the rest of us did.

Two more sons were born: Manfred and then the youngest, Alex, who always said he never had a mother. But he had our wonderful nanny, Schwester Marga, who took care of us all. She was a nun who was trained as a nurse. Very religious, she always wore a nun's headdress with a red cross in the front and around her neck hung a silver cross with the inscription "Friede," which means *peace* in German. She brought peace to the house and love to the children. Not a young woman at the time, she came to us from the household of the Austrian emperor Franz Josef. Her duties were especially to care for the youngest children, Alex and Manfred, but because she was a marvelous, loving person, she was always on my side and treated me like a real sister to the others, when I was made to feel like the "other" daughter by Mother.

Karl and Manfred, pictured at home in Berlin, are dressed in silk suits designed by their mother, Margaret.

In our house, children were to be seen and not heard, speaking only when spoken to. Mother sat at the head of the table if Father was not there. One evening when the maid served dinner, she forgot to offer the platter of meat to Karl, who then started to cry. No one could understand what was wrong because he couldn't tell them. We were taught to be polite, to come into the living room and greet the company. We never had a conversation with anyone but the servants in those early days, and they adopted my stepmother's attitude that I was not her daughter. There were a lot of things that were not allowed, such as not going to the toilet in someone else's house. We had to line up to use the toilet before we went out, and that was that. Everything was orderly, but family warmth was lacking; the emphasis was on behaving properly.

While I was at boarding school the family moved to an impressively large house in Dahlem. There were three floors: in the semibasement were the kitchen, the laundry, and the children's playroom; on the main floor were the spacious dining room and the living room, with a hallway leading to bedrooms for my father and his wife. Schwester Marga and the boys' room and Lucienne's room were on that same level. My father designed three identical beds for the boys. My room was in the attic on the third floor.

I was sent to boarding school in the town of Jena, on the river Saale, when I was eleven. When I was home from boarding school, I lived in my attic hideaway. The ceiling was peaked like the roof of a church and I had a whole big space to myself. I loved to prop myself up in my comfortable bed and surround myself with a lot of books. Sometimes I would sit in the dormer window and look down on the tree-lined street below. I collected pictures out of books and mag-

azines and made scrapbooks, very large in size so that I could design all sorts of picture stories on the pages. I also amused myself with a blank sketchbook that had fairly stiff pages. I cut a door in the first page and the next, and so on, making rooms in which I would paste pictures, say, of the kitchen and the parlor, until I had a whole house, with all the pages fanned out.

The garden surrounded the house, which was set back about forty feet from the five-foot-tall white fence that enclosed the whole property. The entrance was a generous six feet wide, with a double gate painted dark green. Inside the fence around back there was a pond with goldfish. There were apple and cherry trees, berry bushes, a flower garden, and a fine pergola. We had a vegetable garden and a space for outdoor eating and playing, even a good surface for bicycling.

When dinner was served in the dining room, we sat around a big oval table. On one side was a large armoire that was dusty red; it extended almost the length of the entire wall. There was a bottle of Hennesey in the top that I suspected belonged to Mother. On the long side were windows and on the other side was a glass door to the "winter garden," the glassed-in balcony facing the front garden. There was wonderful light flooding into the room. Because the kitchen was downstairs, the food came up on a dumbwaiter to a pantry off the dining room. Food was delivered to the house. Tradesmen used the back door and beggars did too. The cooks would give them things to eat. We had many different cooks over the years. Each one seemed exotic because they were all from other countries; the cooks from Czechoslovakia and Russia are the two that I remember best. They came and went because Mother could seldom get along with them.

Winter vacations brought me home to Dahlem for the holiday. We children would often go sledding and ice skating in a wonderful park, a short ride on the trolley from the house. It was a beautiful *Grünewald,* a green forest, with large fir and pine trees and a frozen lake. There were romantic vistas and little hills perfect for speeding down the snow.

Mother knew how to create wonderful holidays. At Easter we decorated eggs in every color of the rainbow. There were egg hunts and great feasts at the table. Alex remembers birch branches on the doors of the houses around us. Best of all was Christmas. In Germany Saint Nicholas, or *Weihnachtsmann* as he was referred to in German, came on the fifth of December, and we children hung our stockings on the bedroom door at night. The next morning they were filled with nuts, chocolate, and fruit. My stepmother was marvelous at making the gifts exciting. Everything was hush-hush until Christmas Eve, when the door was opened and we children rushed to see the Christmas tree lit with real candles, top to bottom. We always recited poetry and sang Christmas carols. Every year there was a ritual: first the servants received their gifts, then the parents, and finally we children opened our presents. This was a very big moment, after all the long preparations, with secrets and locked closets for months.

One year, we had a very large decorated tree in the dining room, but we also had trees in the entrance hall, all along the staircase, and down to the children's playroom. There were about twenty-three trees in all. It was wonderful, the fragrance and the indoor forest creating magic.

The image of the family at the holiday masks the reality of my life, because my teachers at boarding school showed more interest in me than did my parents.

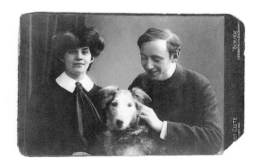

Gertrude and Lucian Bernhard and their dog, Sasha, taken c. 1905 near the time of Ruth's birthday.

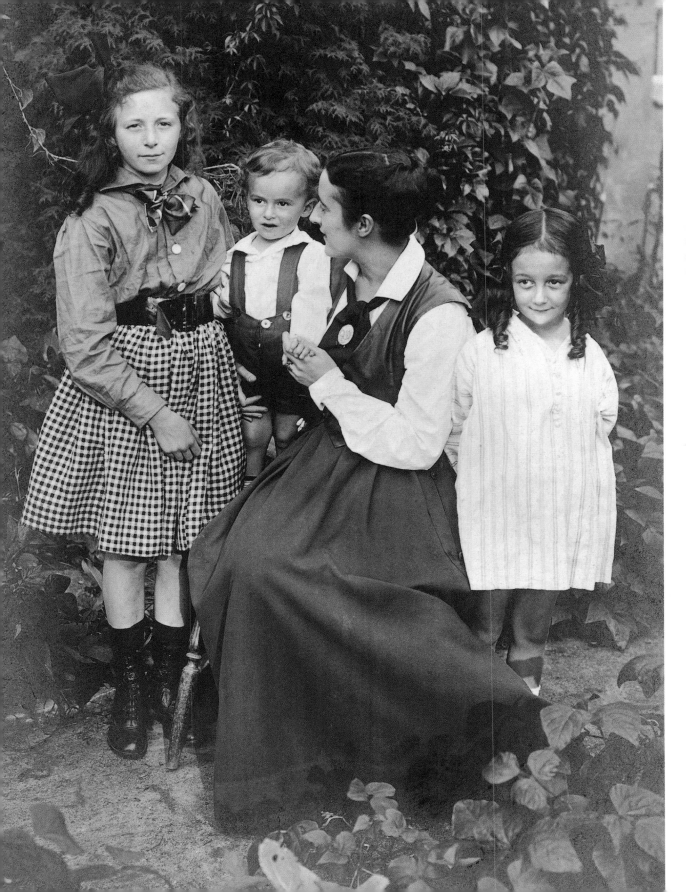

Ruth (at age twelve), Karl, Margaret (Ruth's stepmother), and Lucienne, 1917.

MY MOTHER AND MILDRED

I met my real mother for the first time when I was nine years old. She had been living in Berlin with her new husband and a child, another girl, Mildred. I was invited to attend a birthday party for this sister, who was turning three. I was taken by a hired plainclothesman, because my stepmother did not want the servants to know about my mother and sister. My mother had never told anyone that I was her daughter. She said, "Here is Mr. Bernhard's little daughter." I was speechless. Mildred had never been told that she had a half sister, which was devastating for both of us. I was treated as just another child at the party.

My real mother's name was Gertrude, but everyone called her Doodie. I saw little of her during my childhood, and I hardly saw her at all during my teenage years while I was in boarding school. What visits I made were always in secret. Schwester Marga was my ally and helped arrange our meetings, usually over lunch. My mother was not a warm person and did not especially want to see me. After all, she had her other daughter.

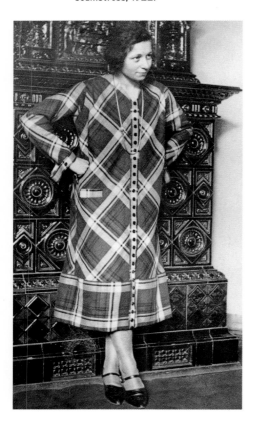

Ruth at age seventeen, standing in front of the ceramic stove during a visit to her mother's apartment. The dress was made by the family seamstress, 1922.

I remember three things that my mother bought me. One was a black velvet sailor suit, which I felt was the most gorgeous thing I had ever seen. The second thing was a book, an American children's book. There was a little girl in the picture on the front, cut out around her face so when you opened it up, her story was inside. The story was about her receiving a new dress and standing on a chair while her mother cut the skirt shorter. She was scared that she might be hurt by the scissors.

The third gift was some beads, like African trade beads, in a box with the sailor suit. These were given to me at Mildred's birthday party. I remember taking them home, a gift from my mother whom no one knew was my mother. I opened the box up and thought it was all so wonderful. The very next day when I went to look at the gifts, they had disappeared. My stepmother had hidden them. She must have thought that it was bad for me to be reminded of my mother all the time. I went through the house from beginning to end, looking frantically for my presents. I never found anything. But later in the year, when my stepmother's mother died, I saw the daughter of the family seamstress wearing my sailor suit.

My main visual memory of my mother stems from a meeting with her when I was seventeen years old. I had just received a new coat for Christmas and I wore it to her apartment, which had been designed by my father. As the door opened, I saw her at a distance, and all of a sudden, I hated my coat. I felt awkward; I felt I was not beautiful. There before me was my mother, dressed in a gray skirt with a tunic above it, in just the correct proportion. Her collar and cuffs were of ermine, a sleek, white fur with little black tipped tails—so elegant. She wore high-heeled patent-leather shoes. She looked exotic, Egyptian maybe, with her stylish pageboy bob. Of course, it was the latest fashion, as were her skirts, cut right below the knee.

A few years later I saw my mother again. She was in the mountains with her husband and daughter. I was invited to join them at a big hotel for winter vacation. She brought her dachshunds and I liked playing with them. Dachsies have always been my favorite dogs; they are so

affectionate and excitable. During the week that we were at the resort, there was a great New Year's Eve party with dinner and dancing. While I was dancing with my sister, someone came up and asked if we were sisters. At the table I told my mother, "Imagine that, they just said we look like sisters," and she said, "They must be crazy." I still had to act as if I were in total darkness about my sister. I said nothing. My story is so impossible to believe that it seems like an article from that magazine *True Story*. I simply couldn't tell my half sister the truth because my mother hadn't told her. I had to keep it a secret.

In 1927 I called my mother to tell her I was going to the United States. I invited her to meet me for a last cup of coffee at Café Ilorel, which was designed by my father. She replied, "I'm terribly sorry but my dog is having puppies and I couldn't possibly get away." Those were the last words she ever spoke to me.

After that, in my new life in America, my mother disappeared from my mind. My father had always said that she would disappoint me. He urged me not to pursue her. He was absolutely right. But somewhere in my thirties I forgave my mother, and my father, too. They were too young when they married. Maybe they never should have married at all. In an odd way, with parents about whom I knew so little, maybe I was always more free to invent myself.

In the early 1930s my sister Mildred came to live in the United States. Our mother was still living in Berlin. I was living in New York in the same building as my father. In Germany someone had told Mildred that I was her sister, but she had denied it, saying, "I don't have a sister. What are you talking about?" She was shocked when the reply was, "Don't you know Mr. Bernhard's daughter is your half sister?" During all those years she had never known.

When she arrived in New York she called my father and he suggested, "Why don't you and your sister go visit the farm in New Hampshire?" This was a place that my father had recently bought. There was still just an old farmhouse on the land and it was quite primitive, so it was doubly difficult to imagine that I would be asked to welcome my sister so suddenly and to take her to such an inhospitable place.

I burst into tears. The doorbell rang. I didn't have time even to breathe, and there she was. I was so cruel to her, cold as an icicle. I wanted nothing to do with her. She represented her mother —*my* mother—who had denied my very existence. So we did not become friends in New York. And she was angry, having been deprived of her very own sister. Over the years, we hardly ever discussed our mother, maybe only five times in all. Later, when I lived in Hollywood, my sister wrote that she was moving to Santa Monica and would like to meet me. I ignored her. After several more really nice letters, I decided that I should see her because if she had treated me as I was treating her, I would have been extremely angry. When we met I found her house full of dachshunds, so I felt connected. We got to know each other quite well. We even traveled together.

I kept in touch with Mildred despite difficulties that were hard to forgive. I recall one time I was visiting and had a terrible headache. She gave me a medication that must have had codeine in it. I had an allergic reaction. I fell and could not walk. Her husband panicked and wanted me

"I put my emotions into my creative work. If you fall in love with a pebble, you have great need."

out. He didn't want me to die in their house, I guess. I got out of bed, put fifty dollars on the table, and left with my friend Joyce Pieper, whom I had called to come rescue me. I recovered at Joyce's house, but I never felt the same about Mildred after that, even though she came to see me and brought me a dog, trying to make friends again. Later her husband killed himself and I felt sorry for her. I tried to support her as best I could and saw her frequently until she moved to Tennessee. I saw her there once more before she died.

Mildred was always angry and could not forgive her mother for not speaking about me all those years. It was awful, just so awful. I had been mean to her also, even though it was not her fault that our mother had withheld this information. My mother had no capacity for love. I don't think she thought about anything but herself.

I had forgiven my mother because she was too young when she married and had a baby with my father, who was not a good husband. I think that she left my father for good reasons; he was not a man I would have married, I can assure you! And in the end, I am so glad that I did not have my mother in my life as I grew up. I think that I would never have become the person I am today had my mother not left me. For both my mother and my father's second wife I was an unwanted child. All my creative work is somehow connected to that early deprivation. I think that because of it, I made a more serious connection to myself, by working diligently to be the very best that I could be and by trusting my intuition above all. I put my emotions into my creative work. If you fall in love with a pebble, you have great need.

I never considered marriage for myself. My parents only showed me how not to be married. I always wanted to become an artist and I saw marriage as leading to a loss of independence, and a subservient role for the wife, who needed to make everything perfect for her husband. I guess you could say that I wanted to emulate my father, not my mother. Because I was not raised by my parents, I never had to unlearn a parental directive. Instead, I lived in my imagination and my mind was my own. I never really experienced motherhood or fatherhood; as a child I experienced love from my teachers. So it never occurred to me to be a mother, but it is natural for me to have become a teacher. I find great excitement in the dialogue of teaching. Students are stimulating and I love them. The influences I had from my teachers were so nourishing, so marvelous, that I cannot be too grateful for what happened. Sometimes what appears to be a tragedy can turn out to be wonderful.

STUDENT

As a child I read a lot of fairy tales—where stepmothers are bad and real mothers are good. But since my real mother disappeared from my life and my stepmother was not a warm and cozy woman, it is easy to see why for me boarding school was so wonderful. My life as a child in the house ruled by my stepmother had been extremely unsatisfactory. My introduction to boarding school was auspicious. I immediately found the resident turtle and refused to return home.

> "My mother was not a warm person and did not especially want to see me. After all, she had another daughter."

Portrait of Ruth taken
in Berlin when she was
fifteen and on holiday
from boarding school,
1920.

At school I had people of my age to enjoy, animals to care for, and, of course, my teachers whom I loved. I was a good student and they knew that I paid a lot of attention to what they liked. In Germany middle school and high school are one, and we call it "gymnasium." The upper grades had the same demands as a small American college.

The boarding school was in a beautiful setting, rather like a park, with trees and foot paths and brick buildings, two dormitories, one for girls and one for boys, a building for classrooms and another for the main rooms and the chapel. I especially remember the dining room, which had a long sun porch. Somewhere on the property was a greenhouse. That is where my little snakes lived. They were about ten inches long and I often carried them curled up in my pocket. They were cool, smooth to the touch and perfectly harmless, but I loved to scare the other girls. I think they forgave me because I always remembered their birthdays. For some reason, I could remember all those dates with no effort.

I always loved to make things. I pressed grasses, leaves, and flowers, as I had when I was a small child living with my teachers. I had a book filled with pressed plants, and I drew pictures of the plants I loved. My favorite class was natural history, where we talked about animals and plants and trees.

The food was perfectly horrible. In the dining room all forty of us girls and maybe as many boys ate at a long T-shaped table. The head teacher sat at the top of the T and ruled the dinner hour. I was a very poor eater. The food was unappetizing, flour and water with cooked onions in the middle, a sort of biscuit in a mug. By the time it got to the table, a little crust had formed on it. A horrible gray thing! I had to be clever to avoid eating it. I persuaded a student for whom I was doing homework to eat it. I had to smuggle it over to where she was sitting at the other end of the table. The teacher was sitting next to me, so I had to distract her. Amazingly, I was never caught. They never even noticed that the other girl got fat and I got skinny!

All our mail was censored by the teachers—even the letters we wrote. My best friend, Krista Bosse, wrote secret letters in tiny handwriting to her Russian relatives in Riga. She was very good at hiding them from the teachers. I was good at distracting them by crying. I would burst into tears as Krista hid the letter. It was an exciting game. One day, Fräulein Bickenbach called me into her office to demand that I give her a letter I was hiding. I put my hand in my apron pocket and took the tiny letter up to my mouth and ate it. The teacher never saw it.

The worst day was always Saturday because we children each had to write a letter home. I didn't have anyone to tell anything to, so there was nothing to write. I remember always writing, "I'm fine. How are you? The weather is nice."

On Sundays we had cocoa for breakfast and a hard-boiled egg and salad for lunch. The only time we didn't wear a uniform was on Sundays, when we were allowed to put on our own clothes. The uniform was a navy blue skirt for the girls and blue pants for the boys, and a white shirt with a neckerchief that had stripes, sort of like a sailor outfit. We also had a blue-checked blouse and skirt with a dark blue apron that tied around the waist. We girls wore black stock-

ings and shoes with laces. During the war, when my father was in Belgium, he sent shoes because supplies were extremely short. We didn't have such things as sugar or butter. He sent me a pair of beautiful yellow, high-tied shoes. I was proud of them, too proud to admit that they were too small. I thought it would reflect badly on my father. So I wore them on Sundays. When I was sitting in the choir I took them off, but it was impossible to get them back on. So I really dreaded wearing them.

We made our beds every morning, six beds in each room with a little corner alcove for our teacher, whose name was Fräulein Sand. I could never go to sleep until she came to kiss me goodnight. She always knew that I was awake. I was so lonely because I didn't have letters from home. I was looking everywhere for love, for a mother. I cared most about the grown-ups. They were terribly important to me. I had to make them notice me, like me, need me. I looked to my teachers for comfort, and I suppose they were more like mothers to me than either my real mother or my stepmother. I made friends with grown-ups more than with children. Grown-ups were attracted to me because I was very curious about life. I had started to read very early and was often interested in books that were really too mature for my age. After all, I had been "mothered" by two teachers who encouraged me to be curious, to ask questions.

At my boarding school, boys and girls were taught together. Because I was a good student and more competitive than the other girls, I made the boys compete with me. My male teachers liked me. Being ahead in my studies, I was often the only girl in a class with boys.

My only experience with photography as a child was standing with the other students, forty in all, for a proper school picture. We were told to smile for the man with the black cloth over his head. For some reason this moment translated in my memory as a deep distrust of photographers and their trade. At this time in my youth, I thought about being either a veterinarian or a musician when I grew up, never a photographer.

The school was very religious and Martin Luther was our fellow. It was a Lutheran school, but with a Catholic priest available to the Catholic children. I was reluctant about the religion, but the singing interested me. There was a beautiful Lutheran church where we sang every Sunday. I loved the hymns. We attended services every Sunday and prayed at every meal, before breakfast, before dinner. In addition to all the prayers we said at meals, there were prayers in the evening every day. One child would lead the prayer and it would always involve saying, "Thank you, Jesus." There was something unnatural about all of this praying. Not until I was a grown woman did I realize that I was more comfortable experiencing life through another spiritual path. When I read about Zen Buddhism, it seemed the most natural way of experiencing the world. I think that I was a Buddhist when I was five years old without knowing it. All I know was that I identified with the universe.

In catechism class I learned all about Jesus, but I thought it was horrible that he was born of a virgin. If sex is not good enough for Mary, why is it okay for the rest of the world? From all I knew of nature, this could not be true. When it came time to be confirmed, I refused. My father

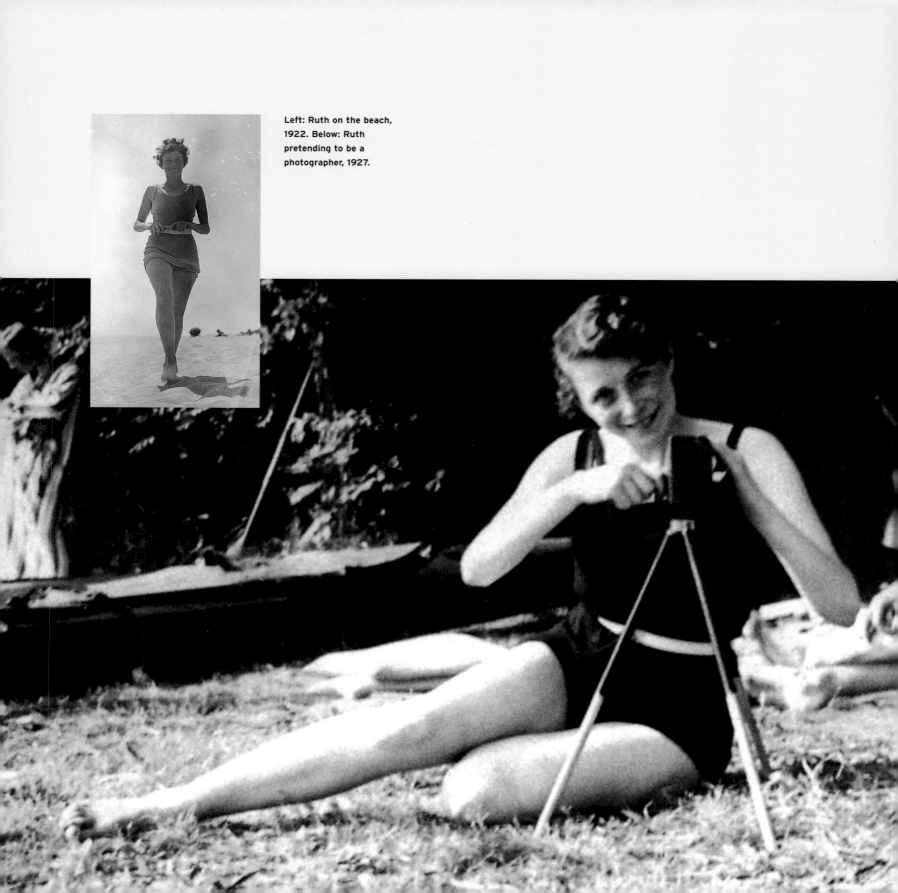

Left: Ruth on the beach, 1922. Below: Ruth pretending to be a photographer, 1927.

approved of my decision, so I was able to follow my own heart and mind.

I wanted nothing to do with confirmation as a religious ceremony. I sat in the back of the cathedral when all the other girls had their little white dresses and veils on. They were little brides of Jesus. Even at fourteen years old I knew that this was not for me. I met with Pastor Bode privately. He told me that I was an honest and good person even with my doubts, so finally I had my own confirmation, there in his office.

I loved poetry. I was able to recite poems and whenever we had a play, I would get the lead part, because I could remember the lines. I had a good time doing that. I sang well and I was a good little actress. When I played the role of Mary at the Christmas pageant, Jesus was a two-year-old who was too big for me. It must have looked ridiculous.

I remember a lot of dancing and singing. We learned a dance from a mother of one of the girls, which we performed in costumes with skirts shaped like petals. It was my favorite, the mayflower dance. I could perform easily but I had little experience playing with other children my own age.

The other children didn't care so much about being away from their families because they had letters from home and cookies and candy and a new sweater and that sort of thing. I had Fräulein Hutt, my favorite teacher. I saved all the cookies and candy from schoolmates and also the strawberries from my little plot of land for her. Each child was allowed to grow something, and I grew strawberries for my teacher. I would stand in front of her door with my offering, hesitating to knock. It was so exciting! I really was in love with her. I followed her everywhere like a dog. I could smell her the way a dog can smell a person.

One day when everyone else was gone, perhaps it was at the beginning of a holiday, I got a letter from Fräulein Hutt that said, "I do not want you to cry. I have gotten married." Well, of course, I was heartbroken. I don't know if I ever saw her again. She knew it was a great blow for me. I remember that day vividly. I was in the large social hall reading the letter and crying. I couldn't stop crying.

Ruth's first romance was with Gustav Adolph Schreiber, a well-known German painter, shown here with his child.

YOUNG WOMAN IN BREMEN

I went on to a college-type school for girls, a lyceum, in Bremen in 1923, a very bad time in Germany. Inflation was running wild and the currency was devalued. I was there for two years, and while life was hard and food was scarce, I was young and excited to be in a new school and living on my own, in a way. I lived at the house of an elegant elderly couple named Alberts, as their paying guest. There were silver dishes on the table, but for people on a pension, there was simply not enough to eat. One day I fainted and my skin got very yellow. I even had yellow eyes. The doctor said it was malnutrition; I had developed jaundice.

Money was difficult. My father sent me a small amount and I had to make it last. I became very clever and bought telephone slugs, which were more valuable than real coins, which kept losing their value. The telephone slugs were my security. I would buy them in the post office

and then sell them in different post offices, making money because the value changed so fast. I made sure that no one would be suspicious that I was not making calls. After all, you do not need twenty slugs to make a telephone call. But with the money from the slugs, I could buy cookies and other sweets.

To this day I am uncomfortable dealing with money. I must have always had this problem because I remember that when I was fifteen years old my father sent me to Dr. Schimmel, a psychiatrist, because I could barely touch money. I could go to the store and buy sugar, but I couldn't give a simple tip without covering the coins with a little gift. Somewhere I had gotten the feeling that there was something dirty about money. In the psychiatrist's office I hid the payment under a book on the desk. He made me take it out of the envelope and give it to him. It took forever to take it out.

Even talking about money is difficult for me. I think this comes from the age of about twelve, when I learned that Jesus was sold for money. How awful to value a person that way. This had a profound effect on me.

Trudi became my best friend in Bremen. She had lost her parents when she was very young and lived with lovely foster parents who were friends of the family. We wrote poetry to each other in a book that had a lock. We shared quotations with each other. We loved to ride our bicycles everywhere. I think that I was her ideal because I introduced her to books by authors like Hermann Hesse. I was very serious in a studious way, older than my age, looking for meaning. I understood what Hesse meant when he wrote that he saw in modern art and literature "a passionate concern for the creation of new meaning." I too believed that "the awakening of the soul, this burning resurgence of longing for the divine, this fever heightened by war and distress, is a phenomenon of marvelous power and intensity that cannot be taken seriously enough."

I had my first great love affair in Bremen, during those two years attending school there at the lyceum, with Gustav Adolph Schreiber. Later he became a well-known artist. We literally ran into each other on our bicycles. I fell and he gallantly helped me up. It was so romantic! He said, "Come to my studio," and I went. I loved to be in his studio. It was in an old deserted hospital and had all white-tile walls. It smelled medicinal. I spent a lot of time in his studio, posing for portraits and as a model in the nude for paintings and drawings. I posed for sculptures, too. Bremen is on the water, so we went to the beach for picnics.

Maybe, for a while, I was Gustav's muse. I saw some of his published work when I was there a few years ago and I remember some pictures of me in a book of his work. His paintings were similar in style to those of Kokoschka. He had a wonderful sense of humor and was a Renaissance type of person, interested in the arts and in trees and leaves. We had a rapport, with him as an experienced artist and me at the beginning of a life in the arts. He excited me. I loved to watch him paint and sketch in charcoal, which he did all the time.

Gustav was much older; I was seventeen and he was thirty-seven. But that was not anything special for me because I had always made friends with grown-ups more than with people of my

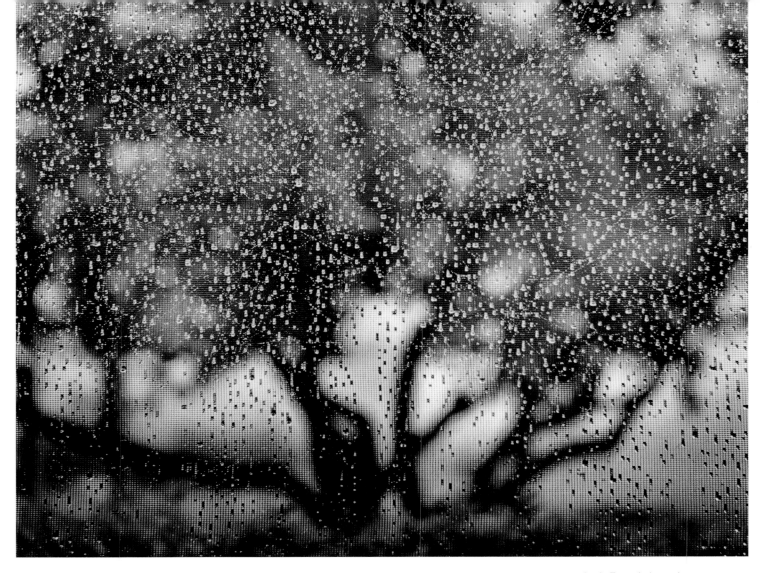

Apple Tree, photograph
by Ruth Bernhard, 1970.

own age. Older people found me interesting, so they paid a lot of attention to me. They would say, "Will you read this? Will you read that?" I was reading philosophers whom other students hadn't read. So I was an admired student; I became part of grown-up life even as a young person.

I completely trusted Gustav. I asked him if I would get pregnant and he said, "No, don't worry about it." I was young, innocent, and stupid, but lucky. Of course, I was not at all informed about birth control. I had had a sheltered life and was completely inexperienced in matters of the heart. At the time I was only vaguely aware that I was not the only one who posed for him. He was a delightful, charming, handsome fellow and I was crazy about his work. It was a happy interlude, romantic like a fairy tale. I knew that he had a wife and child, but I had no intention of destroying his marriage. I never met his wife and I was concerned years later when the Nazis took over, because I knew that she was Jewish. I do not know what happened to them.

I did see Gustav one more time in Bremen in 1929, when I returned for my first visit to Germany after leaving for America in 1927. My father gave me a round-trip ticket on a ship

Top: Gertrude (Trudi) Minsos, Ruth's best friend in Bremen. Above: Faculty and students, Bremen.

called the *Bremen*. Gustav was still married to the same woman. Our reunion was simply that of two old friends.

On that visit I saw my best school friend, Trudi, who in the meantime had married. I told her that I was going to see Gustav at his studio and asked if she would like to come. "Oh no," she replied, "my husband would not allow me to go to an artist's studio." She then showed me her linens and her silver and I became completely bored with her. In earlier days when we were students, she had always said that she wanted to be like me. She had known about Gustav. She thought that he was good-looking too and had gone to his studio, but marriage seemed to change her. Recently we spoke on the phone after many, many years and it was very satisfying to recall those days in Bremen. I think it meant a lot to her to be back in touch with me.

On the same trip to Germany for the summer I went to visit my family in Berlin. I had taken the boat to Bremen and then the train to Berlin. No one came to pick me up. I called the house in Dahlem. My stepmother answered. When I told her I was there, she said, "Would you like to come to tea?" That was my welcome home. My father had forgotten to tell her that I was coming.

That summer, my brothers and I amused ourselves by making a home movie. Karl had been given a movie camera. He was fourteen and was obsessed with becoming a movie director. Of course I was the star performer and played the girl who was kidnapped. Manfred was the detective. There were several criminals, and I think Alex played one of them. After many years the fragile film footage finally fell apart.

ART STUDENT IN BERLIN

It was inevitable that I would go to art school. My father's influence pervaded my youthful dreams. I knew his studio, I had seen him draw on a litho stone; I wanted to be an artist like him. What I remember most about being an art student is the study of calligraphy and lettering, which I did to please my father. His interest in letter forms and masterful calligraphy was a fundamental influence upon my own love of balance and harmony. When I was an art student at the Academy of Fine Arts, he was already professor of poster art at the Royal Academy, another art school in Berlin.

I loved art, too, and it was an exciting time because I met artists and sculptors. One of them was a man named Montag, "Monday" in German. He did public sculpture and was interested in my hands. He made casts of them for his sculpture.

At the Academy of Fine Arts, there was an emphasis on Italian Renaissance art. Mine was a classical education. From studying German art I was influenced by the great artist Käthe Kollwitz, who was always a humanist in her life and work. Her husband ran a clinic for the poor, and she showed compassion for suffering in her prints and drawings.

At some point I saw the book by Albert Ranger-Patzsch called *The World Is Beautiful: One Hundred Pictures*, which made a profound impression on me. Ranger-Patzsch was a very important photographer of plant forms and he also made amazing close-up pictures of highly reflective

pipes and other modern items like faucets and parts of machinery. In these photographs I observed that design connected nature and the machine.

My own formal training never had any connection with the avant-garde. It was completely traditional, untouched by the currents of modernism and surrealism emerging with the Bauhaus and Dadaist forms of artistic expression. It was only in the 1930s that I was introduced to these new ways of seeing, at a distance from the Germany that was developing into a dictatorship. And it was in the United States as a conscious, emerging photographer that I absorbed their messages.

One day, going home on a commuter train from art class, I sat in a narrow compartment next to a man who looked completely pale, with a little blond beard, dressed in faded clothes. He looked to me like a White Russian, a new immigrant from the communist revolution. He had long, thin fingers and clean nails, but he didn't look like a Berliner because of his foreign style of clothes and hair, and the fact that his nails were not polished. Some people started to smoke. He took a cigarette butt out of his metal box, which was the color of pewter. I was the only woman in the car. The other passengers were businessmen. One of them offered him a light and the Russian offered that lighted match to another gentleman before he accepted the light himself. He had such gallantry that I left my package of ham and crème frâiche on the seat between us with the intention of giving it to him. When he left, package in hand, he bowed and tipped his hat. Not a word was spoken by anyone during the whole time, but I knew I had helped him. I wonder if he remembered that gesture as poignantly as I do.

While I attended the Academy of Fine Arts I did not want to stay in Mother's house again, so I went to live with an aunt and uncle (who was my real mother's brother). I shared a room with my cousin Magda, who was also seventeen. We invented games at night in the dark as we were drifting off to sleep. We each tried to have a thought in our mind and see if the other could guess what it was. I was better at sending thoughts. We amazed ourselves when I wanted her to think of the first tooth of her first child, and after about ten minutes she guessed it! We could not believe it.

I needed a job at the time. I met a woman photographer, Frau Willinger, who had a photography studio (her son, Laszlo Willinger, was later a Hollywood photographer). They made professional family and business portraits. By working there, I became acquainted with the world of the commercial photographic studio. I especially remember portraits of children in front of winter backdrops. But the high point for me was meeting Marlene Dietrich, who was posing (rather, her legs were being photographed) for a hosiery ad. I think she posed in exchange for six pairs of silk stockings. Later in Berlin, in 1929, I was given tickets by an actress friend for a musical she was in with Dietrich called *Wie Einst im Mai*. The seats were in the front row. My friend was a very good and very well-known character actress, but she could not match the Dietrich glamour. Later I went backstage and my actress friend accused me of not looking at her all evening.

"It was a happy interlude, romantic like a fairy tale. I knew that he had a wife and child, but I had no intention of destroying his marriage."

Coming of Age

Top: *Beach Dreams,*
color painting by Lucian
Bernhard, c. 1946.
Above: *Hips Horizontal,*
photograph by Ruth
Bernhard, 1975. Right:
Yorkville (Lexington
Avenue and 86th Street),
Manhattan, taken from
Lucian Bernhard's window,
c. 1930.

berlin to new york

MY FATHER CAME TO NEW YORK IN 1922 at the invitation of Roy Latham, the lithographer, to give a series of lectures on European graphic arts. He returned again to New York in 1923 to launch Bernhard Studios, and spent several years dividing his time between Berlin and New York, gradually settling permanently in New York. Lucian fell in love with the vitality of New York City and, as he put it, all of the beautiful girls. For my father, Berlin no longer had the spark. As an artist he had lived his best years there, being well known and successful, but money was tight and he could see that the artistic center was moving to New York. It was obvious that American art connoisseurs were bringing European art to American collections. There were new museums and urban excitement under Mayor Jimmy Walker.

My father was a sculptor and a painter also, but these works are secondary to the calligraphy and designs for type that had made him so famous in Germany. Later, in 1927, he began a contract with American type founders for typeface design. In all, he designed at least thirty-six typefaces. Bernhard Modern, Gothic, Tango, Fashion, Cursive, and Roman are among his best known. Bernhard Antigua had been his first type design produced by the Flinsch Type Foundry in 1913 in Frankfurt. He designed more than twenty other faces in Germany.

Later on, he was a leader in what we now call corporate advertising, designing logo types for Audi, Bosch, Cat's Paw Heels and Soles, Radio City Music Hall, Steinway Piano, Ex-lax, and Amoco Gasoline. It is only now that his career as a designer is being recognized: in 1997 he was honored by the American Institute of Graphic Arts and in 1999 his work was in an exhibition of German design originating in Berlin that is traveling for ten years, sponsored by the German government. The opening in Berlin afforded a reunion for me and my brothers, Karl, Manfred, and Alex.

I have no idea what my father had in mind when he asked me if I wanted to come to the United States. But I said yes! I was twenty-two, still a student at the academy in Berlin. It didn't take me long to pack my bag. I arrived in January 1927 after a rough crossing. The ship docked in Hoboken, New Jersey. It had snowed and then melted, so it was slushy. I was very overdressed for the occasion. I had on high-heeled shoes, which did not belong in terrible wet snow. I wanted to look superb for my arrival in this new life in America and, of course, for love of my father. I adored him. I was not really the right child for him, I was only a girl, but I was the oldest and I was coming to join him in America.

> "Lucian fell in love with the vitality of New York City and, as he put it, all of the beautiful girls . . . he could see that the artistic center was moving to New York."

Above: Model draped with silk fabric ("Penstroke" design by Lucian Bernhard) standing in the Bernhard Studio in New York, photograph by Ruth Bernhard, 1931. Below: *Moonstruck*, color painting by Lucian Bernhard.

"His models are coy and suggestive, and related in style to the pin-up girls of the era."

At first, I lived in the Roosevelt Hotel, right by Grand Central Station. I did all my shopping and sightseeing underground. The Emily shop fascinated me because there I saw the kind of clothes American youth were wearing. I also enjoyed eating at the Oyster Bar.

Eventually, my father rented a wonderful apartment for me on East Forty-ninth Street in Manhattan, on the floor above his apartment. It was all furnished. We had breakfast together every day and I helped him in his studio. He had a friend whom he asked to tutor me in the American style, so she bought me American clothes and shoes. My father loved movies and we went all the time. Greta Garbo was the first movie star whose films I loved. I would take my lunch to Rockefeller Center where the Rockettes performed and see the film and the show over and over again.

I had to learn English. I was greatly helped by the superintendent of the building where we lived, who often took care of my father's apartment and was paid to do things for him. He was an educated black man from Boston. I can remember him saying, "Allow me to correct you."

My father had many wealthy friends whose New York apartments he had designed. His furniture was very luxurious and yet simple and comfortable to sit in. Bernhard style was not at all Bauhaus. The insides of the closets were covered with brocade. The quality of the craftsmanship of everything he designed was of the highest order. It all looked very exotic to me. Many of his friends seemed superficial, but I loved being in his studio. There I worked for my father, draping silk of his own design on either mannequin or model to photograph it.

For a while he had design studios with partners in both New York and Berlin, with several designers working with him, designing furniture, interiors, and other things for his clients. He traveled back and forth, usually spending summers in Berlin. His New York studio was called Contempora. Rockwell Kent, Bruno Paul, Erich Mendelsohn, and Paul Scheurich were his colleagues, and were often spoken about in the same sentence with Lucian Bernhard when people discussed the era. My father's New York studio was mentioned by P. K. Thomajan in his book *American Type Designers* as "a glamorous blend of the old world and the new." There is no doubt Lucian Bernhard was a great graphic artist. However, I have never admired my father's sculpture or paintings. They are all about the female body and my father's attitude toward women. As a girl growing up I had been in love with my father. As a young adult, when I observed him and realized how badly he treated women, I found him out. When I was young, I realized that I could never compete with beautiful women for his attention. I always knew, when he looked at a girl, how he judged her, and I knew that I would never qualify. I was not a pretty little daughter. Nor was I his son.

The only one of the children who fulfilled my father's wishes was Karl, who was the eldest son, the wanted child. Lucienne, my younger sister, was always complaining, with justification. She became a dancer in Paris and eventually came to New York and visited Father in his atelier. When he asked her if she liked his new paintings, she denied seeing any paintings, hurting his feelings. Later we went to the Barbizon Plaza for dinner; he always wanted to eat there because it

Corinne, one of Lucian's favorite models, color painting by Lucian Bernhard, c. 1942.

was where all the young women lived, especially the young models. My sister did not want to be in the dining room with all the beautiful girls. She knew my father would criticize her hair and clothes. Whenever he started, "Your hair is too. . . your clothes are too. . ." I would interrupt and say, "Let's talk about me for a change." Then he would say, "You are always perfect," which meant that he respected my taste because I was on my own and doing things. He was proud of me and admired my style. I never overdressed. But love? *No*. He was very narcissistic.

He fell in love with a model, a young woman who constantly disappointed him. He would make a date with her and she would not show up. Finally she went to Hollywood. My father advised her on how to dress and wear her hair. She became known as "Burnu Acquanetta, the Venezuelan Volcano," even though she came from the Harlem of Philadelphia and never spoke Spanish. I am sure that he never got anywhere with her because he was in his seventies by then, and she was in her twenties.

This behavior affected my father's paintings from the beginning, when he started to paint in 1930. His models are coy and suggestive, and related in style to the pin-up girls of the era. Reviews stated clearly that the paintings were provocative, that the viewer wanted to know more—probably her phone number. This was not art at all, in my opinion. It particularly upset me that he had me photograph his models for him, with him directing.

Detail of *Patti Light*, photograph by Ruth Bernhard, 1929.

COMING OUT

In my first few years in New York I had a lot of time to browse around the city. I spent a great deal of time by myself. My father couldn't be much help because he was not a social person. His connections were with his clients and other designers. I had to seek my own friends. When I was with friends and got home late, I would get out of the elevator on the floor below my father's apartment, then walk upstairs very softly to my floor so he would not awaken.

On New Year's Eve in 1928 I met a perfectly beautiful woman. Patti Light had black hair, black eyes, and a white face, just like a drawing. She flirted outrageously with me. I flirted back. I didn't know I was flirting. The next day and the one after, I was constantly crying and my father asked me what was the matter. I told him about the beautiful, elusive woman I had met and how excited and upset I was. He said to me, "You're in love. You're not supposed to cry about it. It is supposed to make you happy." I was so confused because I didn't understand what was happening. I couldn't imagine why she upset me so. It was helpful that my father told me, that he opened that door. And he never questioned the fact that she was a woman. Most important was that my father understood. It was wonderful. He was wonderful. He understood perfectly.

That New Year's night was my coming-out party. I did not know that I was going to feel anything. I kissed Patti that night. I was so shocked at myself. I know that she liked me, that I was an interesting person to her, but I was too naive, too innocent. I would beg her to come have coffee with me all the time and she would come and then get up and leave. Patti Light was really a femme fatale for me. She was much older, a well-known painter, and she had a husband. I

photographed her with a painting of him. She was not going to give in to me whatsoever, so my love for her remained platonic. Yet it was an experience like a thunderstorm. In the end she protected herself and me. For a long time I was spellbound by her, in a romantic daze. Finally, after several months I found a doll that was like a fashion model that I dressed in exactly the kind of clothes she wore, the hat and everything. I gave it to her, saying, "Take yourself back." That was the end.

Even when young, although I was appreciative of my father as an artist, I did not admire him as a person. He never spoke well of my mother. When my sister and my father and I would get together, the words he used about our mother were not nice. I did not approve. I felt that, even if he were right, he was hurtful to speak that way to us. I did not like my father for a long time; later, I decided that I was going to like him for what was good about him. He had recognized my feelings for Patti Light, so I observed that there were good things. I saw that he did care about people in little ways. One day when cars were still unusual to own, he was driving with a friend. His friend opened the car door before it stood perfectly still, and the door crashed into the pole of a street lamp. My father told me, "I was so glad he was not hurt." I saw his values clearly in that comment. After that turning point I no longer thought about him in such a personal way. I forgave him for everything and it made my life much better. I was about thirty-six years old at that time and I was already having some success in photographing. I was grown up, I guess.

I forgave my mother too, because to have been married to such a man as my father was a terrible mistake. He should never have married anyone. His second wife was not happy with him either. They married in 1910 and had four children, but he lived more in his studio than at home, where he kept his own quarters and did not share a bed with his wife. In the end, my father did appreciate me as an artist. After he died, I found all my mailings of announcements and reviews in a drawer in his apartment.

BECOMING A PHOTOGRAPHER

I had already been in New York for a few years when one day in 1929 my father said, "It's time to get a job." I knew English well by then. He introduced me to his friend, the photographer Ralph Steiner, who said that he needed an assistant in the darkroom for his magazine at the Home Institute called *The Delineator*. My father said, "You know, she can do that; she is a sharp kid." So I became Ralph Steiner's assistant. I was taught how to develop 8 x 10 film in a tray and to set up his camera on the tripod. I watched him make pictures of glass and other objects for the magazine.

I found the job boring. The darkroom seemed cold, uninteresting, hardly a place for a nature and culture lover! The photographs produced for the magazine were perfect compositions of table settings, foodstuffs, and the like, and they were strangely inhuman. I showed so little interest that I came late every morning and left early. After about six months I was fired. Actually, Ralph Steiner told me that I fired myself from the job. That was the end of my photographic career for a while.

> "For a long time I was spellbound by her, in a romantic daze."

Above: Eighth Street Movie Theater, New York (by Architect Frederick Kiesler), photograph by Ruth Bernhard, 1946. Above right: *Lifesavers,* **photograph by Ruth Bernhard, 1930.**

A young man, another assistant to Mr. Steiner named Morris Coleman, had befriended me. He had a dog who destroyed his apartment every time he stayed out after midnight. He told me that he had to go see a dog psychiatrist over this situation, but he could not afford it, so I gave him ninety dollars, my entire severance pay. He said that he couldn't accept my money without giving me something, so he gave me his 8 x 10 camera, a tripod, and two film holders. I no longer had a job, but I still had the apartment that my father had generously provided.

That wonderful house on Forty-ninth Street between Fifth and Sixth avenues was where I started being a photographer. I was curious to see if there was a way to do something that interested me with the camera. With very little knowledge of the camera or the darkroom, I began photography. I had no notion of how a photograph should look. I did as I pleased, making pictures of things that I liked in a personal way. I found my way by trial and error. I was not trying to emulate anyone; I had no external standard that I had to bend myself to meet. I knew enough from my art-school training to know that I wanted to make photographs that would breathe and live.

With my newly developing photographic skills, I was employed by my father to make pictures of models draped in a silk fabric on which he had designed a pattern called "penstrokes." He wanted to see how the fabric draped on a body. Those photographs led to more assignments to photograph "Bemburg silk," a new rayonlike fabric, which I wound around the model. These were used in ads in trade journals.

I began to take pictures for myself as well. In 1930 I went to Woolworths, the famous five-and-dime store, with the little money I had and bought things to photograph. My first real pho-

tograph was *Lifesavers,* which, in the back of my mind, was an image that might become fabric. It was inspired by the busy traffic on Fifth Avenue. And then I bought straws and dressmaker pins in rigid rows and ribbons. So I began to enjoy photography. I worked at night making still lifes, and during the daytime I browsed around the neighborhood. I have always worked best at night, when the world is quiet. For hours I would make light play across objects, or through glass against a white cloth.

Thanks to my father, my experiments were seen by art directors and magazine editors. The January 1931 issue of *Advertising Arts* magazine showed lettering and its place in advertising, using all of Lucian Bernhard's typefaces. It was a surprise to me to see my photograph *Lifesavers,* published by Dr. Agha, the editor, whose work appeared on the page across from mine. He never asked which way the picture should appear on the page, so it was printed as a vertical. That was fine, because then it was seen bigger on the page than it would have been as a horizontal, which is the way I mat it today.

Soon, when his designer friends needed pictures, my father would say, "Ask her. She can do it." Over the next ten years, while in New York, I worked for industrial designers—Henry Dreyfuss; Gustave Jensen; Russell Wright, designer of aluminum ware; and the architect Frederick Kiesler, who also designed furniture and was one of the earliest designers of modern window display. They were part of the modern movement in art and design, and I found myself in the middle of it. I was taught by the medium itself and by the challenge of meeting the requirements of clients who themselves were artists.

In the summer of 1932, a friend suggested that I take a job as a counselor at Camp Red Wing in upstate New York. There, I took young children out to look for grasses and plants. I taught them to be aware of the natural world the way my teachers had taught me. Perhaps this experience was the beginning of my interest in teaching.

In 1971 I was at a breakfast with Cornell Capa, then the director of the International Center of Photography in New York and one of my favorite people. A woman kept staring at me. Finally she came over and said, "Do you remember me?" I had to confess that I didn't. "Well," she said, "in 1932 you were a counselor at Camp Red Wing with me, and you showed me the insect tracks after the rain near puddles on the country road." Of course at the time, I didn't know I was teaching at all; I was simply sharing whatever I observed.

On one of my trips to Woolworths, there was an interesting-looking girl behind the counter. I asked her if I could photograph her. She invited me to go dancing, and that's when I met a lot of lesbian women. We went to Childs at Times Square, where there was tea dancing for girls in the afternoon. The space was always filled, with everyone in snappy clothes, dressed up, even sophisticated. There was a band playing all the best tunes of the era. Everyone danced.

At the Waldorf Astoria Hotel I found a wonderful bookstore run by a little Irish woman named Mary Sullivan, who did not mind that I stayed around reading books and never buying them. She introduced me to Berenice Abbott, and through Berenice, I met her friend Elizabeth

Straws, photograph by Ruth Bernhard, 1930.

McCausland, who wrote books for Berenice. They lived at 50 Commerce Street and had cats. Berenice knew everyone in the photo world, but she was not very social. She and Elizabeth stayed at home, and Berenice worked very hard. She loved her work.

At her studio Berenice had a big wooden bucket in which she washed her prints. It was like a laundry tub, really. One day she looked down at her prints submerged in the water and lamented, "No matter what I do, these prints won't last more than a hundred years." At this point I had already become a photographer and was working for people. I didn't know many photographers, so it interested me that she was a serious photographer. She became a friend, but we did not become close. I admired her because she always said what she felt and was absolutely honest and usually right.

Later in life, as old friends in photography, Berenice came to visit me in San Francisco. We were at the house of a photographer for lunch, who showed us some of her photographs of nudes posed casually in front of white walls. Berenice didn't like them at all, so she said so and then went on to claim the "only one photographer who can truly photograph the nude is Ruth Bernhard." I was so embarrassed that I had to leave the room and go wash my hands, which I did for a long time.

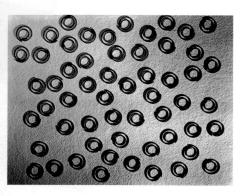

Photograph of paper clips for fabric design by Ruth Bernhard, c. 1930.

Through Berenice I met people in the arts. On Saturday night we all went nightclubbing in Greenwich Village. The Depression may have hit the financial markets, but I, as a young German girl in New York, was hardly aware of it. When I wasn't dancing, I was going to the five-and-ten and buying things to photograph. I was fascinated and visited often, the way others would go to the opera. My first real apartment that I paid rent for myself was at the Bleecker Street curve of the El. Every night when the trains came by, there would be a terrible shriek. New York was noisy even then. The city had so much excitement. It had a jazz rhythm to it. I used to go to Harlem a lot with the crowd from the Museum of Modern Art. We loved the Cotton Club. The black women looked so marvelous in elegant long dresses made of satin or taffeta. I remember bright colors, like bottle green and aqua and deep blue. The gentlemen all wore tuxedos. We went uptown to hear the latest talent. It was a powerful time; the music drew a very sophisticated crowd, and it was perfectly safe. I never had a black-white feeling. It felt perfectly comfortable to be one of maybe two or three other white people at private parties in Harlem. I liked the music, the atmosphere, the style of the people.

When we went to nightclubs, there was a little window in the door with a password to get in because it was still Prohibition. The cigarette smoke was thick and the alcohol was terrible stuff that made us sick. When I look back, it all seems so absurd.

I was a great admirer of Paul Robeson, whom I met in the 1930s. There was a party given in a ten-room apartment on Park Avenue owned by clients of my father. When the dancing began, I was swept in Robeson's arms and fell through, I was so small. He was a big, handsome man. Later, I met him on a plane and was impressed that he was reading Arabic. When we landed, he carried my bag across the terminal.

Kitchen Music,
photograph by
Ruth Bernhard, 1930.

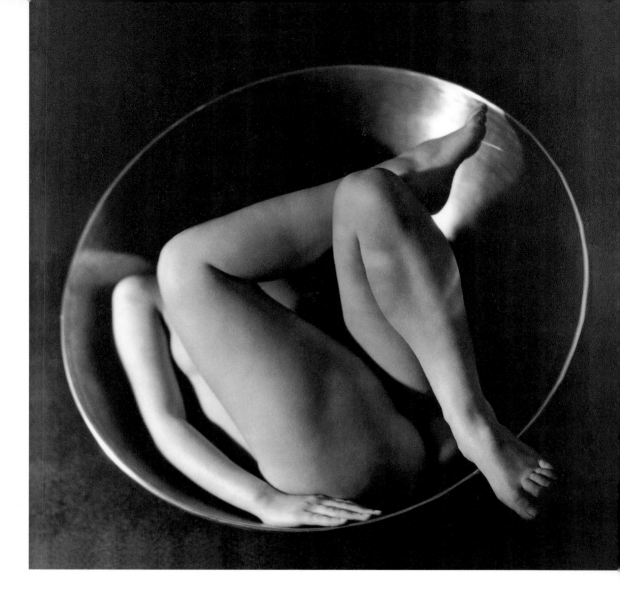

Above: *Carrots,* an unpublished photograph by Ruth Bernhard, c. 1934. The carrots were taken from the family kitchen in Scarsdale, New York. When the photograph was shown, it was considered to be suggestive. Right: *In the Circle,* photograph by Ruth Bernhard, 1934. This photograph is from a series of nudes all taken in the large stainless steel bowl that Ruth photographed for the *Machine Art* catalogue.

In the early 1930s I was living on the corner of Thirty-fourth Street and Lexington Avenue. I loved the apartment because it was very spacious. Jan von Ruhtenberg, who lived upstairs, was in charge of the design of the catalogue for the 1934 *Machine Art* exhibition at the Museum of Modern Art. He probably had never seen a photograph of mine, but, perhaps out of convenience, he suggested that if I'd like to do the illustrations, he'd start sending things over. The answer was "Yes!" It never occurred to me to doubt myself. All I saw was a wonderful opportunity. I think that the first photograph was a large ball bearing, maybe ten inches in diameter, that became the cover of the catalogue. He sent all sorts of objects over, and they sat around until I made 8 x 10 negatives of them. I loved every minute of it. I worked on a table with a simple background. I used photo floods, a no. 1 and no. 2 on stands. I used silver paper and white sheets to reflect light. I arranged jars and glass bottles. I just loved the way they looked. I saw beauty in the light on objects.

One day the museum sent over some large stainless steel bowls. My friend Peggy Boone was visiting. She was the kind who would take off her clothes at the slightest suggestion. So when I said, "Why don't you get in the bowl," the photograph was done! I hadn't given it a thought. Three exposures and that was my first nude photograph. It wasn't a big deal. It was all very natural for me to do. I was delighted that the curled-up nude resembled an embryo. It was a surprise, the work of my intuition.

The photography for the catalogue earned me four hundred dollars, which I spent on a trip to Haiti. I boarded a tramp steamer with eleven other passengers. Once we set out, I spent time with the captain, a charming man who told me about his adventures. I helped him keep at a safe distance from the ladies who were trying to get his attention. On the island I had a fascinating time. People stared at me because my hair was cropped short and I wore pants. They did not know whether I was a boy or a girl. Followed by boys begging for cigarettes, I was approached by the madam of a whorehouse, who invited me for tea. She was so stylish in her marvelous feathered hat that I had no idea who she really was. I might have accepted the invitation if the boys had not warned me.

The captain of the ship introduced me to some Haitians. One was a black lawyer whom I naively invited to have dinner with me on shipboard. Everyone was shocked. I was completely unaware of a potential problem.

During those early days in New York, my life and work centered around my father's interior-design connections. Jobs led to friendships and friendships often led to jobs. One friend, Betsy Hatch, who worked for Macy's, was in charge of the employee magazine. She was lots of fun. Her assignments led me back to playing with dolls—only in this case it was toy animals. I remember doing a still life with bunnies for an Easter publication.

Macy's Easter illustration for employee magazine, photograph by Ruth Bernhard, 1933.

During the 1930s my contact with Germany was distant. I only saw Hitler from the American perspective and learned about Germany from the magazine *Der Querschnitt* (Against the Grain). My father and I never discussed politics. He had turned his back on Germany.

In 1932 my brothers and sister came with their nanny, Schwester Marga, to Scarsdale, New York. Their mother, although American by birth, stayed on in Germany, going back and forth on ocean liners for visits to the family. Karl told me that she went to the 1936 Olympics in Germany and didn't move to America until 1939, at the last moment, just before Hitler invaded Poland.

Schwester Marga remained the substitute mother of my siblings for all their teenage years. I often visited them in the big Scarsdale house, where our Aunt Elsa and Uncle Frank Davenport, who was a dentist in New York, and their sons also lived. Everyone came to New York when Mother arrived permanently. Also living in New York were my Aunt Eda, a character actress, and her husband, Charlie Kuhn, a painter. Our Aunt Lizzie lived nearby. She had infantile paralysis, which was the original reason that her family went to Germany, hunting for a cure. I was always impressed with her. She had a special car outfitted for her physical needs and she had a business, translating books.

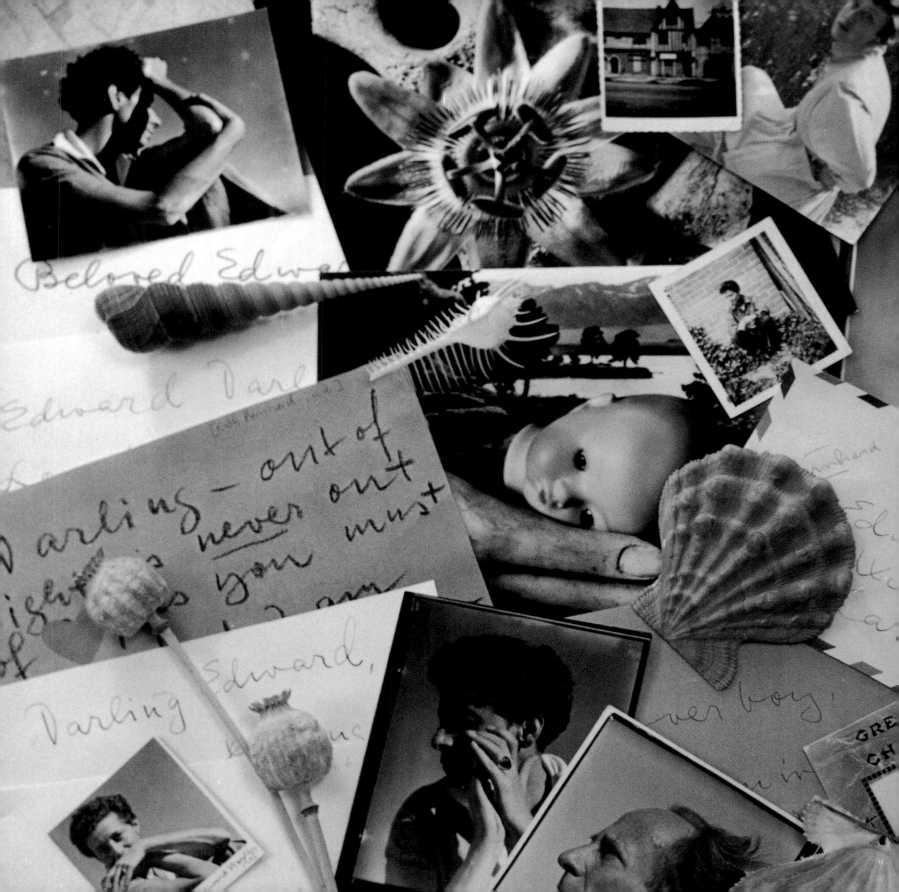

Giving My Heart
to Photography

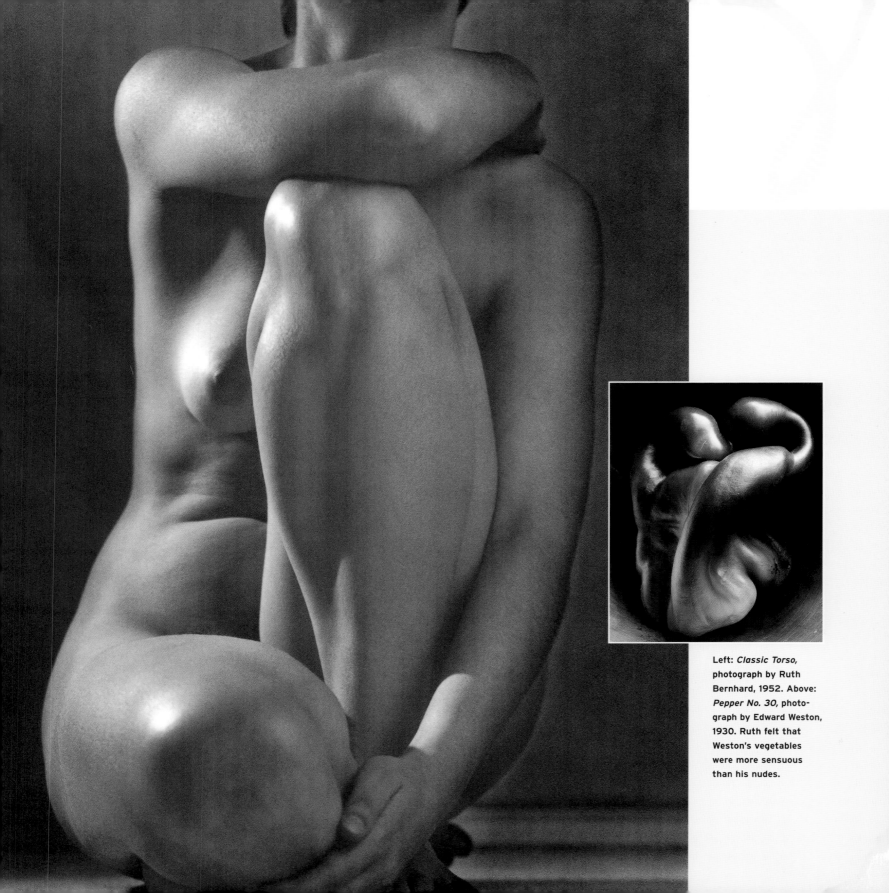

Left: *Classic Torso,*
photograph by Ruth
Bernhard, 1952. Above:
Pepper No. 30, photo-
graph by Edward Weston,
1930. Ruth felt that
Weston's vegetables
were more sensuous
than his nudes.

giving my heart
to photography

WEST TO CALIFORNIA

IN 1935 MY BROTHER MANFRED ELOPED and went west to Los Angeles. We were shocked, my father most of all. Manfred had written him a letter that said, "I know I'm a great disappointment to you, but I have gone to California to make my fortune. Helen and I are married. I couldn't live without her. I hope you find it in your heart to forgive me. Your son, Manfred."

My father showed me the letter and asked what we should do, and, of course, I said, "Let's find him." We had been planning to take the other brothers, Alex and Karl, to a horse ranch in Colorado, so off we went west. We drove with a friend, Rudy Bleston, at the wheel because neither my father nor I could drive. At one point Rudy missed the curve of the road in the pouring rain, and we landed in a field about thirty feet below the road. It turned out that Rudy was a terrible driver. I was always shouting, "Look out for that car!" We had so many mishaps I could fill a separate book with them. My father was, by this time, completely frustrated by the aberrant driving and announced that he was going to leave us to drive the rest of the way while he took the last leg of the trip by train. He walked up to the highway and flagged a big truck. I saw him disappear into the cab. He was driven to the next train station, where he continued the trip to Los Angeles in comfort.

After leaving the brothers at the ranch in Colorado, Rudy drove the car into a riverbed trying to cross it. The wheels stuck in the mud so completely that we had to get a cowboy with his horse to pull it out. I stayed with the car by the embankment. I remember this particularly because I was in a little summer dress and was cold and miserable, and, most of all, mad. Rudy and I continued by way of New Mexico to see an Indian powwow, where Rudy tried to turn the car around and failed. We were stuck in sand this time. I gathered stones for two hours in stifling heat and put them under the tires so the car could move.

Once in Los Angeles, we eventually found Manfred, with his wife, who was pregnant, and we had a family reunion. All was forgiven. Our mission was accomplished. But having come such a long way, we stayed on a bit to visit.

Above: Portrait of Ruth Bernhard by Edward Weston, 1935. Right: Photograph of Edward Weston, by Brett Weston, reminds Ruth of how he looked when they met.

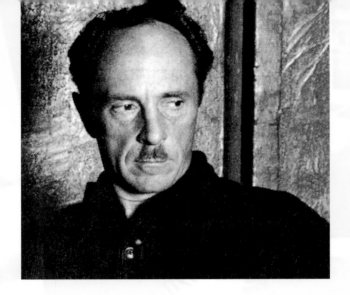

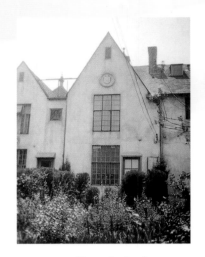

EDWARD WESTON

My father had an industrial designer friend in Hollywood named Kem Weber with whom he stayed while in Los Angeles. Kem took us out to Santa Monica to walk on the beach. All of a sudden, he waved to a trim and muscled young man in pink satiny bathing trunks who was emerging from the ocean. He called him to come over: "Oh, I want you to meet some friends of mine. Mr. Weston, Ruth Bernhard, Lucian Bernhard." That's how I met Edward Weston. When Kem said that I was a photographer, Mr. Weston asked me to come up to his house on Rustic Road and see his photographs.

As soon as my father left for New York, I went to see Weston. On the first visit he invited me to see his work with some other people. We all sat along the couch. When I first saw Weston's work, I burst into tears. It was a complete revelation. I had not taken photography seriously until then. His photography allowed me to accept my own work at a higher value. All of this was a complete shock to me at the time. It was as if I were hearing the music of Bach for the first time—it was overwhelming, engulfing my whole being. I realized that the medium of photography could be my language for saying those things that words can never say, except perhaps in poetry. I was deeply impressed by his photographs. I had never seen the work of a creative photographer, nor had I heard of Weston. I was entirely unprepared for the experience of a vital artistic expression in a photograph. That night he asked me to stay for dinner after the others had left.

Weston photographed me on the first visit. His portraits of me are absolutely me. As in all of his work, he wanted to allow the subject to speak, to keep himself out of it as much as possible. To be photographed by him was not the slightest strain. He made no demands, had no preconceived ideas. He worked simply, unobtrusively, and without apparent effort. In less than an hour, while we were talking, he took eighteen portraits of me. We developed the negatives together in his darkroom. Standing there at the sink, in full darkness, we had a long discussion of darkroom tragedies. Meanwhile, the developing tank, which had been built by one of his sons, was leaking the developer, but we did not know it at the time, so all the negatives are not fully developed along the top. The whole situation was so human and endearing.

After that first encounter I stayed at a hotel on Hollywood Boulevard and took a red streetcar that went all the way to Santa Monica to visit Weston. I went whenever I could, because I thought he was wonderful and I wanted to study with him. Edward had an elegant simplicity as a person that pervaded his life and work. I cherish those first pictures, as I do his letters, especially the first letter he wrote in response to mine. I wrote to him when I returned to New York. I said that I was completely confused about what photography was all about. I told him that I had left my eyes in his studio and had taken his in exchange, for it seemed to me that his seeing was a complete summation of all there was to say, and his photography the only way to say it. I was terrified, in a sense, that I might not be able to do more than copy him. He wrote me a beautiful letter, saying that his eyes would not hurt me and that I should be patient. It took a year before I had an image that I knew was mine.

I wanted to promote Weston because I didn't think anyone knew about him. I went to the public library and found a big beautiful book by him, privately published by Merle Armitage, that I could only look at with a guard standing behind me. It was indeed a precious book. And I thought that I had discovered him!

I couldn't wait to work with Weston, but it took me a year back in New York to make the change. I was restless, but I had work to complete. There was no question in my mind that I had to move forward in my life and learn the language of photography as I had experienced it with Weston. I had to go where I could do the photography that was in my soul. I fell in love with Weston and his work as one entity. Words trivialize the emotional experience, but I truly found my soul through the spiritual crisis his work created in my life. When the intellect is put aside and the heart is everything, a decision is easy.

I decided to move to Hollywood, where I wanted to persuade Weston to let me study with him. But it took me so long to extract myself from New York that by the time I arrived in Los Angeles, he had moved north to Carmel. Such a location was impractical for me as a working photographer, so I set about paying my rent in Hollywood.

In my first year there, I explored everywhere. I discovered Olivera Street, where I found Mexican music and fruit and vegetable markets. I loved it all, especially a little theater with puppets. There I met the artist Wolo, who made his living by doing caricatures of people. Of course, he made one of me. I spent so much time at the puppet theater that they asked me, "You were here yesterday, you are here today, why so often?" I confessed that I loved puppets, and before long they discovered that I was a photographer. They needed photographs and I needed work. It was great fun. I learned how to control the puppet strings and make them perform and made many photos in my studio. My first studio was on Wilshire Boulevard, in a place where there were many little studios in a row. The owner brought me work of all kinds, things like packages to photograph for drugstores. It was a very inspiring place because we were all working hard to make a living and, at the same time, making art for ourselves.

In Los Angeles I also discovered the doll hospital that played an important role in my photo-

RUTH BERNHARD, by the way, has a show of photographs at Jake Zeiltin's, at 614 West Sixth Street, until November 23. Her work is notable for selection, composition, and that mysterious something which can make a cold lense become as subtle in its transmission of the artist's sensation as the crayon held in his fingers. She takes her photography very seriously; her approach to her subject carries an intense, almost startling, mysticism— a pantheistic conception which results in a temporary transfusion of identity such as one seldom encounters even in artists working with paint.

Clipping of Ruth's first review of a gallery show, *Los Angeles Times,* 1936.

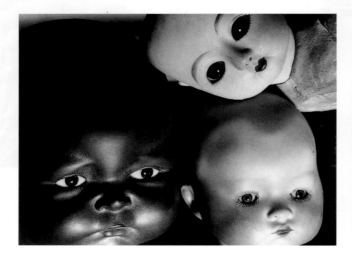

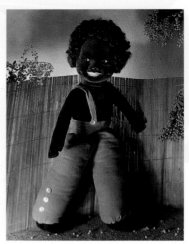

"...the doll's head rested quietly in the hand, and there it was, the first real photograph that I took after meeting Weston."

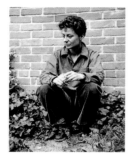

Above: Eleanor Stone, Brett Weston's ex-wife. Top left: *One World,* **photograph by Ruth Bernhard, c. 1946. Top right:** *Velvet Doll,* **photograph by Ruth Bernhard, c. 1938.**

graphic life. It was there that I found and purchased the doll's head without a body that eventually found its way into my photograph *Creation.* I came upon the doll hospital on Hollywood Boulevard when I looked in the window and saw a lot of body parts of dolls, hands and feet and heads. I went inside and asked, "May I buy this head?" The owner said, "What kind of body do you want?" I said, "I do not want the body." He was surprised and asked me why. I explained that I was a photographer. "Oh," he said, thinking for a minute. "Do you have a professional studio?" "No," I replied. He got an idea in a flash. He asked me, "How would you like to have a little studio to photograph the Hollywood stars' children when they come to have their dolls repaired?"

What a good idea! Of course I accepted the offer. In exchange for my rent, I would give a free picture to each of his customers. He gave me a lovely room with children's furniture. It was very comfortable. I would ask the children to bring their favorite toys and it worked well for us all. He could offer a free portrait to each client, who would purchase other photographs. I probably charged as little as ten dollars a print, but it was a lot to me at the time.

The day after I found the doll's head, I saw a wooden hand holding gold-tipped Turkish cigarettes in a window. It appealed to me, so I bought it and took it home. The photograph of Silver Lake in Colorado that I had taken on the original trip west to Los Angeles fit behind the hand; the doll's head rested quietly in the hand, and there it was, the first real photograph that I took after meeting Edward Weston. As with all my still-life photographs, it took days to make. Although I call it *Creation,* it also has been called *The Doll's Head.* Edward wanted to own the photograph, so I gave it to him. In return, he gave me a wonderful photo of seaweed that I loved.

During the late 1930s while I was living in Los Angeles, I went as often as I could to visit Weston in Carmel. I adored him. He was enthusiastic. And, of course, he was charming, witty, and a great raconteur. He was my type. We laughed well together. My visits were never long, but I always arrived with little gifts. One time I brought him socks with leather soles on them.

Edward was a great observer and a sharp wit. One time Eleanor Stone, an ex-wife of Brett, Edward's eldest son, was there. She had left him for a woman. Eleanor made a pass at me.

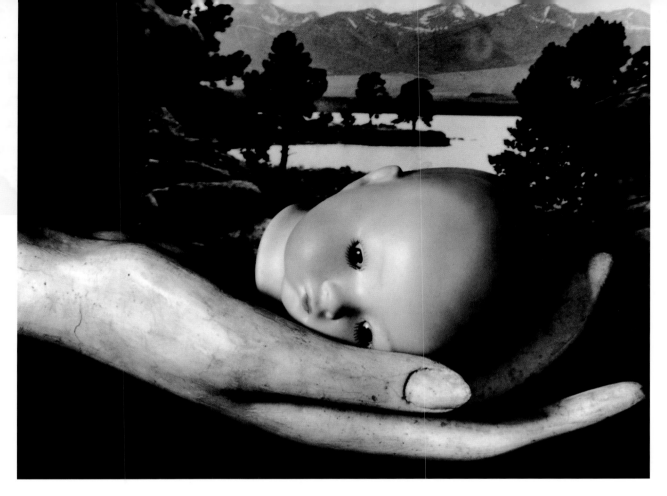

Edward looked at both of us and said, "May the better man win!" We all laughed.

His cats made a large impression on visitors. There were cats everywhere, maybe twenty or
thirty at a time. Weston would purchase big chunks of meat and we would watch them fight
over the food.

Edward always showed me his latest work and he took me to all the places he had pho-
tographed, especially Point Lobos, that wild edge of the coast south of Carmel that his later pho-
tographs would make so famous. I watched him make masterful prints in his primitive dark-
room, exposing each 8 x 10 negative in contact with photographic paper in a printing frame. He
pulled the chain to turn on the seventy-five-watt bulb hanging from the ceiling right above the
printing frame, and then he burned and dodged the print until it was perfect. The simplicity of
his life was inspiring and the complete calm of his manner was mesmerizing.

I met his sons Brett, Neil, Cole, and Chandler. I was impressed because they were so affection-
ate with their father. They kissed him good-bye even when they went on errands to the drugstore.

I also met Charis, who was not yet married to Edward. The last time I saw Charis, she was
across the room in a wheelchair, at an opening of one of my shows in 1998 at the Highlands
Inn. I was touched that she came because when we were young, she saw me as competition. As
a result I was never close to her. After all, Edward had a roving eye, and it must have been hard

Portraits 1936–1939

While in Hollywood, Ruth made many commercial portraits; among them is Paul England's (in profile). The proofs of notable musician and choirmaster Hall Johnson (facing page) reveal the complexity of the portrait session.

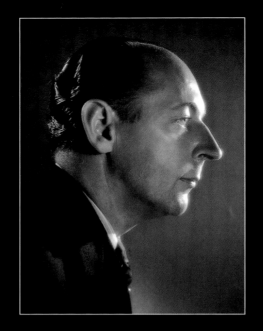

for her. In recent years, when her book on her life with Weston came out, I attended a talk she gave. It was painful to see the beautiful woman on the screen, the body so young and vital, and the woman talking, so old, so in need of help. She was not well. I felt sad for her and wished that I had not been there.

HOLLYWOOD

In the 1930s Hollywood was a natural, woodsy place to live. I eventually settled into a charming studio apartment that was part of a series of picturesque buildings around a courtyard called the French Village on Highland Boulevard, where I had "Ruth Bernhard" painted on a sign extending across the front of the façade. People driving into Los Angeles from the east told me that they could see the "neon" sign from the road.

My studio was on the street across from the Hollywood Bowl, which was one of Hollywood's most amazing places. It was a scene that only California could have imagined, an outdoor theater set against the hillside. Instead of in the dark interior of a stuffy old theater, musical performances of all kinds were accessible to a sophisticated audience under the starry sky. I enjoyed holding open house after concerts for friends in the theater.

My earliest solo show was in Los Angeles, at the Jake Zeitlin gallery on La Cienega Boulevard across from the Turnabout Theater. The street was a place where I loved to browse in shops that sold wonderful things, from antiques to handmade clothes. The gallery was part of Jake's bookstore called the Red Barn, an attractive place with thousands of art books. Everyone went there, and Jake was a delightful and very well-connected person. He had held the first exhibition of Edward Weston's photographs. I was honored to have my photographs on the same wall where Weston's had been shown. My show was reviewed in the *Los Angeles Times*. I had just moved to Los Angeles, my photography was taken seriously, and I was encouraged.

That was the beginning of other connections. I met Elmer Scofield, a well-known landscape and marine painter of the day, who had been elected to the Royal British Academy. He wanted me to have an exhibition in my studio, which he would pay for. We printed a card and sent the invitation to everyone we knew: seven hundred and fifty invitations! On the card we quoted from a review in the *Los Angeles Times* and called the exhibition *Children's Faces,* setting the time from three to six. I was very excited, but when the day came, absolutely nobody attended! I had hired a young woman to wear a lovely white apron and serve little sandwiches, which, of course, I had to live on for days and days. I couldn't understand why no one came. Then I was told that I had to invite a famous Hollywood personality to showcase the event in order to attract a crowd.

A few years later, I had a similar letdown at Lord & Taylor in New York. In the early 1940s I was invited to have an exhibition that included my early nudes in Lord & Taylor's interior decorating department. When it came time to actually hang the show, they had moved it to the fur department on a wall near the cold storage. Can you imagine photos of nudes hanging right outside the fur storage walk-in refrigerator? They had planned a lunch for the press, a special

Postcard of Hollywood
Bowl, 1948, courtesy of
Margaretta K. Mitchell.

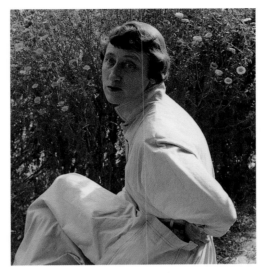

Thanksgiving luncheon to honor the photographer. But no one came. So I said, "Let's eat!" Then the three of us, the picture hanger, his assistant, and I, had a turkey luncheon. Of course, if they had invited the press for cocktails they would have had a crowd. Another reason no one attended was that the person in charge forgot to use the word "nudes" in my title *Seashells, Nudes and Dolls* on the invitation.

I always seem to meet people who are interesting and unusual in the oddest ways. One day I fell down on the sidewalk on Wilshire Boulevard and someone rushed over, picked me up, and took me to her doctor, a naturopath named David Lovell. His wife, Fern, was a painter. They were well known in Los Angeles because he wrote an advice column for the newspaper. We became friends. Fern and I would go on excursions together. On such a trip near Tijuana, Mexico, I found some cows to photograph. They may have been Mexican, but they spoke English to me.

It was at a party at my studio in Hollywood that I met Dorothy Anderson, a poet who was interested in my work. When I was doing a photo essay for an automobile club magazine, she was inspired to write a poem. She was a great admirer of my work and I of hers. Another friend of that time was a magazine- and screenwriter, Virginia Faulkner. As a magazine writer she used the pseudonym Princess Tulip Murphy. She was brilliant and adventurous, a boyish, roly-poly girl who would arrive and scoop me up in a blanket and off we would go in her sports car, driving through the Hollywood Hills to see the moon rise. We never even kissed, though she wanted me to be her lover and would give me anything. She thought that I should have a shop to show my work and she offered to get it for me. She admired me and I her, but I did not wish to be more than a friend.

One day on a walk I saw a bright-looking woman making doghouses in her driveway on Hollywood Boulevard, who turned into a good friend. Bobbi Trout was a well-known amateur

Top left: *Romance in Mexico*, photograph by Ruth Bernhard, 1938. Top right: *Dorothy Anderson, Hollywood*, photograph by Ruth Bernhard, 1939. Above: Feature articles by Ruth Bernhard for the *Southern California Automobile Club* magazine.

aviator. An amazingly daring flyer, she established flight records as early as 1929. She was a friend and rival of Amelia Earhart. Bobbi bought a new Leica camera in 1938. I helped her develop her keen interest in photography and she gave me adventures flying all over California. Even though she called me her "great photographer friend," she never turned me into an aerial photographer.

In 1938 in Hollywood I went to a performance of *Run Little Children* by the Hall Johnson choir that so touched me that I went backstage to meet the conductor. He was six feet, five inches tall, so when he spoke to me he had to bend at the waist. We liked each other immediately, and I saw him many times over the years in New York and on the West Coast. He invited me to photograph him. I made gorgeous pictures of him and his hands, which were so expressive. Hall Johnson was an important black musician and choirmaster who made great contributions to music in America.

Because I could not always make my living at photography, I turned to other interests. My love of dogs drew me to Jane Callendar, who had a factory that produced four- to five-inch ceramic figures of identifiable dog breeds. I finished them by hand after they were taken from the molds.

I needed more steady income, so when I was invited to work for Sears Department Store in Chicago in 1939, it seemed to be a great career opportunity. They promised me the sky. My job consisted of photographing for their various departments. The pictures were of sweaters and other merchandise that were used to announce departments around the store. I found a pleasant room with a view on the twenty-sixth floor of the Stevens Hotel. I had brought with me a deer skull that I placed on the wall and decorated with some tulle fabric. The maid was frightened when she saw it and wouldn't clean my room. It was winter and icy cold. The wind was so fierce that it knocked me down on the sidewalk. Awful, awful, awful! I found one friend in all the people who worked at the store. He was a very nice chap who had just gotten married, and he and his wife were friendly to me. Otherwise, I did not know a soul. I lasted less than six months in Chicago. I was miserably unhappy. When I became ill with an ulcer, I went back to New York and lived with my father for a while to recuperate.

NEW YORK THROUGH THE WAR YEARS

In 1938, once I was back in New York, Tom Maloney, editor of *U.S. Camera,* one of the biggest photo magazines of the era, selected some of my photographs for publication as part of *The American Aces* series that ran on its front page. My favorite Weston portrait of me accompanied the text, which recognized me as his "most ardent student." The article actually predicted my later work on the nude.

This was the same year that Beaumont Newhall published the first edition of his *History of Photography,* in which he mentioned only two women photographers, Berenice Abbott and Barbara Morgan. Others of us who were younger were just being discovered.

In the next few years in New York, photography jobs came to me in all sorts of odd ways.

From a friend who owned a flower shop on Fifty-seventh Street, I was given a portrait commission. She would only give me the address. When I got to the house, which was a long trip on the subway, I was shown in and greeted by an Italian man in a black satin dressing gown. He turned out to be Lucky Luciano, the head of the Mafia. I was there to photograph his wife and son, Lucky Luciano, Jr. His wife looked like a Madonna and the baby was still small enough to be in a perambulator, which had his name inscribed on a brass plaque on the side.

Later when I returned with all the pictures (he had ordered a lot), he gave me cash. With no purse, I had to return home on the subway with hundreds of dollars stuffed into my jacket pocket. I was wearing a brown suit jacket with a beige skirt. The pockets were not very large, so I had great trouble fitting the bills. I remember asking Luciano to give me a check. He responded, "I don't bother about them things!"

My social life in the early 1940s involved a lot of romance, but no settling down. Since I had no interest in marriage, I was focused on my career and did not want to have a serious affair. But there were encounters, and one turned out to be tragic: a young German woman, named Anna Marie Nagel, whom I met at a party at Mary Sullivan's apartment, befriended me because I could speak German, so after the party I accompanied her to Grand Central station, where she was catching a train. She had a job as a nanny to the children of the historian Hendrick Willem Van Loon, who lived in the country. Since she could hardly speak English, I suggested that we have a cup of coffee while we waited for her train. We said good-bye, I came home, and there she was at my door. I gave Anna a place to spend the night. I thought that I could help her adjust to life in her new country and I told her to work on her education. She called later and invited me to the theater. She sent me gifts and pursued me. The situation became difficult and I had to discourage her. Anna eventually killed herself while staying in New York. A letter to me was in her hand, and I had to go and identify the body. She had put her head in the oven. Sadly, it happened at Mary Sullivan's apartment while she was away. It was awful, horrible, and all the time I had had no idea how desperate the woman was, until it was over. I became more cautious after that.

One of my friends in New York was the dancer Jack Cole. We would attend performances together. One evening he took me to see a dance performance he described as "a wild and passionate gypsy flamenco," something, he said, that I had to see.

He was right. The music, and the dancing of Carmen Amaya, drove me crazy. I never had seen an art so full of passion. I was fascinated by this display of a wild creature, the flamenco dancer, abandoned to the seductive guitar. Carmen Amaya performed the male role, her heels pounding and tapping, her female body all the more revealed in her costume of the male flamenco dancer. Her sister took the female role, her flounced skirts trailing behind and swishing with every twist. Carmen would begin the dance with her long, black hair in a tight black bun. As she danced the hair fell and flew with her gestures. By the end, it seemed to be everywhere.

I attended all her performances in New York and Chicago. Wherever she was on stage, I was there. I was Carmen's number-one fan, meeting her backstage, meeting her gypsy family on Long

Carmen Amaya dancing the role of the male flamenco dancer with her sister. Ruth, moved by the passion of the dance, attended all of Amaya's performances.

Top: *Cows,* photograph by Ruth
Bernhard, 1975. Above: Alexandra
Tolstoy on her farm at the Tolstoy
Foundation in Rhinebeck, New York,
photograph by Ruth Bernhard, c. 1944.
Right: Miss Tolstoy seated beneath
the portrait of her father Leo
Tolstoy; photograph taken at the
Tolstoy Foundation, New York, by
Ruth Bernhard, c. 1944.

Island at their home. The family's life was dedicated to flamenco. After a performance they would go home and put on a record and dance.

One day Carmen invited me to meet her at her home, but when I arrived, she was not there. She had taken her sisters to the zoo. So I waited for her for a long time. I saw many pictures of her in costume in an open drawer. I could take what I wanted, her parents said. Two of them were on my wall for years, inspiring me. I gave Carmen a beautiful blood-red scarf. She wore it at a concert to honor me. I was both delighted and horrified, because it did not fit her flamenco costume at all.

After a year or so Carmen moved to Manhattan, to Eighty-third Street, with all the family. I then heard that she had married. I went to her apartment and sat in the lobby, trying to decide what to do. I decided that I could not meet the now conventional married woman.

I was completely unaffected by anything that I heard about Germany as Hitler rose to power and invaded Poland. My father never talked about the war. He did not seem to me to have any German friends in New York, and neither did I.

Early in the Second World War, I wanted to do something to help the war effort, as the young men went off to fight. When I noticed an ad in the newspaper that read, "Needed: farmhands," I said, "That's me!" So I went with an enthusiastic friend to Farmingdale, on Long Island, where I learned how to do all sorts of farm chores, like pitching hay in the silo, milking cows, and driving a tractor, that city girls were not expected to do. For that reason I must have been interesting, because I was interviewed for the *New York World Telegram*.

The article painted me as an artsy young girl from the city. They mentioned that I had on the wall of my room a color page of vegetables for home gardeners and my own photo of sea horses. "She claims her success in New York, listing the prominent artists and architects she worked with, but she prefers photographing ideas." I told them that I wanted to do a book on seashells, but it seemed too ivory-towerlike with the war going on, so I had looked around for something more useful to do. They liked my great enthusiasm for farm work, which they thought would have intimidated a "girl."

Finally, I was sent to Mendam, New Jersey, for a summer, to be a farmhand and to help with the harvest. There I met Bob Comly, the farm manager, who was so handsome that he looked as if he should have been a royal courtier. Over the years Bob became a good friend. He had a house near the farm and was a very elegant fellow. Before we met in Mendam, we had noticed each other at the opening of the ballet season at the Metropolitan Opera House in New York. What a coincidence! The owners of the farm, Mrs. Pitney and her son, Robert Pitney, who was a writer and poet, lived in New York City at 1035 Fifth Avenue in the winter. When they invited me for dinner in their country house on the farm, I had a terrible time getting the cow smell out of my clothes.

Another farm where I went to photograph was run by Miss Alexandra Tolstoy, who impressed me as a woman of great power. She looked through you, rather than at you. She had fled Russia by way of Japan to come to America. In the country she started a farm with large gar-

> "My father never talked about the war. He did not seem to me to have any German friends in New York, and neither did I."

dens, where her group lived and worked. I remember seeing Greek Orthodox priests there in a church that was part of the complex where Russian refugees could find a home.

SHELLS AND SANIBEL ISLAND

One winter in New York in the early 1940s my father said I looked so pale, I should go on a vacation in the sun. I read in the newspaper about the annual seashell show on Sanibel Island in Florida. I had already started photographing seashells and I was enthusiastic about the vision of all the beautiful shells. I had never been to Florida and I had to look up Sanibel on the map, but I was determined to go.

My father gave me money for the trip south. So with my one-way ticket and forty-five dollars in my pocket, I took the train to Florida and stayed at Knapps Hotel in Fort Meyers, Florida. There I met my first collector of shells, conchologist Dr. Jean Schwengel, whose expertise was a part of my new education. Her husband was a general in the army. They came from Scarsdale, New York. We became fast friends over my shell photographs and she introduced me to the head of the show, who allowed me to exhibit my prints. From that presentation I sold all my prints for twenty-five dollars each to Mrs. Alva Edison, wife of the great inventor Thomas Edison, who lived in Boca Grande. That gave me money to stay longer at the hotel.

It was very social on Sanibel and everything revolved around the love of shells, of course. That was how I met Mrs. Carl Miner, whose extraordinary shell collection was in the show. I came to her booth and left her a note saying, "Your work touches me profoundly." And she came to my booth and said, "Your work touches me profoundly. Won't you teach me photography?"

Mrs. Miner invited me to stay for the season with her and her husband on Captiva Island and to teach her how to photograph. She had a huge collection of shells on black velvet. I went out in their boat and had a grand time. I returned to Sanibel and Captiva Islands more than once as the Miners' guest, and eventually I visited them in Evanston, Illinois.

The visit to Sanibel precipitated more than a year of photographing shells, resulting in a major body of work on one of my favorite subjects to study with the camera. The photographs were published in *Architectural Forum* and *Natural History* magazines. From this experience I learned the important lesson that it is wise to become a specialist. Then people will notice you. My curiosity and love of shells consumed my creative energy and really directed my life for several years. Everything worked out perfectly because I said yes to my intuition.

EVELINE

Nightlife in the Village was a typical, lively 1940s scene in New York. The dance music of swing bands provided background sound to a lot of social interaction. Dancing was a way to meet people. It was on such an evening that I met Eveline. We struck up a conversation and discovered that the arts were a common passion that drew us to each other. Eveline Phimister was a stylish person and a multitalented artist. I called her Eveline, spelling it my own

"My curiosity and love of shells consumed my creative energy and really directed my life for several years."

way; the world knew her as Evelyn. Born in England, she had a sturdy, healthy look, sort of Scottish. She came to the United States as a child and studied art in Cleveland and Detroit. Later she designed fabric and wallpaper and sets for Broadway shows and window displays for department stores.

Eveline was the great love of my life, the only one I ever lived with. We shared so much: a love of art and of making things—we loved to gather and press flowers, for example. I learned a lot from her. Her sense of color was extraordinary. Ours was a relationship of mutual admiration.

Our creative partnership began in New York while Eveline was working as a designer in the office of Norman Bel Geddes. I was assigned to photograph miniature airplanes. I made some terrific pictures of them hanging on wires before I realized that they should have been plain photographs of planes seen from below so as to simply identify the plane type. This was a wartime contract, after all. But I had not understood and so I had produced pretty pictures.

Dogs can get credit for bringing Eveline and me together. All my life I have loved animals; dachshunds, for some reason, were the dogs for me, just as they had been for my mother. In 1943 when on that first trip to Florida, I got a letter from Eveline stating, "You have become a mother." She had bought me a dachshund we named Shelly O'Toole. Over the years together we raised dachsies. We had tragedies, losing a puppy at birth, and we also had the joy of saving a

Left and below: Eveline Phimister, artist and designer and the great love of Ruth's life, on the tennis court at fifteen and in a portrait.

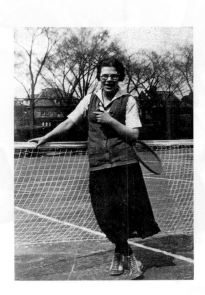

Dear Bernhard
 Being a modest and retiring
bashful youth, I blushed repeatedly when
I read your spread in "U.S. Camera" for
June. I found too much Weston in the text.
But the repr—uctions are evidence that
you withst— —eston influence — thank the
gods! I w— —— my "Doll's Head"
presented. —— —— —— E N reproduced
well.
 I wr— —
are do— —
if the — —

Bernhard —
 You have excellent eyes. Mine
can't harm you. I am glad they
were stimulating. And you were
too, — to me. One day we will
meet again. In New York?
 Negative news from Wash.
Ho, Hum — — — We still eat.
Stew or Beans tonight?
 I have not printed since you
left. Be patient. Have Hope!
 Cariñosamente
 Weston

EDWARD WESTON
WILDCAT HILL,
R.F.D. 187, CARMEL
CALIFORNIA

— Bernhard —
4535 Russell
Hollywood 27
Calif.

Ruth darling — Your letter
made me blush — even at 66!
I can't take such a glowing acc't of
my unworthy self.
 My film, I mean my copy of

VARD WESTON
DCAT HILL,
187, CARMEL
ALIFORNIA

Ruth darling—
or "Bernhard" dea
Tha is for two che
ortfolio wa getting thin.
ews that you are working
is gogo showing
ust invited
f Duck
t

Dear Bernhard—I missed hearing
myself portrayed in the radio by you.
would have & loved it — or would I?
I think that you mentioned
it when you were her
there was too m
any in

pun "hut
years after, I r

CARMEL, CALIF.
FEB 15
5–PM

THIS SIDE OF CARD IS FOR ADDRESS

NEW HOPE FOR H
— SUPPORT
THE HEART F

UNITED ST
2 CENT
POSTAL CARD

— Bernhard—
43-35 Russell
Hollywood 27
Calif.

puppy with hand feeding after the mother had died. It was a family time for us.

Eveline had style; she was also whimsical. When I was in Florida, she sent me socks in delicious colors: pale blue, pink, lemon yellow. I wore one of each and was admired for making a fashionable statement.

At the time I met Eveline, I lived in a studio apartment across from the armory on East Twenty-sixth Street. The building was owned by the actor E. G. Marshall, who lived downstairs with his wife and two daughters. One rainy day I noticed that the ceiling was particularly wet and heavy-looking. In the middle of the night I heard a terrible crash and all the ceiling fell in. I had expected it, so my photographic equipment was stacked along the side walls. I announced to Mr. Marshall that I was going to Florida and not coming back until the roof was fixed. So off I went by train with my dogs in tow.

On the way down south, I was giving a lecture on the art of architecture at the University of Richmond, Virginia, where I had quite an adventure because the dogs were separated from me on the train and I thought they were lost. I was frantic. The dogs were in the baggage car, and at a stop, they switched the cars, leaving the baggage car on the siding. We connected eventually and I was greatly relieved.

When I returned from Florida, Eveline moved in with me in the renovated apartment. In the summer we vacationed in Southold, Long Island, living in a lighthouse. I did a wonderful

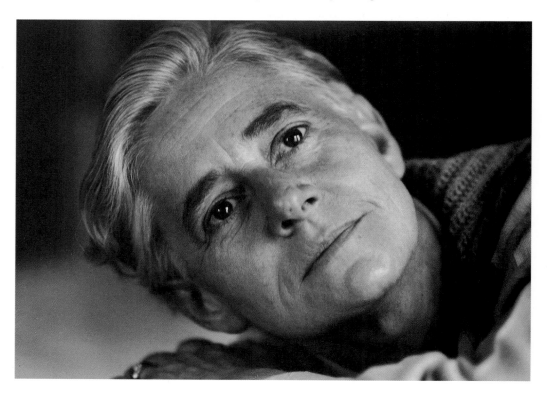

portrait of Dr. Cora Jennings, who lived nearby.

She was serious competition for Eveline. But I realized that she did not have as much in common with me intellectually. She bought one of my dogs, which I suppose was our connection. There was a compatible group of friends there in Southold. Another photographer, Edna Bennet, also rented part of the lighthouse with a friend. She wrote and edited for a photo magazine, publishing my picture of hands, among other images.

Eveline and I eventually moved together to Washington Square. There I often saw Eleanor Roosevelt walking her dog as I was out walking Shelly O'Toole. I lived on the south side and she lived on the Sixth Avenue side, where she had moved after Franklin Roosevelt died. I sent her a gift of seashells.

One day Eveline and I were at the Museum of Modern Art attending an opening when Eveline said, "Who did you just bow to? Who was that?" "That was my sister," I told her. Eveline was astonished that Mildred and I did not speak to each other. I said that it was too painful to see her.

In the summer of 1946, Eveline and I went to stay in a lovely house in the country in Pennsylvania on a little vacation. I had with me some fascinating dolls, made by Dewees Cochran, who was well known for making dolls that looked like real people. The two that I was to photograph had charming children's faces. I noticed that their expressions were sad, and commented to Eveline that they looked as if they had seen a dead bird. That day, outside in front, we found a dead sparrow that had fallen out of the nest. I made the photograph. It became a sweet little story.

MY INTRODUCTION TO STIEGLITZ

The Group Theater was a very important phenomenon in the New York cultural scene of the 1940s. It was leftist, filled with activists who did challenging work, such as the play *Waiting for Lefty*. I was friends with the actors Morris Canovsky, Alexander Kirkland, and especially Bobby Lewis. Because I knew them all, I often was backstage at performances. On our many walks to the theater Bobby Lewis loved to browse, and so did I. One day we saw beautiful spun sugar candies in a store window and I expressed my appreciation. Bobby turned to me and said, "Would you like one?" "What?" I said, "At four dollars a pound?" That was a lot of money for candy in those days. But he bought me some, and I honored the gift by making a still-life photograph of it called *Candy*.

It was Bobby who introduced me to Alfred Stieglitz. We went to Stieglitz's Madison Avenue gallery together, with a box of prints under my arm. Once in the gallery, Bobby and Stieglitz fell immediately into a conversation. I have forgotten what they were discussing but I remember feeling left out. When I interrupted them, Stieglitz burst out, "What do you know about that?" Later, when he had finally looked at my work, he said kindly, "You really do know." I went back often to see his exhibitions. Stieglitz always seemed glad to see me.

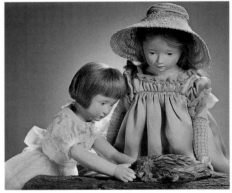

Facing page: *Dr. Cora Lee Jennings*, **photograph by Ruth Bernhard, 1948.**
Top: Note from dollmaker Dewees Cochran.
Above: *Dead Sparrow*, **photograph by Ruth Bernhard, 1946.**

American Indian silver jewelry (photographed for a book published by the American Indian Museum, Santa Fe, New Mexico), photographs by Ruth Bernhard, 1947.

When he saw that I photographed shells and bones, Stieglitz said that I should meet his wife, Georgia O'Keeffe, that we had so much in common. We did! We got together and often had lunch and went browsing in Chinatown. One day we made an imprint of her hand with ink on paper. Her hand was large and strong, like a man's. Later on, she told me that she was going to Santa Fe and asked me to come along; it seemed as if she had some interest in me, but I declined.

In 1947, after the war, there was still a shortage of photographic paper. I was at the photographic store in the Grand Central building buying supplies. They said that since I had been there the day before, I couldn't have more paper. "But I wasn't here," I said. They argued and then we figured out that another photographer was my double. I couldn't wait to meet her. Her name was Erika Anderson and she was eventually known for her photographs and films on Albert Schweitzer. So I called her up and said, "You know, I think that we should meet each other." We made an appointment to meet at Schrafft's at an hour between teatime and dinner. It was amusing for both of us. Because she spent a lot of her time in Africa with Schweitzer, I didn't get to know her well.

In New York in the 1940s there was a wonderful photographer named Marcus Blechman who photographed theatrical personalities. He could transform the most ordinary woman into a glamorous star. In his studio at 40 East Fifty-sixth Street I met many fascinating people. That is where I met Gloria Swanson and Bea Lillie and caricaturist Al Hirschfeld. Marcus was a most charming, delightful fellow and a master studio photographer. He photographed my dogs with me, in one of my favorite photos. And I used his studio to make portraits from time to time. The studio was small and all white, so the light could bounce off the walls and give a soft, flattering illumination, perfect for the face.

Weston finally was given a major exhibition at the Museum of Modern Art and came to New York in 1946. There was a celebration and I wanted so to take him to my favorite Japanese restaurant, but Nancy and Beaumont Newhall (Beaumont was the first curator of photography at the Museum) insisted on having me to dinner with Edward. I had known that Edward had Parkinson's disease and I had been concerned, based on the shaky script of his letters; now I could see immediately how very ill he was. I remember that he fell asleep at dinner. To see him so frail was infinitely sad for me. It was a while before circumstances provided me with the opportunity to move back to California to be nearer to him.

SETTLING IN CALIFORNIA

In 1947, as I was turning forty-two, I had an operation called a suspension to fix an upside-down uterus, a condition that had caused me years of intermittent pain. It was a wonderful relief to feel better. One day in early 1948, motivated by my longing to be near Weston in his declining years and the fact that Eveline and I decided that we couldn't stand one more winter in New York, we moved to San Francisco. There we lived in a storefront on Divisadero Street, not far from where I live now. An Armenian shoemaker owned the building for a short time. It

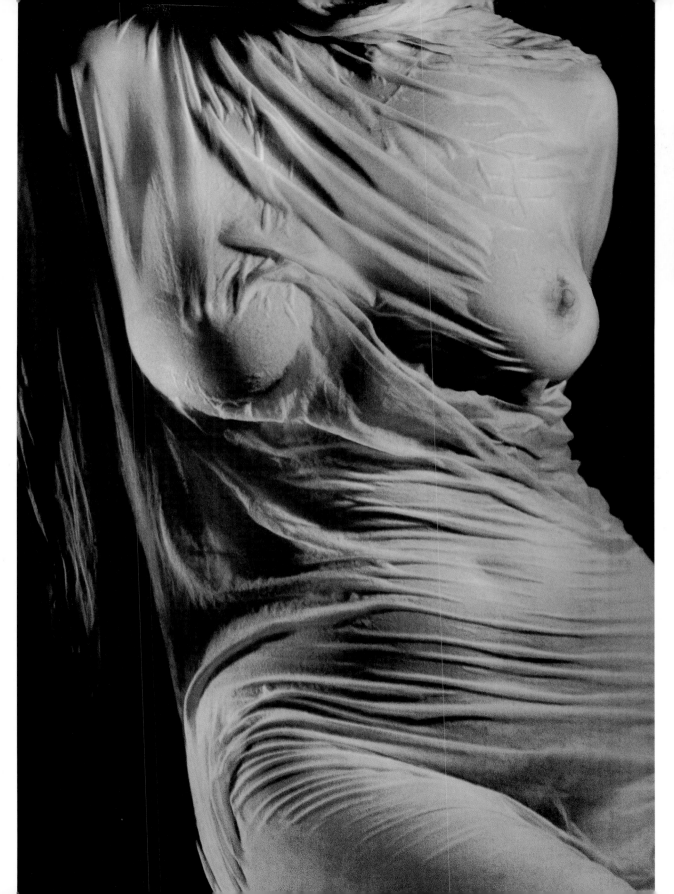

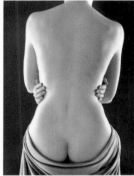

Left: *Wet Silk,* photograph by Ruth Bernhard, 1938. Above: *Draped Torso with Hands,* photograph by Ruth Bernhard, 1962.

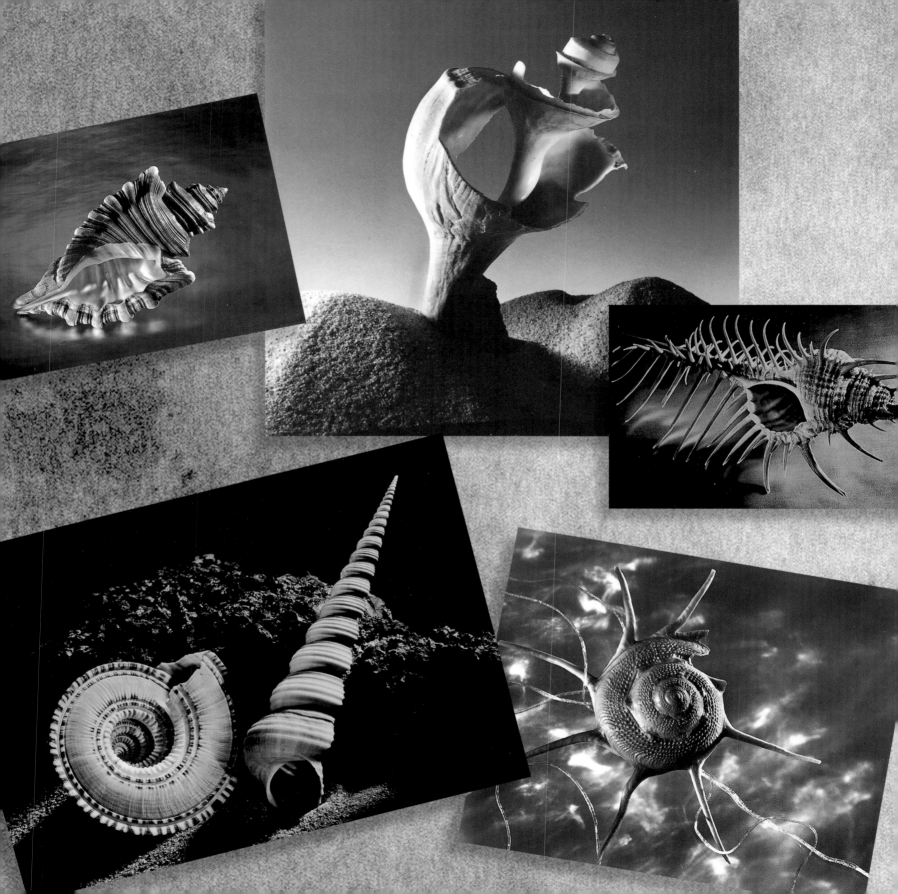

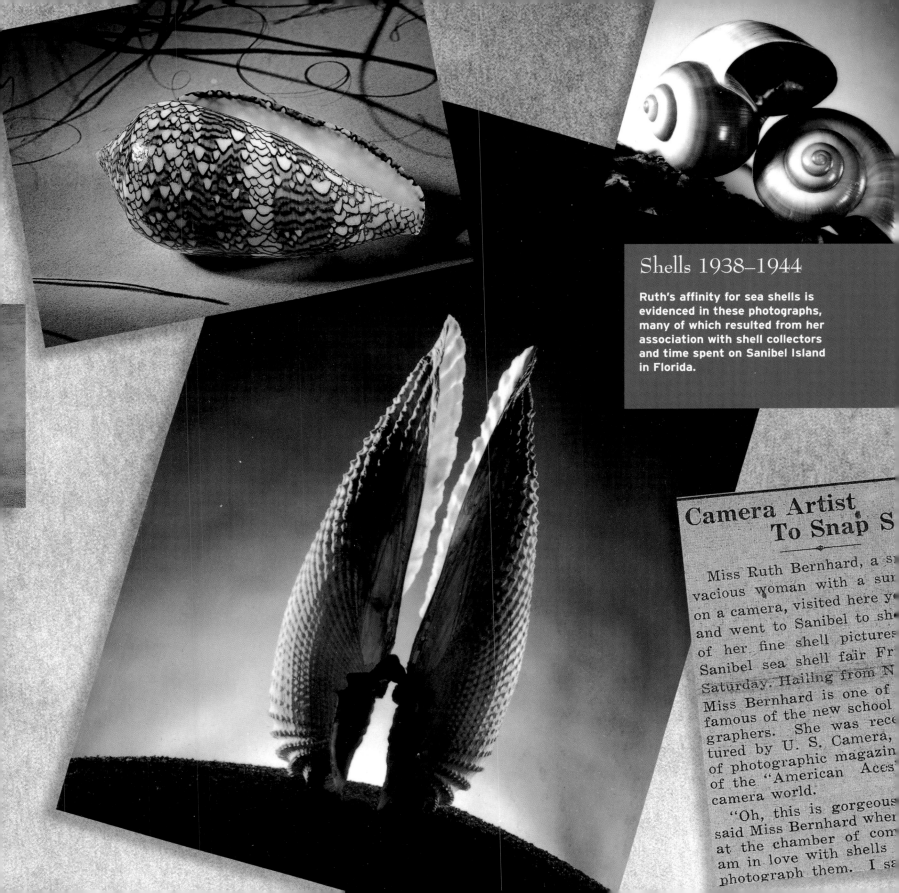

Shells 1938–1944

Ruth's affinity for sea shells is evidenced in these photographs, many of which resulted from her association with shell collectors and time spent on Sanibel Island in Florida.

Camera Artist To Snap S

Miss Ruth Bernhard, a s
vacious woman with a sun
on a camera, visited here y
and went to Sanibel to sh
of her fine shell pictures
Sanibel sea shell fair Fr
Saturday. Hailing from N
Miss Bernhard is one of
famous of the new school
graphers. She was rece
tured by U. S. Camera,
of photographic magazin
of the "American Aces
camera world.

"Oh, this is gorgeous
said Miss Bernhard wher
at the chamber of com
am in love with shells
photograph them. I sa

had a little garden in the back. Unfortunately, it rained constantly. After some months, we left for Los Angeles, where we hoped there would be sun.

We lived on McCadden Place. Neither of us was particularly domesticated but there we enjoyed the quiet life of productive artists. We happily spent many hours manufacturing objects for a shop we called The Pink Pigeon and for Eveline's contracts with Bullock's Wilshire.

We ran the shop together, but Eveline did all of the painting of objects that we sold. There were tea trays, plates, and other items, like music boxes, and it was very colorful. The shop was small, made up of the glass-enclosed porch that served as the entrance to the house. Eveline painted a fine sign to attract people.

Top: *East Coast Sand Dune,* **photograph by Ruth Bernhard, 1951. Bottom: Eveline Phimister profiled in newspaper.**

We lived an active life, often going outdoors to the beach or the tennis courts: Eveline played and I watched. We had friends in the arts and went to their openings. I photographed for people like Bill Alexander, architect and owner of a shop on Santa Monica Boulevard, for whom I recorded the process of the building of his house. This was a good period for me. Eveline and I were both designers, making many of the wonderful products she would sell to Bullock's department store. I also worked for Bullocks Wilshire, doing photographs of lipstick and other beauty products and gift items like inlaid boxes, for their catalogue and advertising department.

The Red Barn, where I had had my first show in 1939, was still the best place to see photography in Hollywood. I attended the opening of a photographic exhibit by Clarence McLaughlin. His work was surrealist and strange, and so was he. I said to him, "Why have you not committed suicide?" His reply was, "Can I take you to lunch?" Later I gave him a reception at McCadden Place.

Marjorie Kane, a New York friend of mine, whose friend Becky had died, looked me up in Hollywood. During that time I was not well, but we managed to have a nice time anyway. One day she said she wanted to learn to drive. I suggested that Eveline teach her. And she certainly did— and more—because eventually, after Marjorie returned to the east, Eveline moved to New York to join her. Marjorie was charming, but turned out to be a calculating person. During that time I was not feeling well and would eventually have a hysterectomy in 1952. I felt that I had very little to give so I accepted the fact that Eveline found someone else. However, strangely enough, our relationship never really changed. Over the years Eveline wrote me all the time. We had an enduring mutual admiration and it lasted her whole life. The three of us met often in New York and together spent time on vacation at a resort in Kitzbuhl, Austria. Eveline died on December 11, 1996.

In the early 1950s, after Eveline left for New York, I lived by myself with my two dachsies, in a cottage on Russell Avenue with a small garden, behind a larger house. It was quiet and pleasant and perfect for the dogs. One weekend, a friend who was dog-sitting for me while I was away called frantically saying that they were nowhere to be found. I asked her if she had looked under the blanket. She dropped the phone and soon I could hear a scramble. She had found them. They simply had not responded to her voice at all.

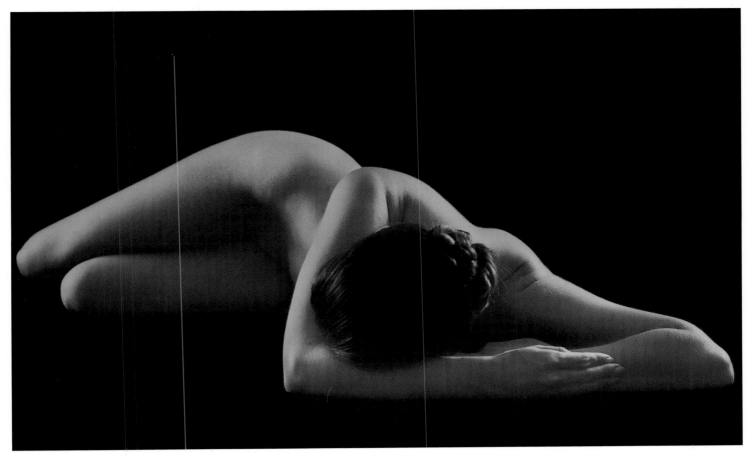

Perspective II, photograph
by Ruth Bernhard, 1967.

It was a difficult time of transition, and I turned to photography.

In that living room I made the image *Two Leaves* one day when I was not feeling very well. I found myself looking at some of the magnolia leaves that I had collected. As usual they were decorating a table with many other leaves. Two of them called out to be photographed. The two leaves in question found each other, and I put my little shaving mirrors to work as reflectors of the light from a seventy-five-watt bulb. I had a terrific time. I felt better too. For me, leaves represent the way a tree grows. The monumentality of these two small leaves carries my awareness that everything in nature is of great importance no matter what its size. My vision gives the subject its importance. When I work, I do not think. I am in the picture, losing myself, being in love.

This was the time when I made the nude image that I eventually used on the cover of the portfolio *The Eternal Body*. The model's last name was Colvin. She offered to pose; I made only two exposures, and the rest is history. I was inspired to make photographs again, and, gradually, I began to yearn to go somewhere new.

RUTH BERNHARD
Internationally Famous Photographer

BE
RETR

BERNHARD

mhard
ft of the
commonplace

San Francisco

Top: Ruth in her apartment on Clay Street, photograph by Bob Clark. Above: Bernhard mailbox, photograph by Marilyn Sanders. Right: Ruth and friends getting ready to drive to Northern California. Facing page: Ruth waving from her living room bay window.

san francisco

SOLO IN SAN FRANCISCO

I TOOK A TRIP TO SAN FRANCISCO IN 1953 to look around. At that time a fellow who said he wanted to advance my career offered to give me studio space and set me up with clients in Corte Madera, north of San Francisco. So he came and picked up my stuff and drove me all the way to San Francisco from Los Angeles in my Ford coupe. Cars never seem to bring me luck, and later, when a friend borrowed the car, he let the engine overheat. The moment cold water was poured over the block, it was over. I never did have a talent for driving, and I was relieved when I got rid of that car. From then on I became a Greyhound aficionado.

In Corte Madera, the offer did not go as planned. Quickly I saw that this was a mirage, and I had to find a place to live, pronto. Things resolved themselves in a strange way. On a visit to Carmel at about the same time, I met Jane Todd, a radio personality of the early fifties, at the house of Larry Colwell, a photographer. I was there for the opening of a show of my photographs along with those of Edward Weston and Wynn Bullock in an art gallery in Pacific Grove. The owner, Ethel Kurland, introduced me to Jane, so I called her and reconnected in San Francisco, and she offered to take me in. She had the stomach flu and I fell into the role of caring for her and her adorable dachshund. She also had a ten-year-old son. Because she was getting a divorce, she was giving her furniture away. I came away with several chairs. In the course of my stay, I found the apartment where I still live. I remained friends with Jane through her next marriage and photographed the wedding at the Swedenborgian Church in San Francisco. Unfortunately, over the years I lost touch with her.

I came to this sunny apartment in the winter of 1953–54. It had been very difficult to find a place in which I could live with three dogs! The owner, Mr. Schaezlein, an old gentleman, had shown me an apartment, but it had no exit in the back to the outdoors. I said, "Do you have another apartment anywhere?" "Oh, yes," he said, "on Clay Street." There was lovely southern light in the living room. The walls were an impossible bright turquoise, but soon I had painted them white. I wanted to create a spare, airy space like a gallery for my photographs.

The kitchen door opened to a porch and a courtyard downstairs. The owner, who lived downstairs, was a silversmith who had his studio in the back. I kept saying to him, "Gee, I want this place so badly for my own studio." We laughed about that for years. One day he said, "You've got your studio," and he moved his to Clement Street, a few blocks away. That wonderful space behind the house became my own. Up to that time I had been photographing in the

> "By the time I moved to San Francisco, I no longer used my 8 x 10 camera. My last 8 x 10 negative is dated 1947."

living room, where the bay window faced the street.

By the time I moved to San Francisco, I no longer used my 8 x 10 camera. My last 8 x 10 negative is dated 1947. My last 5 x 7 negative is dated 1952. I had taken up the 4 x 5 view camera and medium-format Rolleiflex camera. I have never used a 35mm camera for anything serious; I always think that the picture will be a snapshot.

I knew no one in the photo community when I arrived in San Francisco, but in the early 1950s I was invited to one and then another of Ansel Adams's many cocktail parties. It was through those parties that I got acquainted with the community. Because of my association with Weston and my new acquaintance with Ansel, I met people such as Minor White, Wynn Bullock, Ernst Haas, Don Worth, Larry Colwell, Jack Welpott, Dorothea Lange, and Imogen Cunningham. Eventually I visited Imogen in her house and saw her hillside garden. I was much impressed with her photographs of plant forms. Imogen was famous for her salty tongue. It is no surprise that she told me that I was too sweet a personality, calling me a dreamer.

There were so many interesting photographers in San Francisco at that time! Several of them developed a group called the San Francisco Photographers' Roundtable. There was Jerry Stoll, who really was the star of the group, and his wife, Gini Stoll Harding, who has become a lifelong friend. Other photographers in the group were Phiz Mozzeson, Jackie Paul, Miriam Young, Paul Hassle, and Pirkle Jones and his wife, Ruth Marion Baruch. They met in the Stoll studio to share their work and got the idea to have an exhibition on a theme, suggested by Dorothea Lange. It was decided that photographers had to use new pictures all taken for an event that was called "San Francisco Weekend." They sent out a call to photographers all over the city. I heard about it and went over to the studio on Potrero Hill and introduced myself to Jerry and Gini. Now, I never go out with my camera and wonder what I am going to photograph. I never do that, ever. But when Dorothea Lange said we had to, I did. I took myself and my camera to Chinatown. That walk resulted in three photographs, *Pigeons, Hand in Hand,* and *Mr. Reilly.* After attending a sermon by the renowned black theologian Howard Thurman at the Fellowship Church, I noticed a black man and a white girl about nine or ten years old standing together holding hands—she with an expression of complete trust. Responding intuitively, I made the image. When I approached the two offering to give them a print, Mr. Reilly introduced himself and his young friend. They were expecting her mother to join them for lunch.

These photographs hung in the San Francisco Arts Festival in 1955. There were about ten of us in the show. Dorothea was the advisor and Imogen Cunningham, Nat Farbman, who was senior editor of *Life* magazine, and I were the jury. Everyone pitched in and worked for the exhibition, which won top honors at the festival. Gini and Jerry were so proud because we photographers were considered only "button-pushers" in those days. She reminded me that the State Department bought a copy of the exhibit to circulate in Europe, as a way to show American culture. Our group continued to meet and share our work. We met at a picturesque restaurant called Tommy's Joint at the corner of Geary and Van Ness. It was exciting to think that it took me only

Above: *Hand in Hand,* photograph by Ruth Bernhard, 1956. Facing page, clockwise from upper left: *Ruth and Her Two Dachshunds, Shelley and Bonzita,* photograph by Kim Baker, c. 1959. *Cilly,* photograph by Ruth Bernhard, 1972. *Shelley and Bonzita,* photograph by Ruth Bernhard. *Self Portrait with Dogs,* photograph by Marcus Blechmen, 1949. *Two Cats, Schnoo-Schnoo,* and *Shelley and Bonzita At the Window,* photographs by Ruth Bernhard.

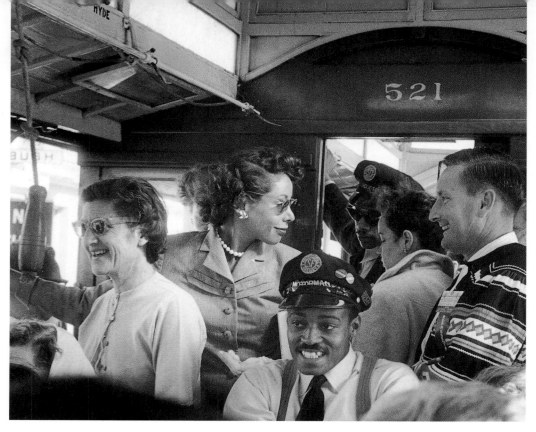

Melvin Van Peebles, Cable Car Gripman, from *The Big Heart*, photograph by Ruth Bernhard, 1957.

"My work is my sensuous life . . . To make the subject become more beautiful took my full attention, the attention of a lover for his beloved."

three years to become involved in the photography community in San Francisco. I loved it.

There were other attempts to do shows, but I was not a part of them. The Roundtable developed into a school housed in a storefront on Divisadero Street. There was a large space for showing prints and holding classes in the front, and in the back of the building there was a lab where students printed their black-and-white negatives. I was the director. I also began giving workshops and classes in my studio, calling the program Insight Photography. The two main classes I taught were Seeing and Awareness and The Nude through New Eyes. I often included other photographers in the program, such as Robert Boni, Tom Baird, Margo Baumgarten-Davis, Roger Minick, and Ron Chamberlain, with Robert Frank as a one-time guest speaker. My community of photographer friends has been expanding ever since.

Once at a photography event in a hotel, Ansel, Imogen, and I were all sitting together looking at Edward's photographs. There was a photo of a shell in a rock. A big debate resulted from the fact that Ansel did not approve of placing the shell in the rock. It should not have been set up as an "arrangement"; the shell should have been found there, he said. Then Imogen scolded him, saying something sharp as usual to spark the conversation.

I had to continue to make my living. One of my earliest Bay Area commissions came from Ilse Wiener, who was a very elegant woman with an import shop in Sausalito that specialized in handmade laces and ribbons, buttons, and teddy bears. I discovered the shop and would go there often, and I suppose I was so enthusiastic that she became interested in me. I started photographing for her and we became friends. I worked for her until she died.

During the mid 1950s I had problems with low energy. No one could figure out the cause

until I met Dr. Roberto Escamilla, an endocrinologist. From that moment, I have been taking thyroid medication. But at the time, I was upset because I thought that I could not go to the opening of my first foreign show. It was in the spring of 1958 and my exhibition, scheduled for the Institute for Cultural Relations in Mexico City, was being arranged by an American painter, who invited me to be his guest there. The whole trip turned into a drama, with the death of Pope John coinciding with the exhibition opening. Very few came, so a second event had to be planned, which fortunately went well. Meanwhile I discovered that my host expected me to pay for his expenses. I paid the landlord and left while the show was still on the walls. Actually, I had a lovely time: the show was well reviewed, and I was served breakfast in bed every day.

At home, I was busy with my camera. I did a lot of dog portraits because of a pet shop on Fillmore Street. The first time I went into the shop, I saw that the owner, a big red-haired butch lesbian, had a dog portrait on the wall. The portrait was so poorly done, I couldn't help telling her so. "Oh," she said, "I wish I knew someone who could photograph dogs." I said, "You know somebody," and I raised my hand. From then on, she sent me many elite dog owners for whom I made portraits of their delightful canines.

In my commercial portrait work over the years I have preferred animals to people for the simple reason that they never complain about their age or their wrinkles. They accept themselves as they are and respond unquestioningly to love.

One of my portraits, of a little flat-faced dog, made it into the *San Francisco Chronicle* and I received a postcard from a fellow who saw the newspaper photograph, asking what kind of dog it was. I lost the card before I could call him. Shortly afterward, on a walk in the Sausalito hills, a little dog came forward and I naturally talked to it. The owners arrived on the trail and we fell into conversation. All of a sudden the man said, "Are you by any chance the woman to whom I sent the postcard?" So I have a wonderful picture of that dog and his owner.

In 1958, I photographed for a book called *The Big Heart* by a cable car gripman named Melvin Van Peebles. He had met a painter in the park and asked her if she knew a photographer. She was the wife of photographer Phil Palmer, who recommended me to Van Peebles. He called and said, "I'm making Southern fried chicken tonight. Would you come over for dinner?" I met his lovely German wife and their adorable child, Mario. He simply asked me to do the book with him. With such an opportunity in front of me, I couldn't say no.

The next morning, with great excitement, we walked down to the cable car turnaround on Market Street and I began photographing. I spent a lot of time with Peebles on the cable cars, riding all over the city. He was a very charming and bright fellow. We became friends and I made a nude family photograph when his wife was pregnant with their second child. Later he became a newspaperman in Paris, and he eventually turned up as a writer and filmmaker in Hollywood.

My family still lived in and around New York and New England, so I often went east to visit. I loved to go to places like Rockport on the coast of Massachusetts and we got together in New Hampshire at Manfred's farm. There were good opportunities to photograph. On one of my trips

from San Francisco to New York, my father came to lunch to see me at Mother's apartment. He ate, wiped his mouth, and left. I said to her, "Why did you marry this uncouth man?" She replied, "He is the father of my children and I love him."

On another visit, I had dinner with my father and learned that he didn't remember his mother-in-law. When I told Mother she said, "How dare you talk to your father about my mother." Later that evening I said to her, "If I have hurt your feelings, I did not intend to." She spent the next hour pouring out her woes, and later in the kitchen I overheard her say, "I'm so happy now." I felt great pity for her in that moment. It was so sad.

EDWARD WESTON

Over the years in San Francisco I went down to Carmel to visit Edward as often as I could get a ride, having no car. He became progressively more ill with Parkinson's disease over the years. Near the end, I offered to Brett to take care of him, but he said they needed a nurse. In 1958 when I heard that he had died, I took the next bus down to Carmel. His wonderful nurse told me that he died sitting in his chair. His son Chandler had been with him. Later I went alone to Point Lobos. It was a sad, sad time, and I was glad to be alone in the place that he loved so much.

Weston was a charming, charismatic man. Over the years we laughed a lot and enjoyed each other. He was as much interested in me as I in him. He was so receptive of me as a person. He completely understood me. I have had many loves in my life, but I have never had a person in my life whom I loved more than Weston. Being with Edward was satisfying; he was never in a hurry, never looked at the clock. Living in a simple cabin in a beautiful spot in Big Sur on the coast near Carmel, his life was focused on essentials and nothing was lacking. I always felt at home there and am still learning from the simplicity that he espoused in both his work and his

Above: Ruth Bernhard and Edward Weston with cat. Right: Ruth and Edward with tiny seashells, Wildcat Hill, photograph by Cameron Macauley, 1949.

life. In looking back, I owe Edward a huge debt of gratitude, which I have expressed in my photography by not imitating his work, but by using his influence to have faith in myself and to take my photography seriously.

As you know, when I first saw his work, I burst into tears. My vision was completely transformed by meeting Edward. I had not respected photography until I met him. I began then to take myself seriously as an artist. He believed in me. Ours was a deeply spiritual intimacy, more than a seduction would have provided. We had an unconsummated love affair. I was so afraid that I would lose him if our relationship were only physical. That would be dangerous. He had written about this in his daybooks and later cut out that section to protect me. I know because he showed me the entry. It would have been so easy to give in to the instincts. I loved him, but I knew our friendship was too important to me to become another of his conquests. I did not want to spoil things. If I did, our connection would go up in smoke. The emotional tie was always exciting; the physical expression would limit our relationship and perhaps create trouble for us both. Of course, there was also Charis. She was there posing for him. He eventually married her and she became jealous of anyone who enjoyed Edward. I had what I wanted. He had done enough for me by being there. It was not physical denial. It was overwhelming enough to have a kind of magic between us, a deep understanding, intimate and delightful, the love of twin souls, not of a couple.

I have a conscience and am an ethical person. Even if Edward and I spent the night together, we were not sexually intimate because my love for him was an ageless expression of soul. We flirted. We danced a lot. He would find a record and put it on the phonograph and we would dance the rumba. We walked on the beach, we would visit Point Lobos to see his favorite places, but we never photographed together. The air between us was charged, as if with an electrical current, but I did not want to destroy that romance with the banality of sex.

As a woman with the perspective of age and the value of hindsight, I realize that my father was a man whose frustration with women is reflected in his paintings. I found it offensive to see his unfulfilled desire revealed for all to see. Lucian's women became objects of desire, as if the only thing to do is to go to bed with someone. If that is all, then the female becomes only an object; this is destructive and the female body is demeaned. In contrast, Edward was a man who loved many women, but he appreciated them in a way that was open and free. Besides, he was a great soul, a fine artist and a true mentor.

Work and relationships are hard for the practicing artist to balance. My work is my sensuous life. I could work all night when I was trying to achieve an ideal. To make the subject become more beautiful took my full attention, the attention of a lover for his beloved. I saw this intensity of feeling and focus in Edward's work and it freed me to follow the same path, with my own intuition leading the way.

For the artist to identify with the subject, whether it is a shell, a leaf, a face, or a body, is to identify with beauty. These are not sexual feelings. These are cosmic feelings: to marvel at the

"As you know, when I first saw his work, I burst into tears. My vision was completely transformed by meeting Edward."

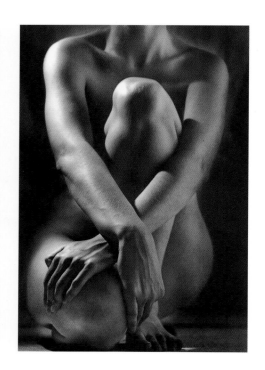

> *"These are not sexual feelings. These are cosmic feelings: to marvel at the beautiful line of a leg, a torso."*

beautiful line of a leg, a torso. This is not creating with power, but with empathy.

Falling in love does not necessarily have anything to do with sex. When people talk about homosexuals they speak as if the only interest they have is sex. They do not talk the same way about all couples, do they? How about love? How about joy? How about adoration? There are people who fall in love with each other, whether a man or a woman. But love is the word, sex is not.

Over the years, I have grown critical of Edward's work on the nude. To my mind Weston nudes are not as sensuous as his shells and peppers. I see the man in the picture every time. Some of his nudes are beautiful, of course, and it is absolutely true that Edward did not do "sexy" pictures. Weston's nudes are sensual, but when I think of them I see his interest in seduction and connection, while in my own work with the nude as subject, my quest was abstraction and sculpture. I wanted to achieve an ideal harmony and to be emotionally connected through photography with the universal idea of the body as a work of art. I wanted to convey innocence in my pictures of the nude, the innocence of a tiger or a cloud in the sky: a picture without desire. I could not photograph a person for whom I had desire because personal feeling gets in the way of expression.

My own studies of the nude began, as I've said, in 1934, when Peggy dropped into that huge stainless steel bowl for the Museum of Modern Art's *Machine Art* catalogue. But it was *Classic Torso* that staked my claim to fame. It became one of my best known images because I used it on the cover of the portfolio *The Eternal Body*. The text summed up my mission to elevate the female nude above and beyond the traditional male point of view: Our terrestrial human body as organic form and personal expression intensely attracted me in sculpture and painting long before I began photographing.

My photographs of the nude are the only work by a woman photographer included in the 1964 book *The History of the Nude in Photography*, by Peter Lacey. In the text I explained more specifically my philosophical goals: "If I have chosen the female form in particular, it is because beauty has been debased and exploited in our sensual twentieth century. We seem to have a need to turn innocent nature into evil ugliness by the twist of the mind. Woman has been the target of much that is sordid and cheap, especially in photography. To raise, to elevate, to endorse with timeless reverence the image of woman, has been my mission—the reason for my work which you see here."

TEACHING THE NUDE WORKSHOP

The main body of my work on the nude was created parallel to my teaching career during the 1950s and 1960s. For me the nude as a subject for teaching has been my greatest experiment. My students always find it a formidable task for their photographic skills. They must learn the difference between the eye and their chosen lens. Generations of artists have struggled with the nude form as an exercise in seeing.

Since the 1960s so many special people have come into my life as a result of my teaching. I

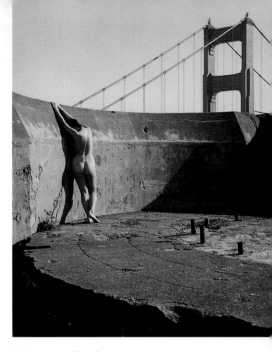

met Tom Baird when he attended one of my classes in the early 1960s. Wynn Bullock had told him to come and study with me. Later Tom was in charge of the photography classes at the University of California Extension program. He attended the workshop on the nude that I held in my living room. We became good friends and he sometimes assisted me in my studio classes. Through working with me, Tom got to know me better, and asked me to teach for the University of California Extension program. A class that I was teaching, called The Art of Seeing, met in my studio. This was so successful that it evolved into another, larger course that I taught at the extension center downtown.

When I look at my years of photographing nude models for my father and, even earlier, recall the experience of posing as a young woman for Gustav Schreiber, I realize that I had absorbed an unusual—perhaps unique—sensitivity to the subject. In the end, I learned most by teaching. Models were paid to pose for classes but they wouldn't allow me to pay them to pose for me. They were honored that somebody took them so seriously. I usually gave them pictures in exchange for their posing.

In the early years in San Francisco, I rented a studio on Sacramento Street from a sculptor friend, Barrie Brougham, for teaching, and I used my south-facing living room as a studio. The photograph *In the Box Horizontal*, which many claim as my best known, was made in 1962 in that space. It is a compelling picture, though I really don't know why. It was so simple to create, the result of a moment's intuition. I looked out of my bay window and saw a large oblong box on the curb. It was from a new enlarger that had just been delivered to a neighbor named Gibson, who was also a photographer. I turned to my model, Joyce, and said, "You are in that box!" We both laughed. Joyce and I ran down to the street, retrieved the box, and put it to work immediately as a prop. It was the perfect setting for that pair of poses. I kept the box for years, until it sagged too much and I had to throw it away. This picture has had a life of its own. Everyone gives it a different meaning.

Joyce Pieper posed for me many times over a number of years, beginning in 1959. She came to my door and said that she had seen my photographs in a nudist magazine and liked them so much that she wanted to work with me. I could not have had a better model. More than a model, Joyce was my friend. I knew her family and visited them in Malibu, where I photographed her with her baby.

One of my neighbors was a nurse who posed for me from time to time. One day in the early 1960s she and another nurse visited during their lunch hour and offered to pose on the spot. I was unprepared, but I got my camera and put film in it. As they took off their clothes I noticed that the black woman had crease marks on her stomach and the white woman had no muscle tone, so I asked them to face each other. The hand was just a happening. Perfect! All of it took no more than twenty minutes. I call this photograph *Two Forms*.

When I was finally able to move downstairs to my new studio, I received a number of platforms that I could use from a friend, Bill Green, who worked for KQED television. I covered the

Facing page: *Classic Torso With Hands*, photograph by Ruth Bernhard, 1952. Above: *Golden Gate Bridge*, photograph by Ruth Bernhard, 1971.

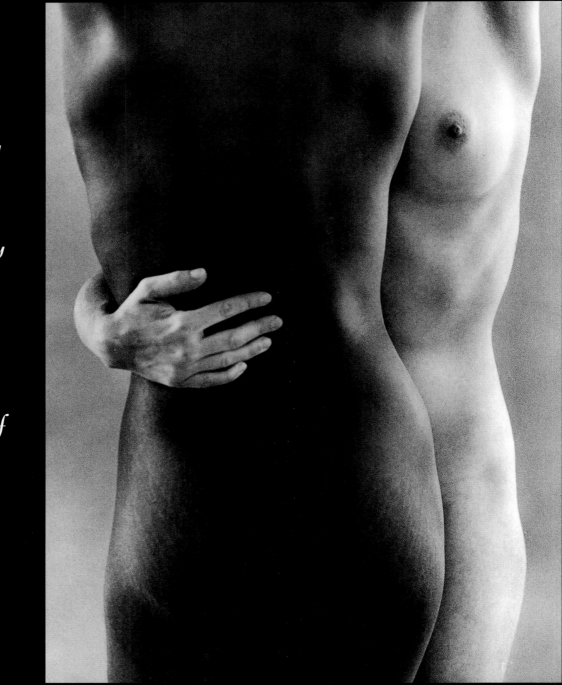

"*I wanted to achieve an ideal harmony and to be emotionally connected through photography with the universal idea of the body as a work of art.*"

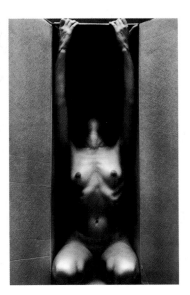

Above: *In the Box (Vertical)*, photograph by Ruth Bernhard, 1962.

Facing page: *Two Forms*, photograph by Ruth Bernhard, 1963. Left: *Two Leaves*, photograph by Ruth Bernhard, 1952.

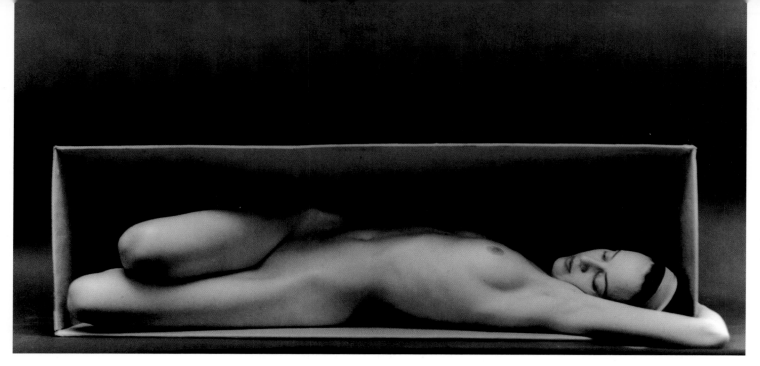

In the Box (Horizontal),
Ruth's most popular
image, photograph by
Ruth Bernhard, 1962.

posing platform with foam so that the model would be comfortable for those endless poses. Behind the platform I designed a semicircular frame on which I fastened two sheets with grommets that allowed the background to stay taut. I then spray-painted the background gray, the tone that Ansel made famous: "Zone V gray."

So, you see, I had a small concave studio that was perfect as a background because it had no corners at all. I then had the idea to cover the ceiling with crumpled aluminum foil stretched out in order to act as a reflector and to approximate daylight above. Even though I have long taught students about lighting in the studio, I remind them that the process of learning to experience light demands more than a few classes. We must wake up each day to a new understanding. Then you can really know that at every hour of every day light is different, as life changes moment to moment.

When I am in the studio, I am a sculptor with light. I want the nudes in my photographs to be like sculptures, an abstraction of the body, of the physical. I see the power of the muscles and bones as well as the beauty of the skin. My nudes are ideals of my own feelings about being a woman, not an expression of erotic power, or a love object. In fact I never photographed anyone with whom I was involved. Instead it was always a way of being beautiful myself. Although I was an ugly duckling as a child, I know what it is like to be a woman. Women are beautiful.

Through my photographs I can create my ideal. I always identify with every woman I photograph and admire the beauty I find. I discover the beautiful shape in some part of her body and intensify it by lighting that part to bring out the physical beauty that is universal. In a sense, I fall in love with the act of photographing. Thus also in my life, I can help others to find the beauty in themselves and in the world around them. I have learned that beauty is within; to be alone with your passionate vision is to lose all sense of time, and for that moment to experience something beyond the physical self.

People always ask me if I have ever photographed the male nude. My only attempt to photograph the male nude was a disappointment to me. In the first place I was never interested in the male body as sculpture largely because of body hair. Many of my female models shaved, or had little hair; otherwise I could not achieve the look of sculpture. The setting for the male nude photograph was a workshop in Sun Valley, Idaho. The group was lively and the atmosphere was free and easy. In a lighthearted moment, one of the participants made a photograph of all the students lined up naked. Such a hilarious moment! In the picture do you notice how the men and women each stood? And no one told them to stand that way! I picked my model from that group. When the whole workshop group posed in the nude, the men standing with their hands on their hips, I saw this well-proportioned chap among the other men and asked him to pose. He was a perfect Romeo.

Unfortunately, the results were not to my liking because the background was too confusing. Because he was very young-looking, I picked a grove of aspens for a setting that seemed appropriate for a kind of wood sprite. He was standing in front of a tree, or almost in the tree, and the sky was too bright so there was too much contrast. He had a suntan, announcing a contemporary look, hardly timeless! Basically, I find that since I can identify with a woman, I am photographing myself. I cannot identify with a man.

I am not content with expressing ordinary life in my photographs. Seeing light is a spiritual experience for me. Certain kinds of light especially affect me. Light has to be luminous, create beauty, and glorify the subject. My photograph *Doorknob* perfectly illustrates this idea. I saw the exciting sprays of light from the glass doorknob in my apartment and noted that it was exactly eleven o'clock. I did not have time that day, so I decided I would do the picture the next. I am

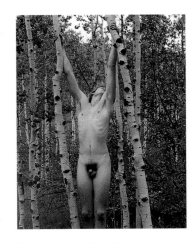

Above: *Romeo*, the only male nude, photograph by Ruth Bernhard, 1970. Left: Workshop students, Center of the Eye, Sun Valley, Idaho, photograph by H. Jay Morris, 1970. Inscribed "For Dynamic Ruth Bernhard in Light and Motion."

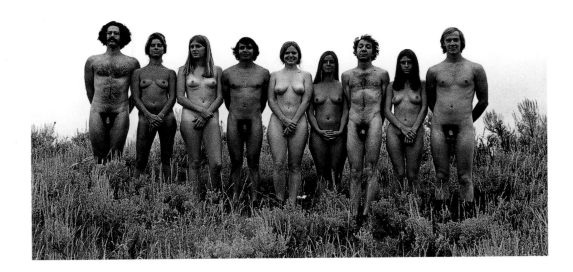

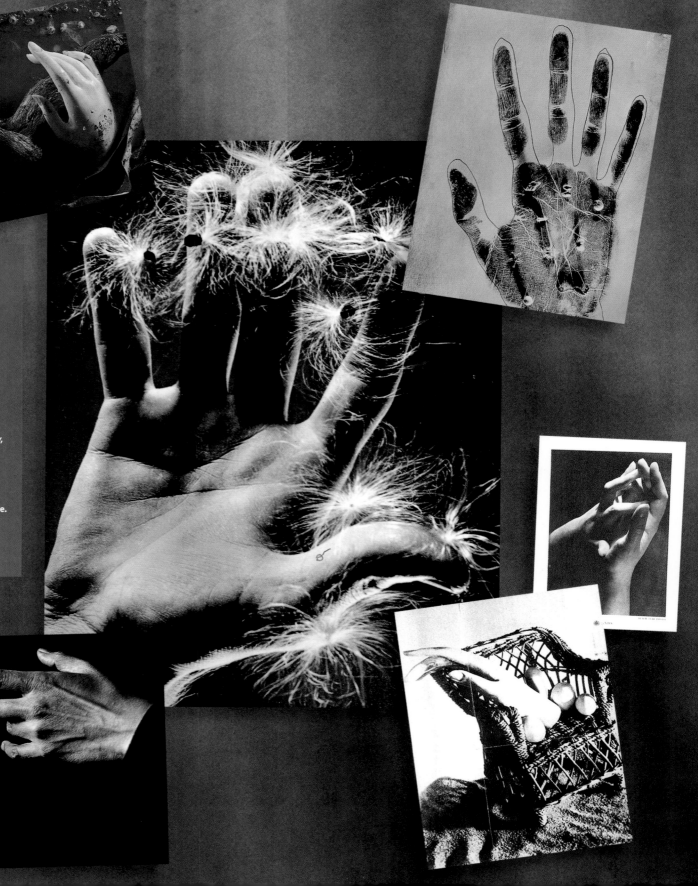

Hands
1937–1946

Ruth uses hands to convey her feelings.

Clockwise from upper left:
Quicksand, 1937; *Milkweed*, 1946;
Palm with Shells, 1945; *Hands,
New York*, 1940; *Society*, 1937; and
Conductor's Hands, 1938. Of *Society*,
Ruth wrote: "Eggs represent repro-
duction, the beginning of life. The
chair represents gregariousness—
family and social life. The hand is
creation—reproduction to continue life.
The little hill of sand is the grave.
It is all as simple as that."

absolutely unable to make a photograph if I have an appointment the same day. My mind must be able to devote full attention to the subject, and here I was with a perfect subject and the light would change before I could do a picture. The following day was overcast, and so was the next. The sun finally shone, but not on the doorknob. Determined, I decided to mark the calendar for one year from the date when I "saw" the photograph, the eleventh of May. A year later I was ready and everything happened as planned. I couldn't have been happier.

In the studio, light has to be created to express what I feel. *Skull and Rosary* is an example of a lighting effect. When visitors see the photo of the cow skull on my wall that I have kept since those farmhand days in Mendam, they always ask me how I made such a mysterious image. I placed the skull on a sheet of that wonderful silvery paper that would come in the box with 8 x 10 film. Above the skull I directed a spotlight toward the forehead. There was no light in the room because I worked at night. Thus, the black background is actually silver paper that has nothing to reflect. With a very long exposure, the silver became black, but the luminous edges of the skull are the reflection of the skull on the silver paper. The rosary beads represent life and death, as do the bones of the skull. That is the paradox, much as the Christian cross and Christ are life and death as one. I have great respect for the brain. The skull provides protection for this most mysterious part of the body.

When I look back on my photographic life I realize that I am not a photographer of color. I am in love with black and white and every shade of gray. There is something abstract about the language of black and white that conveys my feelings best. Had I not become a photographer, I would have been a sculptor. Seeing in three dimensions is natural for me; being patient and observing carefully are natural. Really, the only teacher anyone has is oneself. The camera is just a tool, and the 8 x 10 camera is a great tool because it forces great patience. Lighting can be learned daily, minute by minute. I am sure that the act of looking at grasses as a young child was my first training in seeing.

THE 1970s: CHANGES

The 1970s was a decade of change for me. My father died on May 29, 1972, after an illness. I had been returning to see him every year, and he died in his bed at age eighty-nine. There were major demands on my time with teaching. In one class Dr. Donald Huntsman, a student who was a dentist from southern California, said I should make portfolios of my work. He encouraged me to get going. By the early 1970s I was working on the production of my two portfolios, *The Eternal Body*, which contained ten black-and-white photographs of nudes, and *The Gift of the Commonplace*, containing ten still life and other photographs, also all black and white. It was an overwhelming job. I spent many hours printing in my darkroom adjoining the kitchen and sorting and spotting prints at the kitchen table. I noticed increasingly that I had trouble really thinking. I felt dull, which is not at all like me. I remember saying to the doctor, "I cannot even write a postcard." I even cut the mat boards wrong and had to start again. But I did

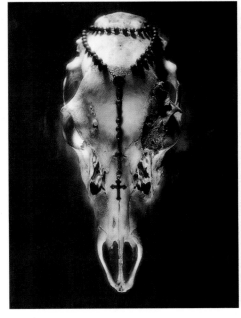

Top: *Skull and Rosary,* photograph by Ruth Bernhard, 1945. Above: *Doorknob,* photograph by Ruth Bernhard, 1975.

Top: *A History of Women Photographers*, New York Public Library (October 8, 1996), photograph by Margaretta K. Mitchell, 1996. Center: Letter from ICP Director, Cornell Capa, 1979. Above: Photographers Ruth Bernhard, Barbara Morgan, and Lotte Jacobi with author Margaretta K. Mitchell (R) and Director of the Museum, Kathy Foley (L), at Northwestern University, photograph by Kitty Reeve, 1981. Facing page: Ruth Bernhard portrait by Margaretta K. Mitchell, 1978.

complete fifteen portfolios of each subject, though I had to hire a darkroom assistant to complete the printing. Wynn Bullock, whom I admired greatly, generously contributed an introduction. All was complete at last.

I wrote a letter to announce the publication and sold a few copies for cost. Both portfolios were limited to editions of fifteen. Published in 1976, they sold for twenty-five hundred dollars each and they sold promptly. It was amazing that I found the energy to complete them, even with some support. As I look back, I realize that I turned to others for assistance because I was really ill, but did not understand why.

Finally my doctor did a blood test. The medical paper reads December 31, 1974, which was while I was visiting my sister in Los Angeles. Doctor Hotchkiss came to the apartment to find me, thinking that I was already dead. My neighbors told him that I was away and gave him the phone number. I was called and told to come to the hospital immediately. Then I had a brain scan. They saw the problem on the brain scan—some sort of spots that showed carbon monoxide poisoning. The doctor asked me if I lived over a garage and eventually, after discussion, realized that the water heater in the kitchen had to be tested. Indeed, it was leaking. Since that day I have been forced to use oxygen daily.

The poisoning from carbon monoxide changed me forever. I think that I was much more quick, much smarter before. I was a very sharp cookie! Since then I have found it very difficult to write letters. In fact, all writing became difficult. By 1976, I had to stop photographing seriously. I could not fully concentrate without enormous effort. At that time I threw out a lot of my 8 x 10 negatives, especially of commercial work. I simply did not think that anyone would ever be interested in them. I did not think that I would ever print them. It was a really depressing time for me.

EXPANDING RECOGNITION

At the same time, the 1970s ushered in a time of more frequent exhibitions. My work was in an early show at Helen Johnston's Focus Gallery in San Francisco, one of the earliest galleries for photography in the country. Having my work on the walls with Ansel Adams in 1975, at the Silver Image Gallery in Seattle, Washington, put my photography in a new context. Ansel was a generous man and helped many younger photographers. He and his wife, Virginia, became friends of mine over the years.

I was not particularly aware of it at the time, but during the 1970s the women's movement drew attention to the contributions of women in the arts. In 1975, the curators Margery Mann and Anne Noggle included me in an exhibition called *Women in Photography, Historical Survey* at the San Francisco Museum of Modern Art, which came at a perfect time in my life. My work found new audiences as women were being appreciated in the museum world, at last.

The book *Recollections: Ten Women of Photography* came along at just the right moment. In 1977, when author Margaretta Mitchell came to interview me for the book, I was teaching and

Above: Ruth visits the home of a tattoo artist with Japanese photographer Takeshi Yuzawa, former student from an Ansel Adams workshop, and her former student, Hisako Ohashi, whom she met while teaching in Logan, Utah; photograph by Mr. Sato, 1985. Top: Ruth pretending to take a picture, posing with her tour group, 1983.

up to the ideal. Somehow it worked, and I am amazed to report that this was the longest relationship of my life. We traveled together to Paris, Venice, London, and Hawaii. My first trip to Japan was with Price. I had always wanted to see Japan, having been introduced to the simplicity of Japanese design even as a young student of art. I especially enjoyed having my work shown in the Min Gallery. Price and I were royally entertained. We loved to travel; however, we never lived together. I knew that at this stage of life and with the intensity of my new focus as a teacher, I could not give up my independence. But when Price had his first back operation, I had a hospital bed set up in my living room. I wanted to care for him.

He was a sweet man. I always felt complimented when he would say, "That was a lovely dinner, let's go home now." We went out two or more times a week. We loved dinner and dancing at the Officers' Club. Sometimes we went to the symphony. Mainly Price loved to cook for me, to give parties at my studio. He loved to have me come to his house. After all, he had a double bed. He called me every night before he went to sleep.

On a plane in 1979, in the crush of people anxious to get off, someone pushed me in such a way that my knee was bruised. Price picked me up at the airport, and by the time we arrived at the apartment, I could not climb the staircase. Price gallantly carried me up to the second-floor entrance hall. This went on for a long time, until later that year when I had to have an operation on my knee. The other knee failed because I had favored it, and in 1980, there I was again in the hospital. I had to learn how to walk all over again. I was proud of the fact that I live up two long flights of steps and managed to conquer it with two steel knees. I also love it when I beep in the electronic sensor at the airport. Today I am amazed that I can still navigate these stairs without giving it a thought.

With each operation, Price arrived at the hospital with food and flowers. What could be more romantic? It was meaningful to me that I had meaning for him. Isn't that what love is all about? Of course, we disagreed on many things. I would ask him about his life. "Have you been

afraid?" "No." "Weren't you afraid when you flew planes in the war?" "No." How very different we were! I loved books; he loved politics. He loved meat. I prefer vegetables. We enjoyed dinner and dancing and shopping, traveling and holding hands. He did so many lovely things for me, but as two older adults, we had our own lives.

Price was a military man, a colonel, a Tuskegee airman, one of the elite black fighter pilots with the famous ninety-ninth fighter squadron that saw combat flight in the Mediterranean during the Second World War. In the air force he had to overcome racism to fly a plane, to drop bombs. In one year he flew sixty-one missions. A peaceful person, he had to take heroic actions that were challenging. After the war he was a test pilot and an assistant professor at Howard University, and later he had a post in Korea. When he retired in 1965, he had been in the military for twenty-three years. I was impressed that he then received a master's degree and joined the United States Customs Service, where he rose to become a deputy assistant regional commissioner. Most of all, he enjoyed friendships with other original Tuskegee airmen. We went to many local and national meetings of this noble group of American heroes. I was honored to be on his arm; we were quite the couple!

In our moments together Price was more aware of skin color than I. At first he protected me from any embarrassment. For example, he would not kiss me on the street. Even though he was younger than I, he thought of me as a sparkler, lighting up his life, and I adored being adored. Love invades life in so many surprising ways and takes command. Being in love keeps you young. You can have a lifelong romance, if it is built on love. The most important word is passion. Price was a passionate man and he loved to tell me so in myriad ways. I gave him the opportunity to express himself. I think that I represented a creative life for him. For so many couples there is little passion in the older years. To have passion you have to make an effort, to pay attention, to be in love with life itself.

I was told once that men and women are like a pair of foreign countries. That is the way it was for Price and me. We did indeed speak different languages and it was an adventure to find common ground. When we met, he was a handsome, dignified black man who was proud of his military service and devoted to his family. He painted portraits of his four daughters. I was an artist, a woman who could be called a lesbian, who had spent her life developing herself and her art and was helping others to do the same. Perhaps you could say that Price was my best student! He was writing poetry and discovering the world of the arts that had been put aside for the years of his demanding careers. For the early part of our thirty-two years Price was expanding his interest in the arts, and I guess you could say that I was his muse. My enduring image of Price in those days was of him sitting on my white couch, a gorgeous black nude, reciting poetry to me. It is a picture I wish I had made.

Later, after Price had operations on his back and other health problems related to his diabetes, he gradually lost some of those lively elements of his personality because he was in such relentless pain. There is no doubt that from then on he needed me more than I needed him. In a

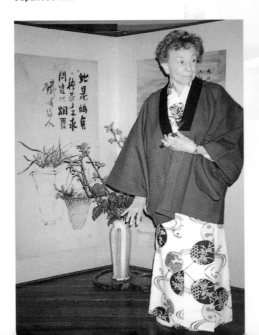

During a 1985 visit, Ruth donned traditional garb for a picture at a Japanese inn.

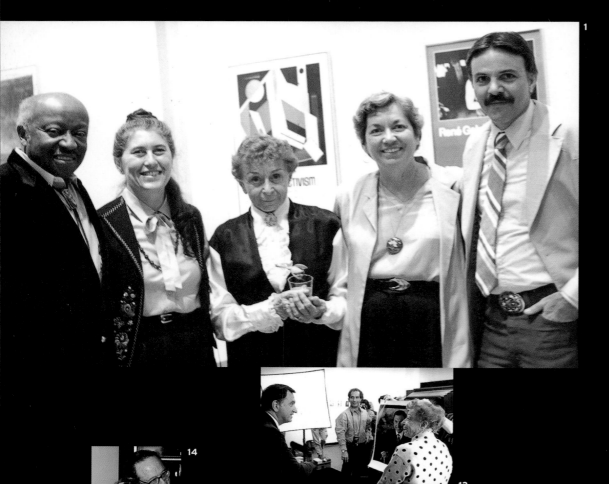

Family & Friends 1991–1999

The public Ruth enjoying friends and family at openings, birthday parties, and workshops.

1. Price Rice, Anita Fein, Ruth, and Virginia and Tom Newton. 2. Ruth with Joe Folberg. 3. Ruth and Ansel Adams. 4. Ruth with Cornell Capa. 5. Ruth with her brothers at the Berlin opening of Lucian Bernhard Retrospective, photograph by Janet Bünger, 1999. 6. Ruth's birthday party, photograph by Robert Burrill. 7. Ruth's 90th birthday party, Vision Gallery, left to right, Frederick and Margaretta K. Mitchell, Ruth, Avery McGinn, and Arlene Diehl, photograph by John Chan, 1995. 8. Ruth with Brett Weston, photograph by Mary Ann Helmholtz. 9. Ruth with Wynn Bullock. 10. Ruth's birthday dinner, left to right, Avery McGinn, George Becker, Margaretta K. Mitchell, Mary Ann Helmholtz, Debra Heimerdinger, Price Rice, Ruth, Doris Folberg, and Jamel Hamilton, October 1997. 11. Ruth with Graham Nash. 12. Ruth with Ernst Hass, photograph by Leonard Delune, 1996. 13. Ruth with Art Agnos. 14. Ruth and Arnold Newman, photograph by Leonard Bryce, 1996. 15. Ruth with Jane Totten and Arnold Wasserman, photograph by Nancy Ericsson, 1999.

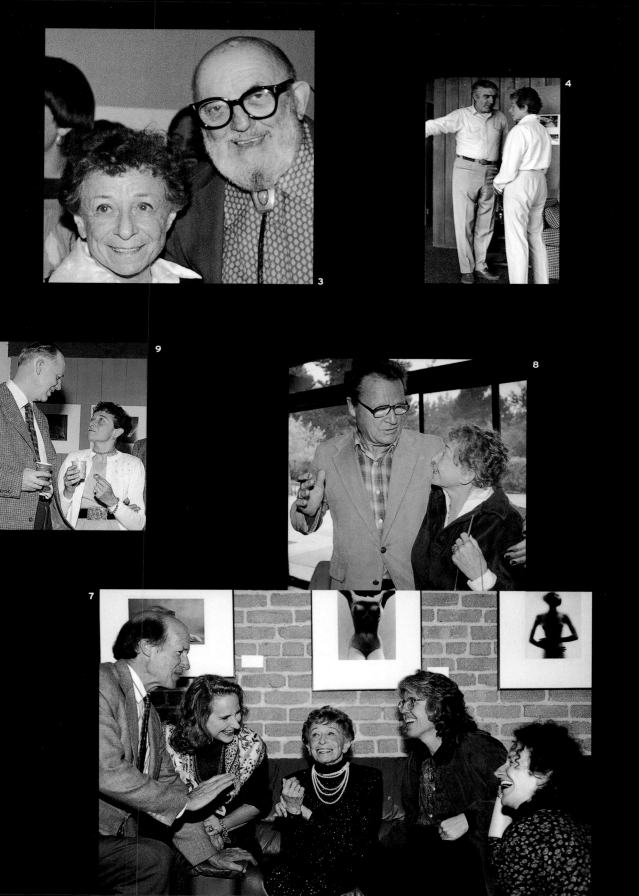

Ruth Bernhard october 14
1905

Andy William
Linda Williams

ルースさん
いろいろありがとうございました
了

Sharon Rawson

Jeff Rawson

Mary ann Helmholz

Mark Wizard

Michael Kenna

Camille Kenna Jean Colvin

Betty & Carl Estersohn

Margaret Mitchell

Sim Warkov

Dave Jushford

D Mitchell

Jane Tother

Nancy A. Brossia

Debra Heimerdinger

Nancy McKinney

Donald Wasserman

Robert Anderson

Helene Fraçce

way, I became his life. It was a terrible responsibility, and I have complained about it, but I never abandoned him, nor he me.

When Price died early in 1999, my youth was buried with him. When you love someone and you are loved, you have youth. Price loved me in an ageless way. Now I cannot help but feel deprived. I cry for myself, not for him. I am old now and perhaps this was the last love of my life. Even if I am reminded of all the love around me, I know that there will not be another who dotes on me as did Price.

Over the last two weeks of his life, I saw him fail. He was recovering from an operation that caused him to lose his foot. It was terrible. I tried to visit every day. I took little things to amuse him. I tried to cheer him up. One day, Price squeezed my hand and said, "I want to make mad love to you." These were the last words he spoke to me while he could still recognize anyone at his bedside. Shortly after, he became unconscious and left this world on February 21, 1999.

MARY ANN HELMHOLTZ

On July 13, 1999, my assistant, Mary Ann Helmholtz, and I celebrated her twenty-second year as my right hand. No, really, she has become my mother. Perhaps I am different with her, close the way a daughter is—and stubborn. She tells me what to do, what to pack for a trip. She puts everything together for exhibitions and runs my business more and more. One day a week Mary Ann comes and takes over my life, making things right and seeing that prints are picked for the next show, letters are written, dealers are happy, checks are deposited, and bills are paid. The rest of the time she works at home. I know that I am a big project for her. She knows that I could not manage without her.

Mary Ann is the neatest person in the world, and I am the most disorganized. How she puts up with me, I'll never know. If there is a God, she arranged for me to have Mary Ann in my life.

I met Mary Ann when she was a student in a workshop. During lunchtime, the other photographers and I were all complaining about the lack of time in our lives. Each of us exclaimed in unison, "What I need is a secretary!" Two days later she called and asked me if I was serious. I was.

Facing page: Ruth's ninety-fourth birthday party at the house of Margaretta K. Mitchell, October 11, 1999. Above, left to right: Ruth with Margaretta K. Mitchell and Mary Ann Helmholtz, 1999. Ruth and Mary Ann in Ruth's apartment. Ruth and Mary Ann with Captain and Mrs. Marshall Bronson at the Compass Rose Bed and Breakfast in Coupeville, Washington, at the time of Ruth's last workshop, 1998.

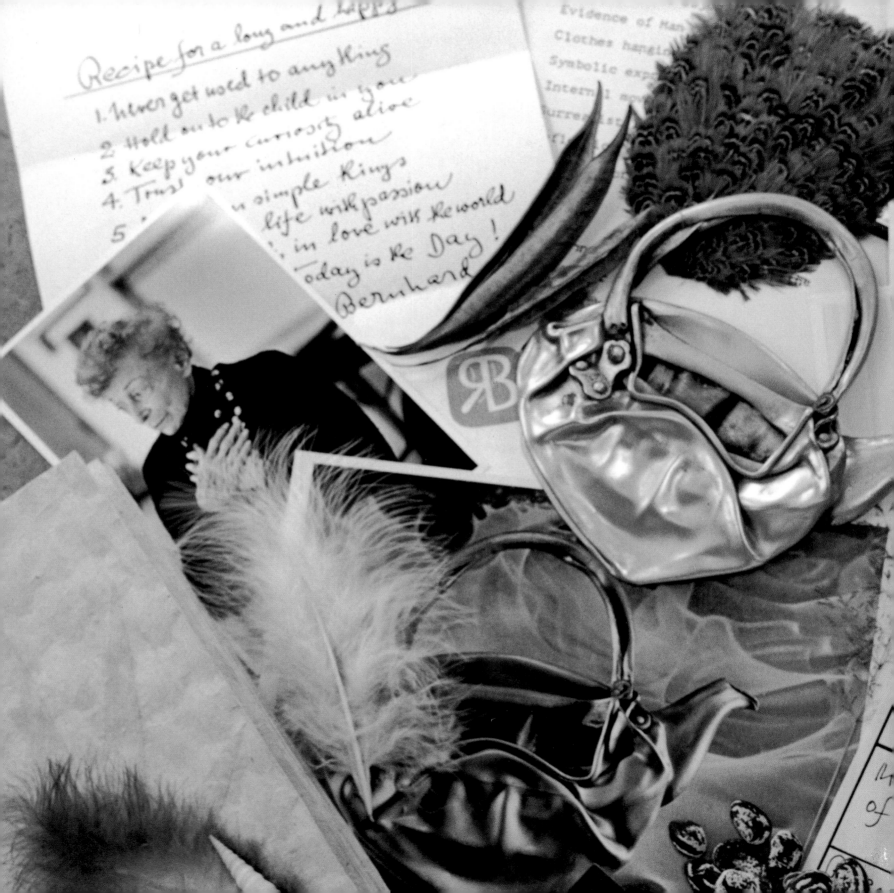

Teaching

teaching

*The art of seeing:
On being a good audience
Concept versus subject
Transforming reality to
personal vision*

> "After giving work-shops and lecturing for more than thirty-five years, I have come to believe that my teaching is more important than my photographs."

MY TEACHING LIFE

AFTER GIVING WORKSHOPS AND LECTURING FOR MORE THAN THIRTY-FIVE YEARS, I have come to believe that my teaching is more important than my photographs. While my photographs can burn up, my teaching is passed on from one person to the next. If I have done anything for my students, I have helped them develop enough to make a contribution of their own. So many young photographers want to do something new and different, when, really, they should be photographing from deep feelings. Looking and feeling are not the same. I always tell my students to photograph what they believe in. If they do, then their photographs will not be separate from their life.

My teaching has been vital for my own life. In some ways I have always been a teacher. Certainly I learned from my two childhood teachers who were great examples for me. I refer to them all the time. I was influenced to use my imagination and to express myself at a very young age. In some ways I prefer to think of myself as a gardener, cultivating the fertile soil, encouraging students to grow. My teaching is really a catalyst to arouse an intensified awareness of creativity in the student. I always aim to help people have clearer vision and thus to live more fully—the basic development of a creative person and a good photographer. We may not verbalize the most important aspects of our lives, but we often can photograph them as equivalents of our feelings.

Thus creative work is born of emotional necessity. It represents the fulfillment of an artist's thoughts and feelings. Art can be communion: speaking from heart to heart. I tell students that the camera is only a tool for the photographer as a brush and canvas are tools for a painter. The artist is successful only if he or she can use the tools at hand to express feelings. Words can convey our ideas about our feelings but never the feelings themselves.

Feeling produces identification with the subject. As a photographer, I try to become the subject of my camera. I "am" a shell, a doll, a leaf. I become the ideal woman my photograph of a female nude represents. I seek harmony. The human body is art. The body is universal. It expresses life. I want to express the connection we have beyond time and beyond the body to all of nature. From that point of view, the body is a very unusual seedpod. It is the past and the future generations. Because the face is personal, I seldom emphasize it. I often remind my students that if the face stands out, the viewer might want to ask for the model's phone number rather than experience the universal beauty of the body.

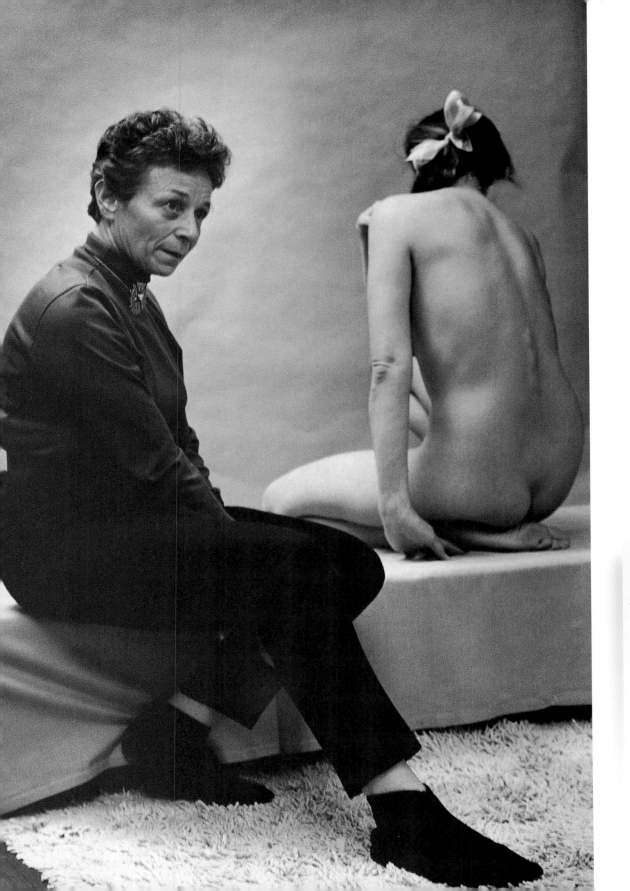

Left: *Ruth with Model in Workshop*, photograph by Pierce Lyon, c. 1959. Above: *Rag*, photograph by Ruth Bernhard, 1971.

JIM HILL, *student, 1976*

ON RUTH: *All I can really do is make photographs and think about you when I do. You are never far from my mind. … You seem to have the right words at the right moment. This is the mark of a truly great teacher—which you are— and a gift that cannot be taught.*

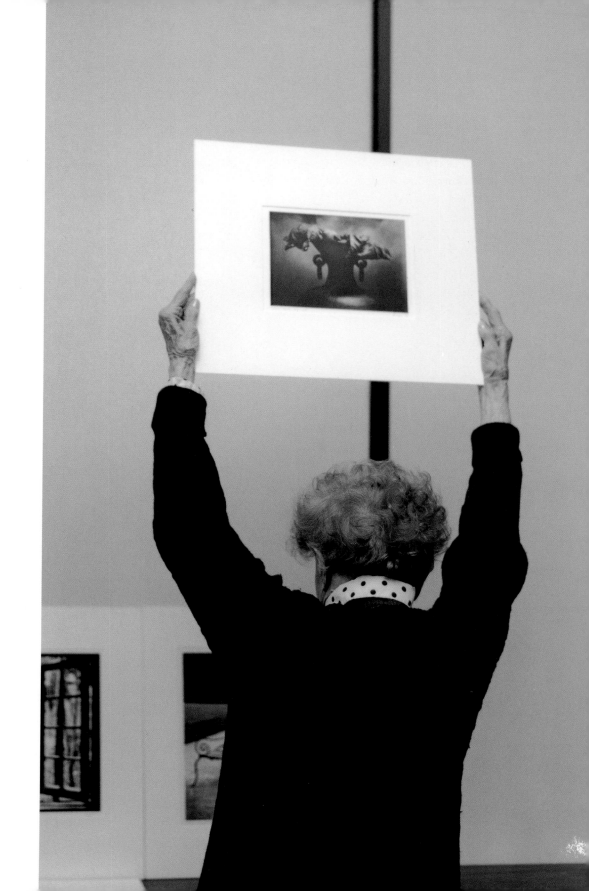

HAL EASTMAN, *student, 1993*

ON RUTH: *Ruth is the catalyst in my metamorphosis from corporate executive to artist-photographer.*

One of Ruth's life lessons, by example, is that you can retain youthful vitality in spite of chronology, wrinkles, and stiff bones, to your very last breath. On a recent trip to Italy, I was overwhelmed by the soft, serene sensuality of Venice and the beautiful play of light visible everywhere. I rushed to send Ruth a postcard, thanking her once again for her influence on my ability to really see, and to have so much more joy in each of life's moments as a result of a heightened awareness of the beauty light provides around me every day, wherever I am.

My teaching life was encouraged initially by the photographer and teacher Minor White. I met Minor in San Francisco in the late 1950s. Our paths crossed because we were both giving classes. We were congenial. He wrote about me in *Aperture,* which he edited. He encouraged me to do workshops. We talked a lot about philosophy. The concept of workshop teaching was new at the time and Minor devoted an entire issue to the subject in the fall 1961 *Aperture* (vol. 9, no. 4). I contributed an essay on my workshops in which I defined my purpose: "By workshops, as distinguished from classes, I mean a group in which there is a free interchange of ideas and work among participants. I do not consider myself a teacher, but rather a catalyst, one whose function it is to arouse in the photographer an intensified awareness of his potential creativity. The emphasis is on feeling and the free expression of one's self. My aim is to help people to clearer vision and thus to live more fully, which is primary to the development of a good photographer."

In my role as teacher, I try to demonstrate for students how I see the world in a photograph. I show them one of my photos and reveal the intuitive process that made the picture live. For example, *Rag* is not just a rag on the clothesline, drying in the sun. It is the whole universe, remembering the cotton field where the fabric originated and the cotton pickers. The shape of the rag becomes a holy shrine, like the crucifix. I want to help people trust their feelings and gain insight and have the courage to work from inside out.

As I began teaching, I found the work of other photographers who expressed themselves in their photography. I saw better and different pictures by my students, and in the 1960s, I conceived the idea of a book emphasizing the camera as a tool of self-exploration. I would include great examples of creative photography to illustrate the volume and include technical notes. This book, which I called *The Eye Beyond,* was never published, but I used the ideas in my workshops.

From the teaching experience I have gained insight into myself. One year at the Friends of Photography workshop one of my students was a Native American, a Hopi. I noticed his photograph of two Native Americans with hands holding onto a barbed-wire fence, looking over it straight into the camera. It was lying among other unmounted photographs on the large coffee table. I burst into tears. My assistant took me outside to recover and when I came back into the room, the student approached me and said, "Thank you for helping me make peace with white people." I turned to the class and told them, "I want to see photographs that make me cry."

My emphasis is on feeling, self-expression, and growth. Photography is the medium, but the person is more important. In my book, I wanted to share the way that a photographer can use the medium for self-expression to keep the joys of innocent imagination that belong to childhood alive in the adult mind. "Insight," I wrote, "has a way of germinating for years, unknown to us, and then forcing itself into our consciousness with sudden movement. One is amazed perhaps by its remarkable clarity and simplicity, exclaiming, 'But, why didn't this come to me before? Why didn't someone tell me?'"

LUCY ASH, *student, 1975*

ON RUTH: *Two unforgettable ideas, namely that it is quite honorable to be an amateur photographer, because "amateur" means "lover," and that to be a photographer, one must practice.*

Facing page: Ruth in University of California Extension Workshop, photograph by Margaretta K. Mitchell, 1997. Above: Ruth and student in Everglades, Palm Beach Workshop, Boca Raton, Florida.

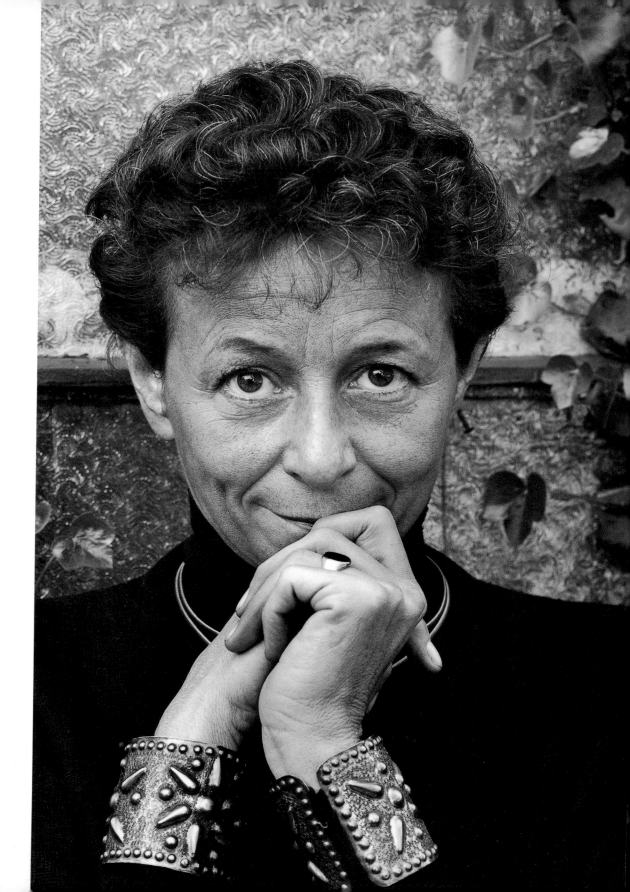

Ruth 1950–1960

Portraits of Ruth during her San Francisco years.

Clockwise from right: Ruth by Larry Colwell, 1953; Ruth, photographer unknown; Ruth with Emmett Smith at San Francisco State University, photographer unknown, 1959; Ruth by Larry Colwell, 1953; Ruth at the beach, photographer unknown; Ruth's only self-portrait, 1960; Ruth at a Mexican festival, photographer unknown.

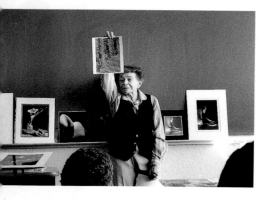

Ruth, Workshop, U. C. Extension, photograph by Margaretta K. Mitchell, 1998.

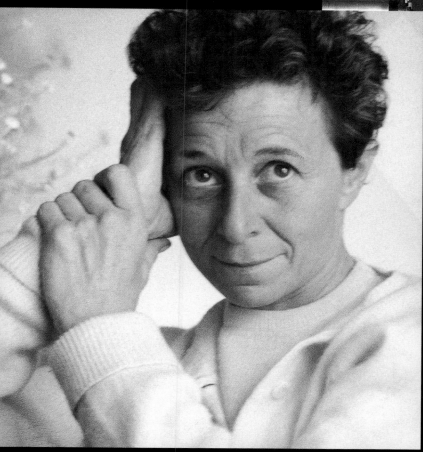
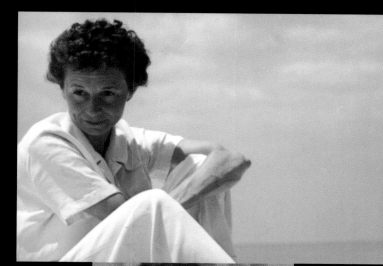

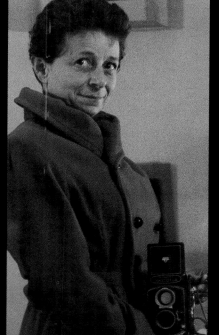

Experience: a huge
kind of spiderweb of
finest silken thread
pended in the chamber of
consciousness catching every
particle in its tissue

ry James

© 1997 ARNOLD NEWMAN

ANDY EADS, *student, 1998*

ON RUTH: *I wanted to let you know just how important your workshop has been to me. Your admonitions to find connections, observe changes, and diligently seek the simplest expression of the whole have had the beneficial effect of expanding my experience of life.*

This blessing has doubled as I've shared this way of seeing with others, especially my daughter, who has joined me on walks. As we go along, I apply the lessons you taught. My constant delight has been to see my daughter make her own discoveries and sharpen her vision. Many times we make a photograph to express the discovery; sometimes it is enough just to enjoy the moment.

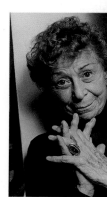

© 1997 ARNOLD NEWMAN

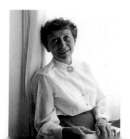

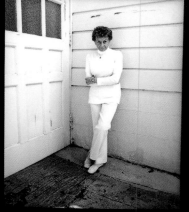
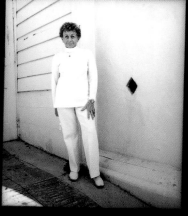

Miscellaneous pictures of Ruth.
Facing page, clockwise from upper
left: photographer and date unknown;
photograph by Abe Fieginder, 1988;
photograph by Alex Bernhard, 1995;
photograph by Arnold Newman, 1997;
photograph by Miriam Young, 1955;
photograph by Mark Tuschman;
photograph by Arnold Newman, 1997.

Clockwise from upper left:
photographs by J. D. Mercer;
photograph by Kurt Fishback, 1981;
photograph by Gary Buehlman, 1993;
photograph by Roger Newbold, 1986.

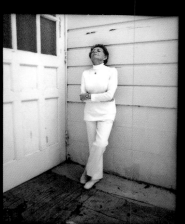
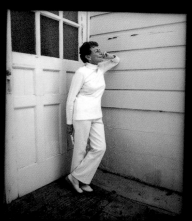

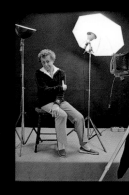

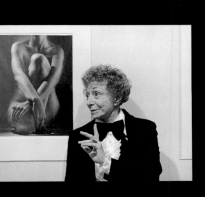

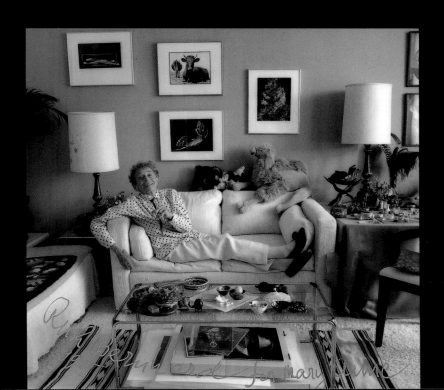

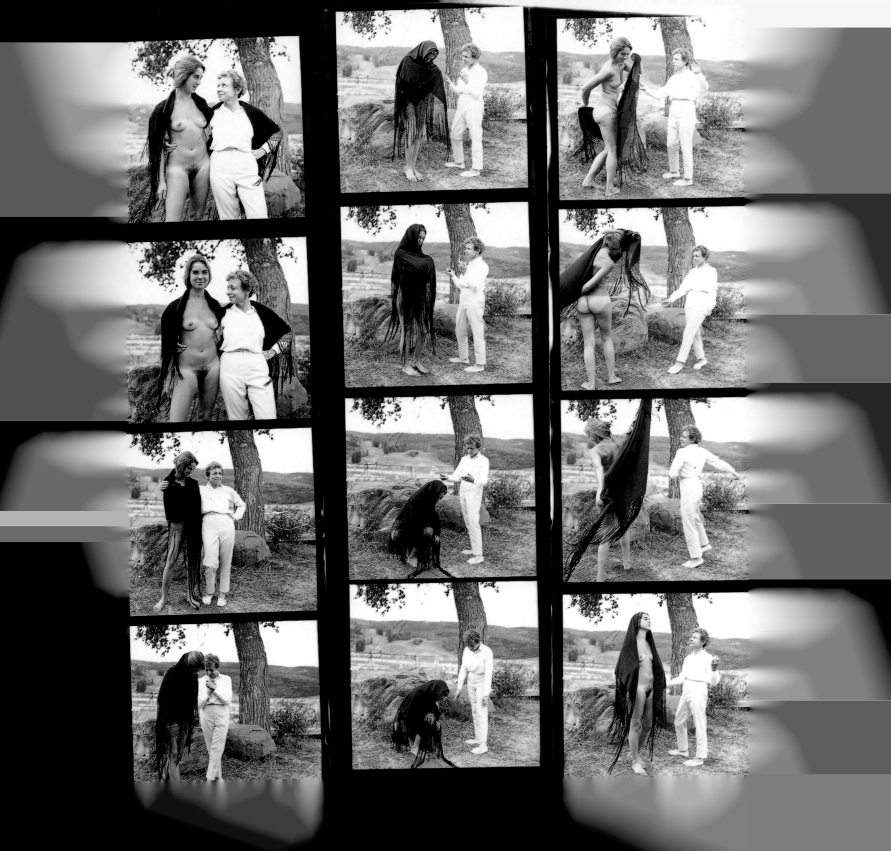

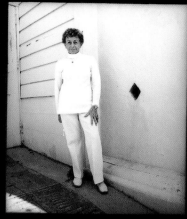
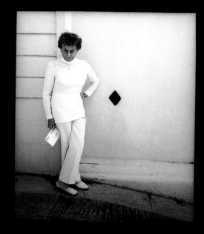

Miscellaneous pictures of Ruth.
Facing page, clockwise from upper
left: photographer and date unknown;
photograph by Abe Fieginder, 1988;
photograph by Alex Bernhard, 1995;
photograph by Arnold Newman, 1997;
photograph by Miriam Young, 1955;
photograph by Mark Tuschman;
photograph by Arnold Newman, 1997.

Clockwise from upper left:
photographs by J. D. Mercer;
photograph by Kurt Fishback, 1981;
photograph by Gary Buehlman, 1993;
photograph by Roger Newbold, 1986.

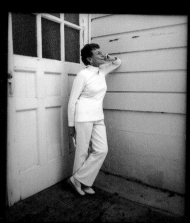
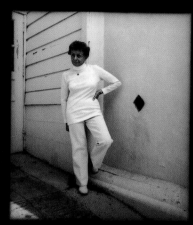

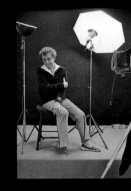

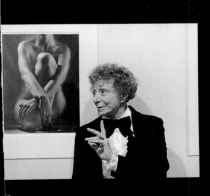

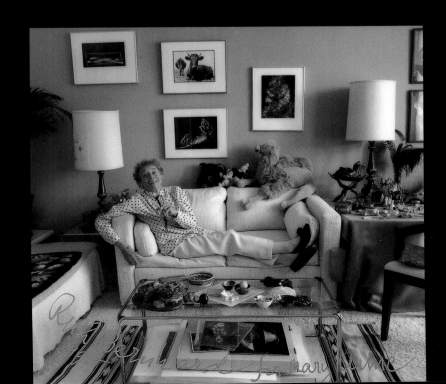

We call the spark that strengthens and spurs creativity joie de vivre. This means that we approach life without reservation and bring to it our highest, most intense, and passionate capacities to anticipate, to appreciate, and to love. We begin with curiosity and compassion. We must be single-minded in the cultivation of intuition and insight. Art, like life, is an event, and its individual maturation is alien to the formula, the cliché, the stereotype. The search for the medium through which to express our talent is often confusing and indeed agonizing. It is a poet's path to distill emotion; the photographer finds the subject that arouses feeling. We discover the world again each time we fall in love without fear and see the subject for ourselves. We become absorbed in the subject and we become the medium of its expression. Thus, an expressive photograph is made.

I like to compare the poetic photograph to haiku, the Japanese poetry that is the quintessence of a word picture. Haiku, with its seventeen syllables, has great freedom, as has photography, with its technical restrictions of camera, film, and time. Both capture the ephemeral moment, implying the past and the future in that moment. Greatness in both haiku and photography is marked by expressive intensity, intuitive vision, and simplicity of form. My photographs have the same basic intentions.

workshop

THIS WORKSHOP WITH RUTH *is based on her last workshop, held at the Coupeville Art Center in Coupeville, Washington, with additional material from the workshops with John Sexton and earlier workshops held at UC Extension and in her studio. Before a workshop, Ruth usually asks students to write an essay describing the place of photography in their lives. She also requests that they bring several examples of work: photographs they like and others about which they feel insecure.*

THE TREASURE BOX

The students sit expectantly facing Ruth as she bends over a candle she has placed on the large table at the front of the room. "Light makes the subject available to us," she says. "All of a sudden, it becomes important." While Ruth perches on a high stool next to the table, the candlelight flickers. Her eyes meet those of the students as she asks what motivates each of them to photograph. "We are all students," she tells them. "And it is the responsibility of each of you to seek self-knowledge, to know your own vision and what you feel. You must know yourself so well that you remain faithful at all times to yourself. To your own handwriting. Your style. At the same time, you must be faithful to what you see. Only what you see. Nothing is ordinary. You must wake up with your eyes open and see that everything changes all the time. Getting used to anything is fatal for an artist.

"The camera is deceivingly simple," she continues from her perch. Then shifting her focus and taking her students by surprise, she asks, "What does this landscape mean to you? In what

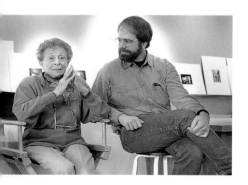

Above: An example of the workshop materials Ruth provides for her students. Below: Ruth Bernhard and John Sexton leading a workshop session in Carmel, California; photograph by Lloyd Lenmerman, 1995.

Expectation:
Greater awareness—
See as a child—as if for the first time.
Develop neglected senses.
Seeing depends on the state of mind. We see what we expect to see. We are culturally influenced.

Discover your motivation from the inside out!

128

Left to right: Workshop Group portraits. Coupeville Arts Center, Coupeville, Washington. Ansel Adams Workshops at Friends of Photography, 1991. Coupeville Arts Center, Coupeville, Washington; photograph by Judy Lynn, 1998. Ansel Adams Workshop, Carmel, California; photograph by Sam Hay, 1983.

way are you connected? In what ways is death connected to the landscape? All the life that has been there before: our bones, our ancestors, the animals. Our life is in the earth: every tree and every animal. This is the universal order. Nothing is only what it is in the moment; it is always in the process of change. The next time you go into the mountain landscape, you will think deeper. The more deeply you are affected, the more your photograph will express. I do not know how, but I do know that the picture shows what the photographer is thinking. It seems magical. So you see, to be a photographer is not all simple.

"A photograph finds you; you do not look for a photograph. Your knowledge of yourself tells you, 'Ah, that's my thing. I am here for you.' It is your handwriting, your place, not another's place. We make a photograph; we do not 'shoot' it. Use words with an awareness of their meaning and you will make better photographs because you are cultivating a more beautiful garden of thoughts.

"Knowing this, how can we become better photographers?" Ruth asks. Then she answers her own question: "By examining our own lives, other photographers' lives, other artists in painting, dance, sculpture, etcetera. Build an awareness around you every day. When you go home, approach the door as if you had just come from Mars. See afresh. Walk along the street. Are the leaves on the sidewalk a nuisance to sweep up or messages from nature?

"When I look at a linen shirt, I see so much more than the way the light reveals folds as it hangs on the hook. I see the soil, the seeds, the plant the cloth came from, the design, the loom that wove it, the rain that fell on the ground. Nothing is ordinary. Never take anything for granted. We have to notice everything; do not get used to anything. Our hair and our nails grow a little overnight. How do I express the awe I feel when I stand before a rock? How do I reveal the force that cracked it?"

The room is quiet, the students all facing Ruth, their eyes intently on the tiny figure perched

RUTH BERNHARD MASTER CLASS

FOR DISCUSSION

The secret of looking
Revealing mysteries of light
Art of observation
Transforming reality into personal image
Concept versus subject

Qualities to cultivate
Centering on intuition
Thinking in cosmic terms
The Commonplace world of mystery
Inside and outside

Pure seeing
Simplifying
On being a good audience
Meaning of craft
Light as experience

Negative viewing
Photographic assignments
Written assignments
Landscape
People pictures

Social commentary
Organic compositions
The single image

PHO-CABULARY
EXPOSE — to lay bare, to reveal
FOCUS — to concentrate, to sharpen
ILLUMINATE — to enlighten
INFINITY — eternal, boundless
VIEWPOINT — both physical and philosophical
IMAGE — imagination, illusion, symbol, representation
All are important beyond the craft of photography.

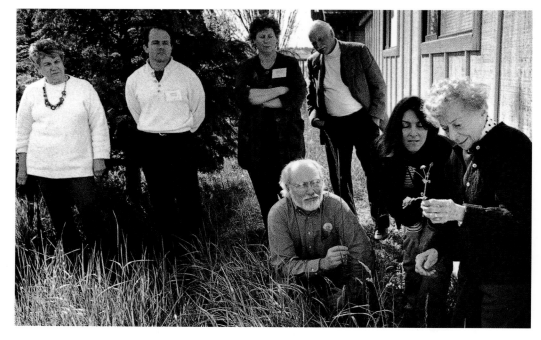

GARY J. MELLINGER,
student, 1998

ON RUTH: *Ruth ignited a flame within me to diligently explore, experiment, and develop confidence to see things in ways others have overlooked. This was reinforced in class, when Ruth removed a small royal blue velvet bag from her portfolio case. After loosening the drawstring, she removed from the bag—ever so gingerly, almost reverentially—a small metal object, which slowly revealed itself to be a miniscule teapot. Ruth explained that while walking in San Francisco's Chinatown, she had found her "little treasure" while crossing the street. This smallest of teapots had been completely crushed by traffic. Ruth plucked it from the pavement, carrying it off to her apartment for future study. This became the photograph* Teapot.

While looking now, I actually SEE.

on the stool. They watch as she opens a box she has brought with her and removes a necklace of beans, which she places around her neck. "These are my diamonds," she announces. "These beans are symbolic. They are life, like us."

Fingering each bean, Ruth continues to speak, her voice quiet and full. "It is important to practice. Give yourself an assignment, perhaps a still life, and give it a lot of time. In the daylight, in your kitchen, with a pile of beautiful vegetables and pots that you love. Watch the light, try the exposures, and try again. In my early attempts at photography, I found treasures at the five-and-dime store and made photographs with Lifesavers, dressmakers' pins, straws, and even an egg cutter. I gave them my undivided attention. I made one exposure in one night. It is not intense enough to take a lot of exposures and choose later.

"When I arrange a still life, I often work late into the night because I can work without anyone over my shoulder. I am a collector of seeds and rocks and all the marvels of nature. Eventually they call me to make a photograph."

Ruth reaches into her treasure box again. This time a sheet of white paper emerges. Upon it is written, "Today is the day!" in big bold type. "What happens to you today will affect the way you see for the rest of your life," she tells the class.

The eyes of the students are fixed on Ruth. They do not want to miss the smallest of her gestures. They know it will be important. "Here is another present I brought for you," she announces, as she reaches for a pile of cardboard rolls—cardboard toilet-paper rolls covered with pretty contact paper. "These are insured by Lloyds of London! By looking through the circle of

the tube, you can develop a single selective eye! Ask yourself all the time: What does light reveal to me? What subject do I like? Be specific.

"It is through your eye that a photograph comes about. Everyone asks me about the teapot. It illustrates the idea that a photograph can be more than it is. The teapot was lying in the street. It had been smashed by a car. I saw it and it screamed, 'Ruth Bernhard,' demanding that I take it home. I hung it on a nail and I enjoyed it for a long time—maybe a year. One day it said, 'Today is the day.' I put my hand on a poster of an electronic water drop I had bought at the Exploratorium a few months earlier. Together they said something. Such an experience is a gift of the gods. If I follow my intuition, I have no regrets."

Again Ruth reaches into the treasure box. This time she extracts a bowl of many-colored beans, which she passes to the students, urging each one to select his or her own bean and keep it, moving it into a new pocket every day. "This is serious," she tells them emphatically. "There is only one bean like it. It reminds you of life, this little bean. If it is planted and nourished, it will grow. The bean represents the potential of life. Each of you has the potential to grow and live more fully. Today is the day! This is the only day there is. Maybe what happens today will affect the way you see for the rest of your life!"

Again, Ruth reaches into her treasure box, this time revealing to the class a carton of boiled eggs. Taking one egg from the carton, she holds it delicately in her hand. "This is the most perfect form in nature. There are no two alike. Pay attention and pick out your favorite. Notice that there is a subtle difference between eggs. Most people think they look alike. They do not. Absolutely not! The egg is symbolic of new life."

Now she holds up a pinecone. "How would you represent this?" she asks. "As a seed holder? As a symbolic tree? As a future forest? Have great respect for such an object. It is purposeful, one of a kind, and it reminds me how complicated life can be.

"And now, look at this feather," Ruth invites the class, waving a feather before her face. "A feather is a masterpiece. Look at it closely and see for yourself the ingenious design of the parts of each feather, the quill and feathers of different weights which make it possible for the bird to fly. You can notice that there is a difference in the way feathers are arranged on birds that do not fly. The process of close observation will change your life and your photographs. Perhaps you will do what I do and start a collection of feathers. Mine are kept in a beautiful book that I bring to workshops."

LIGHT

After a break for snacks and leg stretching, Ruth is ready to talk to the class about light. "The magic of light has always excited me. One of my earliest pastimes was watching the changing shapes of shadows, observing the way light reveals and conceals. As a young photographer, I discovered the advantage of studio lighting and loved it. I could make light work for me. Time did not matter. I could spend days and nights on one assignment. After all these years, it is still the quality, the mood, the radiance of light that motivates me to work passionately.

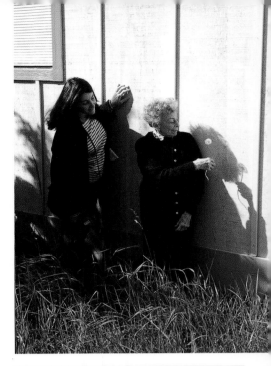

Facing page: Light Walk with Students at Coupeville Arts Center, Coupeville, Washington, photograph by Margaretta K. Mitchell, 1998. Top: Light Walk at Coupeville Arts Center, photograph by Andrew Eades, 1998. Above: *Teapot*, photograph by Ruth Bernhard, 1976.

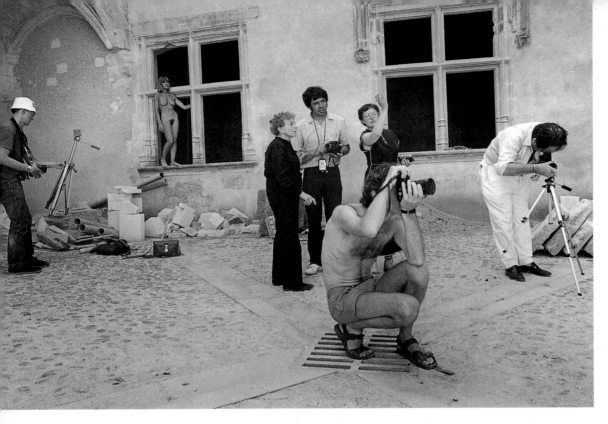

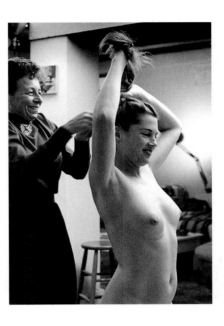

Facing page: Ruth and model at a workshop. Above: Ruth teaching at the Recontres Internationales de la Photographie, Arles, France, photograph by Jean-luc Deru, 1983.

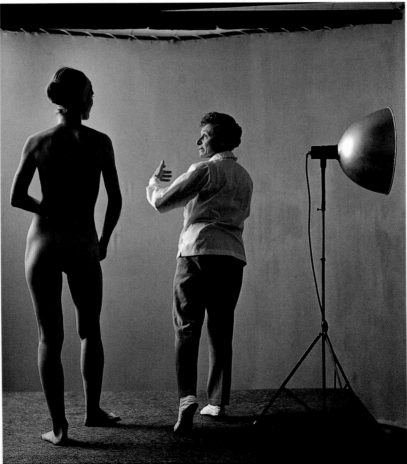

Above: Ruth and model in her Sacramento Street studio, photograph by Pierce Lyon, c. 1959. Left: Ruth and model in her Clay Street studio, photograph by Joan Murray, 1970.

Almost like an obsession." No longer on her stool, she stands before a window and explains, "Lighting technique is very simple. Slow film and long exposures help. You can use small mirrors to reflect small spots, as for example in *Two Leaves*, where I used one light and two mirrors. You can make a reflector out of foil on a piece of cardboard. If it is too bright, some Ajax dusted on parts of it will cut the brilliant reflection. Most important is to be daring and inventive and to use what you have on hand so that you avoid developing a formula that will make your pictures boring."

Now Ruth walks toward the partially open door of the classroom and stops, one hand on the knob. In her other hand she carries a book. The class quickly gathers round her and quiets down. All the while, Ruth remains silent, looking at each student in turn. Slowly, directly, she meets their gazes, waiting. She sways, supporting herself on the doorknob. The door moves slightly, the hinge creaks. A student breaks the silence and asks about one of her nude images. Ruth brings her fingertips to her lips, her eyes sparkling. More time passes. The door hinge creaks again. Finally, Ruth speaks. "Do you see it? Do you see what is happening?"

"The light," one student responds. "You're changing the position of the door and it's changing the lighting on you, on us, on everything, as you let in a little more or a little less light."

"Exactly!" Then Ruth smiles and stops speaking, as she sways, opening the door ever so slightly more. The effect is dramatic. The sunlight strikes a side wall, then illuminates Ruth's face and hair in a soft, warm glow. The students watch intently. The hinge creaks, the door closes a fraction of an inch. The reflected light retreats from Ruth's face as the direct light retreats from the side wall. "I can see the light change on each of you. And I can feel the light. If you watch long enough, you may be able to feel it too."

Ruth walks outside and the class follows, gathering around her as she hovers near the door. In direct sunlight now, the folds of her clothing and lines in her skin stand out in the harsh light. She watches the students again; her hands, which carry a large book, are clasped in front of her. She moves the book slightly. This time the response from the class is immediate. "Whoa! Look at what the light from the book is doing to your face!" She tips the book down and the reflected light disappears from her face, the harsh light returning. She tips the book up again, and once more the reflected light from the book softens the lines on her skin and the folds in her clothing.

"Contrary to what the lighting equipment manufacturers would have you believe, you don't need a lot of equipment to light a subject. Just your eyes, a little knowledge, and some imagination. Little cards and shaving mirrors make great reflectors for lighting small subjects, and as you can see, an ordinary book can have a great impact on even fairly large subjects." Now she smiles and beckons her students to follow her.

She walks a few paces, then stops. "Turn around. Do you see how the sunlight is bouncing off the glass window and lighting the ivy on the small berm we just passed? Do you see how the light from Faye's red blouse is reflected into Mike's face, giving it both light and color? You need

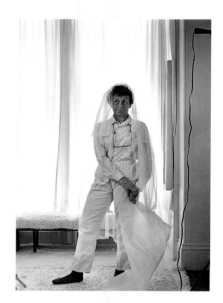

Ruth in her living room, photograph by Miriam Young. Facing page: Ruth posing the model in teaching session by Elizabeth Van der Mark.

to always keep her next to you, Mike, if you want to look lovely like this." Mike smiles. And Ruth continues. "Do you see how Mike's black shirt soaks up the light, reflecting nothing back into that side of Faye's face? Faye, move forward one inch. Now do you all see how the light from Roma's blouse, she's standing next to Mike, strikes Faye and brightens her face?"

For the next hour and a half the students trail after Ruth as she bounces over the grounds, pointing out an acorn here, a reflection there. She suddenly exclaims, "Now, this is beautiful light!" She holds out her hand. "You always have your model with you. Just hold out your hand and look at it if you want to see the light." She swings her arm forward. "Oh my, too harsh here." Her arm swings back, and she takes a few steps. "Here. This is the place. This is where you want Faye to take her clothing off." Ruth beams and giggles, and the class laughs as they move on, all eyes watching the light.

PORTRAITS

The next morning, Ruth talks about portraiture. "Portrait photography will always be difficult because, unlike the painter who can learn about his subject in many sittings, the photographer must accomplish the expression of the sitter's character during a split second. The portrait painter can present on a single canvas the total personality by synthesizing many fleeting moments of expression. The camera makes it possible for the photographer, working with fractions of seconds, to capture each small facial expression. What expression will reveal the whole person? How does the sensitive portrait photographer step aside to allow the subject to speak? Beyond techniques of exposure and focus lies the challenge of developing a sensitivity for looking into a person's face. It is our inability to see ourselves, to know who we are and how we really look, that makes the study of portraiture so fascinating. A portrait is more than a personal revelation, it is a historical and sociological document speaking to us across time, showing us the passing of generations and styles. At the same time the portrait is immutable, poised between past and future."

THE NUDE

In another session Ruth speaks about the nude as a subject. "Our bodies express our feelings through gesture. In my work with the nude figure and from my interest in dance, I have discovered the extraordinary way that the body reveals emotion. The face is individual humanity speaking; the body expresses the universe. A perfect body rarely exists. But the perfection of proportion in the body has to be discovered, organized, and expressed. The nude body is an arrangement like a still life. Imagine a sculptor working on a figure that is meant to be seen on a tall pedestal at eye level. The figure must have good proportions from that perspective. In other words, it makes a difference what point of view you take with the camera. There is no recipe for the perfect nude. If the model wants to work with you, that is enough to begin to make a beautiful photograph. Most pictures of naked bodies are not satisfying because they are full of lust.

CHRISTINE BURGOYNE, *student, 1998*

ON RUTH: *I registered a year before April 1998 for the Ruth Bernhard Class in Coupeville, to assure a seat in the class with this major photographic legend! I attended to be in the presence of an icon.*

During the workshop, I felt slighted by some of Ruth's criticism of what I was doing. How small and smug of me! We can all learn and grow if we just open up and do it! I thought I had been listening to what Ruth had to say, but when my assignment was criticized, I realized I had not really listened, I had not heard her intention. Alexander Pope said, "Some people never learn anything, for this reason, because they understand everything too soon." Step away from your ego and open up to the possibilities! Thank you, Ruth!

135

A break during a workshop on the nude, photograph by Jean Kitmin.

SUE THORSON, *student, 1998*

ON RUTH: *The workshop was Easter weekend, 1998. What better way to celebrate Easter than to be with someone like Ruth who fully loves and appreciates life and who finds beauty everywhere and in unexpected places?*

What Ruth taught was so much more than photography; it was about life and its beauty and the wonderful treasures that surround us, which are everywhere, waiting for us to see them.

The model is unhappy and you can see that she is not pleased with who is looking. What I call an 'innocent picture' is the result of the natural attitude that we humans did not come into the world fully dressed.

"What are the elements that make the photograph successful as a poetic means of transmuting feelings into a visible image? The subject itself indicates the artist's intention. As in music, the continuity of tones is important: the way the gray scale is played, its contrasts and harmonies have an effect on our feelings. Then there must be rhythm. The direction of the forms suggests movement, which gives us a sense of time. Visible tension may indicate inner conflicts or the mood may convey serenity.

"Realism is not realism. It is your point of view. Your feelings add you to the picture. People usually try to do too much in one picture. No one can give you the answer. You have to fall in love with your own reality.

"Ask yourself: What is it that I want to photograph? What do I collect? At the moment that I press the shutter, is it the only picture in the world?"

THE LAST AFTERNOON

The last afternoon of the workshop, Ruth asks the students what they have brought from home. They present their objects to her one by one, and then she asks them to write about their relationship to their treasure. "What is its origin? Express its connection to nature, to the universal order. Think beyond your relationship to the treasure and be surprised to discover it as something that has a history and a life of its own. In this very room there are forces that we cannot touch and vibrations that are always changing. Allow the mystery to be part of your awareness every day."

After giving the class an assignment to photograph not more than ten feet from their bed, she shows them a photograph of an old woman sitting in a chair by a window. "Study this photograph," she tells the class, "and then write about this woman." She allows the students at least an hour to write. Some write five lines, some five pages. Each sees a different picture. After all the students have read what they have written, Ruth tells them, "The lesson here is to discover how much we do not notice when we observe something. We have to learn to see with more than our eyes. We have to include the invisible in our discussion of seeing. If you do not see the roots, you have not seen the tree.

"What the human eye sees is an illusion of what is real. The black-and-white image transforms illusions into another reality. What actually exists, we may never know. But we can express our awe of the mystery of life in our photography and perhaps bring ourselves a little closer to understanding our relationship to the universe. This way we share and communicate and fulfill a deep human need."

It is time to leave, and as the students begin packing their treasures and reassembling their portfolios, Ruth talks to them. "Two experiences touch every human being ever born. One is the

DANE MEYER,
student, 1991

ON RUTH: *I am different now. Lacking is the tension that used to rob me of my free spirit when doing photos for clients. I value myself more.*

Left: Ruth and model during teaching session. Above: Ruth with students during a teaching session, photograph by Pierce Lyon, c. 1959.

awareness of one's own body. The other is the earth and where we live. Physically, we never lose our relationship to the earth. Primitive people are more attuned to their physical roots than those of us who are born into complex industrial cultures. Yet I cannot imagine anyone who has not felt the urge to touch the ground with his feet, to feel the sand at the ocean's edge between his toes, and to seek his place in the native order of space."

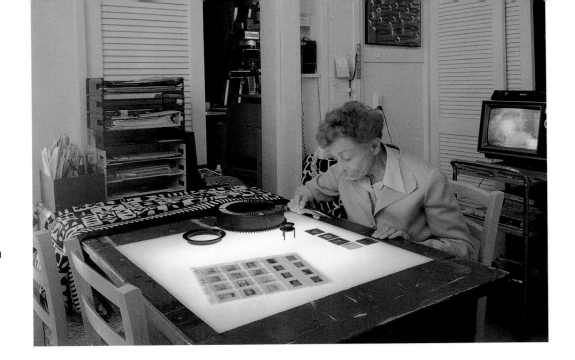

voices

From the many people in Ruth's life, *here is a selection of voices to complete this dialogue between art and life.*

TOM BAIRD

Ruth was instrumental in my becoming a serious photographer. When I came to Berkeley in 1962, I was interested in photography and wanted to photograph the nude. Wynn Bullock suggested I study with Ruth Bernhard. Classes met every week in Ruth's living room. Most of all she taught "light" and made us "see." She had lights and reflectors arranged around a raised platform with a backdrop. During part of the evening, students worked in pairs, one adjusting the lights, the other photographing. Ruth might set the pose with the model. Everything was reflectors. She would have students start with one light and get that right, turn it off and use the second light. Then we would combine the two. Everyone shared ideas. As a result of all this we made very few photographs in the class itself. When I eventually coordinated the photography program at the University of California Extension program, I asked her to teach a workshop, Seeing and Awareness, in 1967. It was a big success. From that time, until I left in 1974 to become chairman of the photography program at the Maryland Institute in Baltimore, Ruth and I worked together, becoming partners in teaching. We were close friends, spending time together, photographing, and touring galleries. I also assisted in the studio. During the late sixties her little dachshund, Schnu-Schnu, died. She was terribly sad, insisting that she could never have another dog. A few weeks later I arrived

with a little eight-week-old dog under my coat. When the dog peeked out and looked at Ruth, I laughed and she cried, melting into a tearful welcome for Cilly, as Ruth named her.

Ruth taught me by her example how to concentrate and really examine things in the world. On a trip to Point Lobos near Carmel I recall vividly that she staked out a spot twenty by twenty feet and she stayed there the entire day. When we left, she took away many little shells and stones and objects from the beach that made their way onto her display tables and even perhaps into a photo or two.

Ruth's energy amazed me. Once, after a day with students, we went out for dinner and then she presented an evening's lecture to a full house. Afterward, she heard a band playing and wanted to go dancing!

CAMILLE SOLYAGUA

At the Academy of Art College where I was studying photography, a notice appeared of an upcoming photography contest. Ruth Bernhard and Michael Kenna were to be two of the judges. I was already familiar with the work of Michael Kenna and wanted to meet him, so I entered the contest and put a note to him on the back of one of my photographs. Michael didn't notice my message, but Ruth did—she never misses anything!—and called his attention to it. Only two years later Michael and I were married, and it was Ruth who brought us together!

Soon after the contest I began retouching prints for Michael. One day he gave me some prints from another photographer. I was completely shocked when he uncovered a 16 x 20 print of *In the Box/Horizontal*. It was by Ruth. This was my good-luck charm that inspired me to move to San Francisco and study photography. I immediately phoned and was invited to tea.

Ruth has become my most cherished teacher and has opened my eyes and heart to the most beautiful things: the way sunlight casts shadows or a tree has decided to grow; the remarkable ways insects communicate; or the way seashells form. She, more than anyone I have ever known, observes and appreciates life's minutiae.

JACK W. WELPOTT

I came to San Francisco from Indiana in 1959 to take a teaching job at what was then San Francisco State College. One evening I was taken to Ansel Adams' place on Twenty-fourth Street. My recollection is that Ansel was there, as was Ruth, also Don Worth, Philip Hyde, Don Ross, and Gerry Sharpe. I was made to feel somewhat like an outsider by Ansel and his crew. Ruth, however, was very warm. I think I was suspect because I was from Indiana. Did they have photographers in Indiana? It was an interesting evening with the usual cocktails that Ansel supplied. We traded jibs and jabs, and when I left, Ruth invited me to come over for tea. I felt that she was the welcome wagon, the only one in town. I, of course, took tea with her and so began a friendship that has lasted to this day. She had something to do with organizing a show for MOMA and she graciously included one or two photographs of mine. I took it as a great

"I affectionately call Ruth my 'photography mother.' She has taught me that giving is the highest expression of receiving."

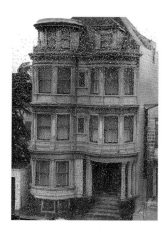

honor and was very grateful to her. In the ensuing years she would invite me to go on field trips with her and some students, which I always did. I was much taken with her lust for life. She showed me what it meant to be alive. We always made the trips to Carmel down Highway 1 so that we could make stops along the way and commune with nature.

One day I called Ruth and asked her if she would like to go shooting on the weekend. She admonished me that we should never use the word "shoot." We should go and expose. I replied, "Ruthie, women expose, men shoot." She said, "Naughty boy."

One of my favorite Ruth stories took place when Ruth gave a talk to a Camera Club in Palo Alto. She was telling them what they should all do when a lady interrupted and said, "But Miss Bernhard, if we do what you say we won't get any gold medals." Ruthie replied, "If you want a gold medal, why don't you just buy one?" Vintage Bernhard.

MICHAEL KENNA

Ruth and I first met in 1978. I was struggling to gain a foothold in the United States after a move from England. Stephen White, a photography dealer, was picking up some prints from me. In passing conversation he told me that he had just signed a contract to represent Ruth Bernhard exclusively for two years, and did I know anybody who could help her make prints? A life-changing opportunity for me! I would go on to assist Ruth for over eight years. In that time we shared a great deal of time and grew to be very close friends.

Printing with Ruth was an education. I had previously worked as a photographic printer for a number of commercial photographers, both in England and the U.S. I therefore considered that I had some experience in the darkroom. However, Ruth's vision of what a finished print should look like severely challenged my printing skills. A technically competent, perfectly crafted print was not expected. Ruth's prints are highly subjective and very personal interpretations from quite raw negatives. For her, the negative is equivalent to clay, which should be molded and crafted, shaped and smoothed, before finally being caressed into a unique emotional experience.

My previous experience had taught me that she was asking the impossible from her negatives. However, her sheer audacity in cropping, drastic "burning" and "dodging," subtle diffusing, even tilting the easel to elongate an image, and never giving up, continually proved me wrong and miraculously ensured that she usually got what she wanted. We would normally work with a single negative for four or five hours before coming up with three or four "good" prints. Then the next time we printed the same negative, she might change her interpretation completely and would certainly want that print to be even more perfect than the last!

The darkroom was small and quite simple, primitive compared to most of the commercial darkrooms I had worked in. Ruth's darkroom did not have space for drying racks, so after a printing session we would put white sheets on the living room floor and lay the prints out there. However, sometimes during the night, one of Ruth's many house plants might decide to drip some sticky substance on them, so we would need to wash them again the next day. We would

"But Miss Bernhard, if we do what you say we won't get any gold medals." Ruthie replied, "If you want a gold medal, why don't you just buy one?"

occasionally wax a print to eliminate extensive retouching. Later, we learned the trick of running the prints through steam from a boiling tea kettle. Ruth's printing process was not undertaken with detached production line efficiency! The end results were always beautiful, but I can say with a smile that every Ruth Bernhard print from that time has a most interesting history and probably some unique characteristics. Ruth's ability to envision an image is very well known. As her assistant I was perhaps privy to some other, lesser known, aspects of her complex character. If I had to pick out just one, I would concentrate on her generosity. I cannot, in this space, even begin to describe what she has given me. I owe her much. Ruth's insistence at the time that only I be allowed to print her negatives was instrumental in allowing me to emigrate to the United States. For as long as I have known Ruth she has been constantly bombarded with requests for her time, energy, wisdom, and other material resources. She has treated all these solicitations with equanimity and openness. I affectionately call Ruth my "photography mother." She has taught me that giving is the highest expression of receiving.

JOHN SEXTON

Ruth's excitement for life is contagious. She has had the dedication to do what many people only dream of doing, devoting themselves to their art. She lives in the moment, and finds beauty in everything. The subjects she photographs are transformed from the mundane and prosaic into photographs that are etched into the viewer's soul. The world is indeed a better place because of Ruth's vision and her photographs.

She is an extremely effective teacher. She has the gift to inspire students. Once inspired, her students are like sponges—ready to drink up the information presented. I am reminded of the many times I have seen Ruth show the actual teapot she photographed so many years ago. I have watched as students' eyes widened with amazement as they saw the dull, dented teapot alongside the glowing, magical print. They could see the creative process clearly revealed.

I first met Ruth in 1974 at a small workshop organized by Donald Huntsman in southern California. There were only five or six of us in attendance. The workshop lasted just a few days, but I still feel the effect in my photography. My previous workshop experience was with Ansel Adams, and I was not prepared for such a different approach to the making of a photograph. Ruth's critique of my prints was a severe, but constructive, experience for me. It was not an enjoyable experience, but it proved valuable in helping me find out more about my motivation to be a photographer. In effect, she made me think about why I made photographs. Her teaching often ignites the fire that smolders inside a creative person. One of my favorite Ruth Bernhard quotations is, "There are no unworthy subjects; there are only unwilling photographers."

Ruth served as an instructor at Ansel's annual photography workshop in the early 1980s. During this period, while we were teaching together at these workshops, the germ of an idea for teaching workshops together began to grow. I would send students who needed help with the creative process to see Ruth for late-night critiques. Ruth was sending students to me when they

Facing page: *Victorian House, San Francisco*, photograph by Ruth Bernhard, 1963. Above: Ruth in her living room, photograph by Saïd Nuseibeh, 1996.

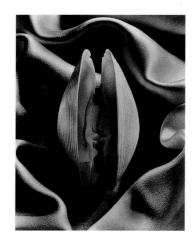

Shell in Silk, **photograph by Ruth Bernhard, 1939.**

needed help with craft. Neither of us knew that the other was sending students to see us. One night, over dinner, we discovered this surprising activity! It was at this time we began to talk about doing workshops together.

We offered the Gift of the Commonplace workshops about every other year. Each time I asked Ruth if she would be interested in offering this particular workshop again, she would always preface her yes with: "If my roller skates are still working"—in later years it was "roller blades"!—or, "If I'm not flying with the angels."

Ruth truly inspired the students to breathe new life into their photography. She is the last of a great generation of photographers whose vision is so pure and clear. They lived their lives with a dedication to the medium and commitment to creative expression.

DAVID HOLMAN

In 1960 I met Ruth on the steps of the Masonic Auditorium, when Eleanor Roosevelt came to San Francisco to speak. While my parents, my wife, my brother, and I were waiting to go in, Ruth came by. At that moment my brother, Shaun, recognized her because she lived upstairs from him on Clay Street. He presided over the introductions and later, because of my interest in photography, mentioned to me that she gave evening classes. I soon signed up and became her student for the better part of the 1960s.

Our first assignment was Doors and Windows. I remember coming home and telling my wife, Barbara, that it was a crazy subject. It was not until we students had made our photographs and had listened to Ruth's explanation for the assignment that we understood her reverence for the beauty that can be found in patterns of light.

There was great excitement in coming to class each week. You wanted her to like your photographs. Her teaching centered on the critique of each student's work. She had a way of finding something to say that would nudge you to make the next photograph. Her critiques were quietly revealing so that you knew where the photograph worked and where it needed improvement. She had a thoughtful and gentle way of encouraging a student by finding something positive to say about an otherwise mundane photograph. One evening she looked at all of my pictures one by one without saying anything and at the last one, she burst into tears and left the studio! The picture that made Ruth cry was of light coming through trees that I made with a magnifying glass as a lens in an old folding Kodak camera.

In the 1960s I was a physician at Children's Hospital in San Francisco. There I ran the heart-lung machine for the surgeons and then would care for the patients after surgery. It was very hard; there were times when we would lose a patient. It was awful and I felt so discouraged. I would ask Ruth if I could come over. I needed to look at something beautiful, and talk to her about photography and the creative process. Ruth and I share a deep, deep respect for nature and a fascination for the earth and its history. We have shared our ideas and have been friends all these years, never out of touch for more than a month or so.

SCOTT NICHOLS

At Ruth's gallery opening on October 16, 1999 she swept through the door as if she were walking onto the stage of a Broadway show. She performed the role amazingly well, for three hours straight, including many conversations about each and every photograph on the wall. This meant having to go through the show several times and repeat the stories, each time bringing the photographs to life with vivid anecdotes and details of inspiration and emotion.

It was fun watching the audience returning her enthusiasm. When I walked her down to the waiting car at the end of the day, she was beaming, almost like a teenager in love. Could there be a way to bottle Ruth's many years of experience combined with her youthful enthusiasm, curiosity, and energy? She had given a command performance just two days after her ninety-fourth birthday. And I can't think of another person as alive as she is!

VIRGINIA BULLER

"Oh, Virgeenia," said Karl Seigel, an old German photographer who was a friend of Ruth's. Both had escaped the Second World War. "Ruth Bernhard is great!" He chewed at a piece of bologna on a crust of bread, chased with a nip of rum. "She is one of my dearest friends, and my Gott!, she will love your body and your face. Ruth is an artiste, a great one. Show her my pictures of you." He patted my arm and my face. "She will know how to photograph you. Not like the others, not those girlie schwine." He thrust his packet of 8 x 10s into my arms and pecked my lips. "Come soon and we will have a session and you will tell me all about it." I was so young and naive and already in bad love affairs. I had modeled at the commercial girlie studios enough to be disgusted with the whole experience of being groped by the camera and the insulting eye of the lens, probed by the sly prurience of the male gaze.

I climbed Ruth's long porch steps at eight one night early in November 1959. This first night I climbed them with anxiety, not knowing what to expect. I arrived at the top of the steps and rang the bell, clutching the packet of Seigel prints under my arm. Everything there was in blues and grays in the windows and white within. She startled me. I had been expecting something more formidable, certainly, but not the contralto voice which greeted me, with the two tones, first down, then up, half-sung: "Ha-allo-o?" Nor was I prepared for the absolute forthrightness of this woman as she held out her hand to shake. There was power and grace, and I accepted her before I knew it. I knew that she would be truthful, perhaps uncomfortably so, as her voice told me. Her eyes also, large, dark, and direct, assessed me, although not blatantly, as I knew her photographs would—never prying, never sexually teasing, never pornographic. When she uttered that "Ha-allo-o" so saliently, I was ready to bend further than my instant respect for her and carry out her second words' implicit command: "Would you mind taking off your shoes at the door, please. I must keep a clean carpet."

I was eighteen when I met Ruth. She was interested in my English past, about which I was woefully ignorant, and she liked my long bones and my interest in, rather, passion for, language.

Below: *Hips Horizontal*, photograph by Ruth Bernhard, 1975. Bottom: Ruth at her celebration of fifty years in the United States, 1985.

That first night, Ruth took one look at me and produced a sky-blue felt near-circular shawl, more like a matador's cape than anything else. She then encircled me in it from chin to shin, leaving the front free for the body's lines and limbs. She adjusted it herself, a pin in her teeth.

The first time we worked, she stripped me of my dreadful shyness. She set me at ease by being herself. In a matter-of-fact tone she told me what she wanted me to do, and she told me why. She directed me to look at cloths and objects and her walls, the marvelous shells and flowers and creatures.

This sounds sexy, and in a way, I suppose, it was. But only in the way things should be and often are not. In a word, Ruth had a grasp. She ordered my hands, my arms, my face's tilt: with her small, strong gentle hands, fierce in their authority, she set me in order. Nothing struck me more forcefully than Ruth's actual touch. Her eye appraised keenly the body it saw, and her hands executed with equal, clean scrupulousness their tasks. I had never been touched so fastidiously and so intimately in my life. To prepare for posing and turning me into a sculpture, Ruth cut my pubic hair. Her hands cleared away the curly bush precisely, and gently as a lover's hands could do. "I would like you to lie . . . so." This, on the third session, each about an hour long, twice a month. "Now I want you to relax. Relax. That is right. Now, that is marvelous!" She brought out a box of some yards of lace that I felt that she had in waiting, or was it spontaneous? With Ruth one was never sure. "Now Virgeenia, I want you to wear this. That is right. Stand up straight. Yes! Turn your head. Show us your profile." She would adjust my neck with a tracing, seeing finger, a finger that I knew was sure of itself and its intentions as if she were part of me and I part of it. So much so that I could forget it.

With Ruth, I had a place to put my trust, personally and artistically. When I posed for her class she would direct me, "Give me your El Greco." Turning to the students, she would continue, "See how beautiful that is, look at those lines." I knew that she was loving and impersonal and saw me wholly. I was not an object, but an observer too. To be her El Greco! To have her see that lovely, brave yet tortured form of the artist's realization of Christ, and for me to be that, carrying a hidden part of me. It was a great experience.

AVERY MCGINN

When I saw Ruth Bernhard for the first time in 1991 at her opening at Vision Gallery, a small group was gathered, listening intently as she held court. I edged in to listen. Her eyes met mine and then moved from face to face settling on first one, then on another, pausing and emphasizing her remarks as she inquired, "Why do you make a photograph?" Her gaze moved from face to face, awaiting an answer. "You must fall in love to make a photograph. If you haven't fallen in love with what you are seeing, don't make the exposure."

I quietly pursued Ruth for months after that first encounter. I went to all of her workshops. Gradually, she noticed that I kept reappearing. In February I sent her a handmade Valentine that said, "Love is in the air and you are in my thoughts." When I saw her at her next opening she

**Ruth, photograph by
Price Rice, 1983.**

said, "Your heart is on my wall." She added, "I am not very good at writing, but I have been sending you thought waves." Our friendship had begun.

During a visit, Ruth spoke of the effect of the carbon monoxide poisoning she had suffered in the early 1970s that made it difficult to put her thoughts on paper. She felt such a responsibility to her friends, students, and admirers who wrote to her that it weighed on her soul. I asked if she would like me to assist her with her correspondence. She cried silently and thanked me for the ease she felt with me.

I helped Ruth transfer her words to paper. She would dictate letters to me. Her messages were perfect. It meant more to her to spend an evening writing letters than almost anything else she might do. It satisfied her spirit and relieved her conscience.

Ruth is as sensitive to language as she is to light. I remember one December when she spoke of how she enjoys seeing the Christmas decorations in downtown San Francisco. I offered to "take" her downtown to see the lights. She quickly answered, "No, we either go together or we don't go at all." When you are with Ruth, you are awake! An evening out with Ruth is an adventure. Every time. Ruth is not casual with her vision or her relationships. She is intense, vibrant, and engaged. She is loyal to her vision and to her friends. Her work and her life are one—full of wonder and devotion.

GWEN EVANS

I met Ruth when I was a young kid of twenty-four. I was working as the society reporter for the *San Francisco Sun Reporter,* a small African-American community newspaper. Besides getting the names straight, I had to take pictures. On one occasion I photographed a dark-skinned bride in a white dress in bright sunlight. The resulting photos were a disaster: the bride's dress was visible, but none of the faces were. Dr. Carlton Goodlett kindly suggested that I take a class with Ruth Bernhard. I called Ms. Bernhard and she invited me to visit and bring my photographic work.

Ruth asked what I knew about photography. I told her that the only art photograph I remembered was a black-and-white photo of a sensuous bell pepper on a book cover. Ruth smiled, took me by the hand and led me into her photography studio. There, on the wall in a central place of honor was the very same photo of the bell pepper, taken by Edward Weston, her mentor. The warmth between us deepened. Whether it was coincidence or synchronicity, I felt as if I had found a kindred spirit. Ruth began my lessons in seeing with the mind's eye. Instead of talking to me about light meters and overexposures, Ruth took me by the hand, as if leading a child, and walked with me around the outside of her house. She pointed out how light fell and illuminated the objects, plants, shadows, and reflections. "It's not the object that is beautiful," she said, "it's the light in which we see it." Was she talking of light or spirituality? I couldn't tell. But I fell in love with her. Being a late 1960s African-American hippie waif from New York City, I had no relatives in California. Ruth and I formed an instant familylike bond.

In the 1970s I attended her informal salons, held in her studio. The collection of artistic

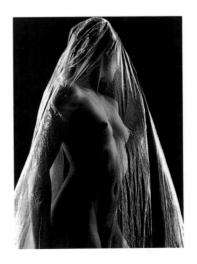

Top: Ruth Bernhard and students with John Sexton. Above: *Bone and Passion Flower,* photograph by Ruth Bernhard, c. 1960. Below: *Transparent,* photograph by Ruth Bernhard, 1962.

people around her and their ideas were exciting and nourishing to me. I loved Ruth's energy, her outlook on life, her friends. From time to time, she let me have the run of her studio for my own artistic experiments. Then, times would come when Ruth would phone me and say, "I'm going to disappear for a while into the darkroom. See you when I reemerge." She would disappear for weeks, and I couldn't wait to see the results of her artistic time alone.

Ruth was like my spirit mother, really. From time to time, when I couldn't afford to pay, I would clean her apartment in exchange for lessons. I eventually became an arts and culture reporter for KQED-TV, the local PBS station. Ruth again came to my rescue. She taught me how to dress, how to wear my hair; she launched me into the local San Francisco art world by allowing me to go to gallery openings with her. On these outings, we would discuss art, and I learned to be an art critic from experiencing her way of perceiving.

Eventually I wrote a piece about Ruth for the *San Francisco Chronicle*. It was during this interview that she observed, "You should be a psychologist, Gwen." Although I didn't become a photographer, I still use everything I learned from Ruth about seeing, vision, and insight. As a psychologist I sit with people and let them be themselves. I provide the holding space, where my job is not to judge, but to appreciate the person. I learned this technique from Ruth: the technique of meditating on the potential perfection of something that manifests in the material world, be it object or person. I try to use myself to give back to the person a perfected view of themselves. The goal is that they know themselves. It is a quality of loving that Ruth used with her teaching and in her photographs. Only, with photography you get to keep the picture.

I have also seen the vulnerable side of my friend. In 1973 we were at an opening of her work. We were in the ladies' room and suddenly she broke down and wept, saying that she would never be famous and her life's work would disappear. This is the struggle of the artist in our culture. Ruth came into the world with a strong mission and resilient spirit formed by her childhood loneliness. She has achieved the success that she wanted so much.

SAÏD NUSEIBEH

Joe Folberg at the Vision Gallery asked if I would be interested in a job printing for Ruth Bernhard. Her previous printer, Michael Kenna, had gotten too busy on his own; she needed help. Joe arranged a meeting at Ruth's. We had some tea and she looked at each one of my photographs from an Arabian desert portfolio; the mats leaned back on the cushions of a white sofa, with a host of teddy bears arranged on top looking back at us. She delightfully acknowledged details, pointing at patterns like the ones we'd just seen on her table, or turning the mats upside down to refresh perception of the weight distribution; all a matter of making each photograph part of a unique personal experience. When we'd scanned the lot she looked up at me and said, "Great! When do we begin?"

Working with Ruth in the darkroom over the years has become a foundation of my professional and personal life. Ideally, I spend a day exploring and troubleshooting the negatives with

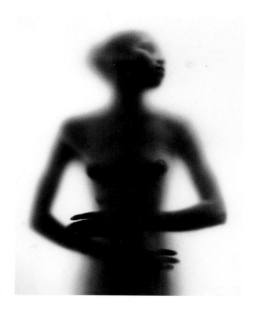

Veiled Black, **photograph by Ruth Bernhard, 1974.**

which we are working. Then Ruth joins me for a feisty session in "the magic room" to fine-tune the print, and then I produce a set, or "crank some out," as Mary Ann says. Many of Ruth's procedures were new to me, such as her insistence on reinventing the image with every printing— "We are not a machine," she says; or, "Have you seen any exciting new papers?"—and her multiple techniques designed to diffuse the print, which she calls "confusion," as in, ironically, "Let's give it a little more confusion, Saïd!" In her hands, the easel itself springs to life; it transmutes into a three-dimensional spherical object with which she modifies the image, rotating it through the planes to elongate or thicken parts of it.

A typically good day begins with me getting the darkroom all warmed up with fresh chemistry, a negative in the enlarger and cropped on the easel, and the exposure tested for an approximate image. I pick up Bernhard around eleven A.M. and bring her back to the studio, where we talk about the image and where we want to go with it. Then after a quick sandwich and cup of cardamom-spiced coffee, we get to printing. When we are not dodging together, Ruth will usually relax on a special cushion in the chair and follow her own thoughts while I make the exposure, sometimes lasting up to thirty to forty minutes apiece. Then we'll chat up a storm while I run the photograph through the chemistry trays. Always, Bernhard is right there peering over the edge of the developer tray to watch breathlessly the magic of the image appearing on the paper.

Our time in the darkroom is a treasure beyond measure. We stand there in the warm yellow glow and confide our innermost thoughts: a photograph and its effect; stories from the history of an image or tales of her life; our emotional travails and professional paths; the ways and problems of the world and the failure of our species to rise to its challenge. No subject is beyond our compass in that special room. The intimacy we've developed over the years is the alchemy that makes the photographs happen. I'll never forget a period in the midst of the U.S. war on Iraq when Bernhard and I were printing *Two Forms*, the image of two faceless nude figures, one black and one white, with a stark alabaster-white hand pulling gently on a deep mahogany back. At the time, I felt so alone and angry and impotent in the face of the wantonly lethal situation in the Middle East. Ruth and I shared a wrenching despair over the civilian bombings and radioactive munitions. At one point we were crying so hard that tears were rolling off our cheeks into the trays. Ruth looked piercingly up at me through blurry eyes and said, "This is the chemistry that makes for real communication." Not only did Ruth stand by me through that difficult emotionally raw time, giving me work when I could hardly face anyone else in the outside world, but she showed me how, through feeling and beauty, we artists can resist surrender; we can manufacture a positive truth that opposes the chaotic expression of suffering.

Creation, Two Leaves, One World, In the Box, Skull and Rosary, Dead Sparrow. . . So many of Ruth's works distill pain from her lifetime, expressing personal feelings of isolation and connectedness, despair, rebellion, and hope. The diffusion of prints in the enlarger has become emblematic for us of looking at the world through tears in our eyes. It is ironic that she and I feel more clearly when our vision is blurred.

"So many of Ruth's works distill pain from her lifetime, expressing personal feelings of isolation and connectedness, despair, rebellion, and hope."

> *"Posing for Ruth was a challenge... Ruth was a perfectionist and often moved my fingers on the platform as little as an inch, while I had to hold a position for... as long as several hours."*

MARY ANN HELMHOLTZ

In June 1978, I was attending Aperture '78, a photography workshop at San Francisco's Fort Mason. Among the faculty was Ruth Bernhard, who gave a glowing slide lecture on her work. I was deeply moved by the extraordinary beauty of her images, and following the lecture, walked over to her and thanked her for the privilege of seeing her work, expressing the feeling that I had just had a "religious experience." She smiled appreciatively. Later that evening at dinner I happened to be sitting at a table that included Ruth and Ellen Gibson, her former neighbor and one of my former photography teachers, and San Francisco photographer Michelle Vignes. They were bemoaning the fact that their many activities were overwhelming and they sorely needed assistance. A couple of weeks later I telephoned Ruth inquiring if she were serious about needing help, and she responded with an enthusiastic, "Yes." Her favorite word, I was soon to learn.

On Tuesday, July 15, promptly at eleven-thirty A.M., I arrived at Ruth's Victorian flat. She greeted me in a printed cotton dress and bare feet. Coming up the steep hallway stairs, I was immediately immersed in a visual feast of Bernhard images. And upon reaching the top of the stairs, I came upon seed pods, seashells, stones, and other small treasures that have touched her life, displayed on narrow shelves on either side of the long hallway. In the living room, on a music stand, rested the surreal image of a doll's head held in a mannequin's hand, Ruth's renowned *Creation*, her favorite Bernhard, I was later to learn.

After chatting and becoming a little better acquainted, we moved to the kitchen, not knowing then that this would become our "office." Our goal was to make order out of chaos, as we often say, of her voluminous slide collection—pages and pages, boxes and boxes. We continued to early evening, and it was already apparent I would be coming to Clay Street for many more sessions.

Over two decades my precious friend and colleague and I have shared many wonderful hours pursuing her numerous projects, and laughing at little inconsequential things, and at ourselves. We are serious, however, in agreeing that June 3, 1978 was a fateful day for both of us.

JOYCE PIEPER

Thirty-seven years ago, in 1962, I was the model for Ruth's most popular photograph, *In the Box/Horizontal*. As I remember the day, Ruth and I were having tea in the bay window of her living room. She noticed a large, oblong box being delivered at the curb outside. Ruth called the neighbor and asked for the empty box. I posed in it for two successful black-and-white negatives and one color negative. I am very proud to have been her model.

I met Ruth because I saw her photographs in a magazine of nudes. The bodies were beautifully ethereal. My husband had encouraged me to model, but I was uncomfortable. I thought that if I posed for Ruth, it would be different. So I looked her up. She was interested, but said that she could not pay me. We agreed to exchange posing for pictures.

From 1959 to 1964, I posed for Ruth for two or three days at a time. Posing for her was a

challenge for me as a model. Ruth was a perfectionist and often moved my fingers on the plat-form as little as an inch while I held a position, sometimes for as long as several hours. Of course, we did take breaks for tea and snacks and conversation.

Ruth and I became friends. We maintained our connection over all these years.

DEBRA HEIMERDINGER

I met Ruth Bernhard in 1992, when I was director of Vision Gallery in San Francisco, one of the largest galleries for fine-art photography in the country. The intention of its owner and founder, Joe Folberg, was to encourage people to look at photographs by making them plenti-ful and easily accessible. Joe especially loved Ruth's photographs and was instrumental in promoting her reputation. Several major exhibitions were mounted at Vision, the scene also of festive birthday parties for Ruth that filled the galleries with admirers and well-wishers.

Joe and I began talking about publishing photographs in platinum. Ruth was our number-one choice. Thus Vision Editions was born with a platinum portfolio of Ruth's nudes. Working during the long, involved process we became friends.

Vision Editions subsequently published two Bernhard platinum-palladium portfolios: *The Eternal Body* in 1993 and *Gift of the Commonplace* in 1994. They stand as presentations of some of Ruth's most accomplished photographs, and they were instrumental in extending her reputa-tion, particularly on the east coast.

When I was preparing to launch my own business as a private dealer in 1996, Ruth asked, "What can I do to help you?" The result is a series of single platinum prints. I consider Ruth's generosity to be the cornerstone of my business. I owe much of my success to her.

GERTRUDE MINSOS

I am Trudi, Ruth's oldest living friend. Ruth and I were best friends as students together in Bremen, Germany, at the lyceum, a girl's school that was rather like a superior high school. I never met her family, but she liked to be with mine, who were actually my foster parents. I lost my own parents, who were both artists, when I was very young. I remember exactly when I met Ruth. It was in the art room. There were long, high tables with seats that were like those piano stools that you can roll up and down, very tall. A girl had taken my special seat and I was angry and spoke rudely to her. "Oh," she said, "I am so sorry." She used the adult form, "Sie," that conveys respect, instead of "Du," which is used with children. She was so polite, so apolo-getic. It impressed me. So we became friends.

Gustav Adolph Schrieber was a very good painter and well known in Bremen. He was nice-looking and looked so artistic with his hair wind-blown. Ruth fell madly in love with him. I accompanied her to his studio several times. There were canvases everywhere against the wall.

I got back in touch with Ruth in the 1980s and now she is back in touch with me. We have not seen each other in seventy years! I always knew that Ruth would do something original.

Recipe for a long and happy life

1. Never get used to anything
2. Hold on to the child in you
3. Keep your curiosity alive
4. Trust your intuition
5 Delight in simple things
6. Say "Yes" to life with passion
7. Fall madly in love with the world
8. Remember: Today is the Day!

Ruth Bernhard

October 14, 1995

afterword

"To be a creative person is a significant privilege as well as a great responsibility." In this book we have the background history and personal narrative that give Ruth Bernhard the authority to make this statement. To be a creative person is to recognize what creativity is, and to know what such a gift begets is to bear it as a privilege. To harbor all of this, a serious matter, is to be an exceptionally responsible person.

Bernhard, an artist in photography and a gifted teacher for over fifty years, has enriched our comprehension of the world, its people and things. She has given us the results of an expressive enterprise that above all reveals how she feels. The telling confirmation is echoed in her students and her work, the inspiring pictures—from those made under struggling circumstances early in her career to those made when, at the height of her powers, she labored in a tiny studio and darkroom in San Francisco. She showed that all that mattered was deep feeling and love, combined with a consummate yet transparent skill. This wisdom, charged in a state of heightened awareness, gives us the realized image in photography. To a student, it imparts the confidence to be one's self.

Ruth has qualities that should be honored. This book pays tribute; other such accolades have come already, and more will follow. I say the latter because we at Princeton University, the institution that will receive her life's work, plan to ensure that this artist's accomplishments will not languish in the hidden recesses of an archive but will be a living legacy from which generation after generation of students—women and men—will learn. As she has said, "my own creative work comes like a gift, pushing itself into my consciousness."

This book comes into our consciousness, where it will remain forever. Margaretta Mitchell has brought Ruth Bernhard forward in a new way, providing us with a shared journey made up of reminiscences and not-so-subtle, poignant reflections, such that together with her photographs, the whole of Bernhard's life will be better understood. She is what her ideas and emotions have made her. Ruth will be celebrated even more now for her candor and perseverance, and the sheer beauty of her insight. This beauty is one of affirmation through deep affection and, above all, connectedness to the gentle and humane spirit of life.

Peter C. Bunnell
Princeton

selected lectures and accolades

WORKSHOPS & LECTURES

1966 University of California at Berkeley Extension, San Francisco

1968 University of California, Berkeley, Visual Awareness Workshop for Elementary Teachers (June 24–28)

1971 New York University and International Foundation for Concerned Photography, New York, New York (October 13–December 8)

1973 Country Photography Workshop, Light Works, Woodman, Wisconsin (Summer)

1974 Sun Valley Center for the Arts and Humanities, Sun Valley, Idaho (June 8–19)

1978 Aperture '78 Photocommunications Conference, Fort Mason, San Francisco, California (June 3–4). Faculty: Ernst Haas, Ruth Bernhard, Al Satterwhite, Monica Suder, and Michael Mathers.

1978 Stanford University, Tressider Union Lounge, Palo Alto, California. Lecture: The Art of Seeing (March 9)

1980 Friends of Photography Asilomar Workshop, Asilomar, California (July 15–20)

1981 Ansel Adams Workshop, Yosemite National Park, California (June 12–19)

1981 Mills College, Oakland, California, in connection with exhibition *Recollections: Ten Women of Photography.* Lecture (September 30)

1982 Northwestern University, Mary and Leigh Block Gallery, Evanston, Illinois. *Recollections: Ten Women in Photography* exhibition (week of February 8) Lecture

1982 Society for Photographic Education, National Conference, Colorado Springs, Colorado, featured speaker (March 18–21)

1983 Recontres Internationales de la Photographie, Arles, France. Retrospective exhibition and workshop (July)

1983 Palo Alto City Library, Palo Alto, California. Lecture and Workshop (November 4)

1984 Center for Creative Photography, University of Arizona, Tucson, Arizona

1987 National Geographic Photojournalism Annual Seminar, Washington, D.C. Lecture (January 7–8)

1987 International Center of Photography, New York, New York. Workshop and Exhibition: *The Eternal Body* (February 21–25)

1989 Museum of Photographic Arts, San Diego, California. Lecture (May 4)

1989 Bryn Mawr College, Bryn Mawr, Pennsylvania. Lecture: Women in Photography (June 18)

1989 John Sexton Photography Workshops, Carmel Valley, California. (November 16–20) Gift of the Commonplace

1991 DeSaisset Museum, Santa Clara University, Santa Clara, California. Exhibition and Lecture (April 18)

1992 Coupeville Arts Center, Coupeville, Washington. Workshop and lecture (April 4–6)

1996 The Art Museum, Princeton University, Princeton, New Jersey. Exhibition: Ruth Bernhard: Photographs. Lecture (October 12–November 17)

1997 San Francisco Art Institute, San Francisco, California. "An Evening with an Artist: Ruth Bernhard," sponsored by the Northern California Women's Caucus for Art (November 5)

1998 Coupeville Arts Center, Coupeville, Washington. The Art of Seeing. (April 11–12) Farewell Workshop!

AWARDS

1976 Dorothea Lange Award by the Oakland Museum

1987 Distinguished Career in Photography Award. Society of Photographic Education, Midwest Regional Conference, Chicago, Illinois, November 8, 1987

1990 Presidential Citation for Outstanding Service to Utah State University. Logan Utah, October 25, 1990

1994 Cyril Magnin Award for Distinguished Service in Photography. Presented by the San Francisco Chamber of Commerce

1996 Lifetime Achievement Award. Women's Caucus for Art, California Regional Chapter. Presented at Mills College, Oakland, March 30, 1996

1997 Honorary Doctor of Humane Letters. The Academy of Art, San Francisco, June 1, 1997

acknowledgments

MY GRATITUDE FOR THIS BOOK BEGINS AND ENDS WITH RUTH BERNHARD. Indeed, the sources for the text start with Ruth herself: our conversations, her teaching voice, her writing for her books, especially the unpublished manuscript *The Eye Beyond,* the many interviews, audio and video, and the countless articles that present her work and ideas that comprise the Ruth Bernhard Archive. She has allowed me to grow so close that by now I find myself finishing sentences for her. Ruth has told me the facts as she remembers them and whenever I could make them more accurate, I have done so. When the manuscript was complete, I was pleased to give it to Ruth to read and to receive her blessing.

Ruth's brothers have been very supportive of the project and I want to thank all three, Karl, Manfred, and Alex, for their enthusiasm. Each has helped me in specific ways. Thanks to Alex, I could describe in detail the Berlin house in a way only an architect could remember. He recalled the floor plan and other details about holidays and family life that gave more flavor to that period. For much of the factual information about the career of Lucian Bernhard and for the use of photographs and his own memories, I am indebted to Karl, the eldest of Ruth's younger brothers, who worked with his father for many years. To Manfred, thanks for providing the visual material to reproduce Lucian's work.

There were times when facts just could not fit together and Ruth sent me to other colleagues to sort them out: Gini Harding, Jack Welpott, Norman Jensen, and John Lafler made contributions to the story of the San Francisco weekend and the subsequent "school" on Divisadero Street.

I applaud Judy Lynn, her staff and students at the Coupeville Arts Center in Coupeville,

Washington, for meticulous planning and attentive support for Ruth's last workshop there in April of 1998. Special appreciation goes to Captain and Mrs. Marshall Bronson, of Compass Rose, a most delightful bed and breakfast.

I want to acknowledge Mick Briscoe as the contributor of the "light walk" ritual. As her assistant at the John Sexton workshops, Mick observed Ruth teach for over eight years and gave his quiet and effective voice to my text on Ruth's workshop teaching.

The voices throughout the book speak for themselves. Ruth sent me to many people who have been part of her life and photography over the years and are still in her life today. There are more than I can mention or include, but the list includes Tom Baird, John Sexton, Jack Welpott, Gwen Evans, Margo Davis, David Holman, Avery McGinn, Michael Kenna, Camille Solyagua, Saïd Nuseibeh, Jennifer Masek, Mary Ann Helmholtz, Jane Totten, Debra Heimerdinger, and Scott Nichols. Thanks for your generous contributions of time and text.

Other voices speak from the ranks of Ruth's students, past and present. Their words represent boxes and boxes of letters and pictures. This book is a way for Ruth to thank all of her students for that incalculable richness that they have added to her later years.

Gertrude Minsos responded to my out-of-the-blue call with the thrill of knowing that both she and Ruth were both alive and able to recall their school days together so long ago.

Embedded in the text are many facts and atmospheric details that I had to obtain from research. First of all, I thank Georgianna Greenwood for knowledge of things calligraphic and Germanic; Fritz Safier and Julie Prandi for insight into German culture, language (Julie made translations), and history;

Ben Sonstein for a text on Lucian Bernhard; Eleonore Rios for documentation on Eveline Phimister; Damon Mallard for thoughts and background material; Jason Langer, Carol Lucero, and Maryon Maass for observations; and Sim Warkov, whose insight always went to the heart of the matter.

I was fortunate to locate and interview two of Ruth's models, Joyce Pieper and Virginia Buller, whose remembrances provided unique information about the partnership of model and artist.

Many thanks to Peter Bunnell, McAlpin Professor of the History of Photography and Modern Art at Princeton University, who has championed Ruth's life in photography with eloquence. I am grateful to Peter not only for his fine afterword in the book, but also for the assistance that he, as faculty Curator at The Art Museum, Princeton University, Toby Jurovics, Associate Curator of photography, and their research assistant, Stuart Reynolds, provided during my visits to the Ruth Bernhard Archive.

The correspondence between Edward Weston and Ruth Bernhard is published for the first time, thanks to the kindness of Ruth Bernhard and the Center for Creative Photography, at the University of Arizona in Tuscon. Director Terrence Pitts and everyone there was eager to be of assistance, but I want to particularly thank Dianne Nilsen for her help with permissions and Assistant Archivist Leslie Calmes for her forbearance with my attempts to get the letters in a logical order, without all the dates available.

For the hospitality of faraway places to increase my time to write undisturbed, I thank Susan Koger and Margaretta Anne Mitchell, Trish and Tony Hawthorne, Sarah and Ivan Diamond, Kyra and Stephen Kuhn, and Sally and Mike Gale.

selected exhibitions

I am grateful to all of those brave souls who read the manuscript in the various stages of preparation: Jeff Kausch, Linda Williams, Gwen Evans, Saïd Nuseibeh, Sim Warkov, and members of the writing group led by Jane Anne Staw. I am indebted to Jane for her editorial support without which the book would still be in process.

On the production side I thank Kaz Nishita for computer assistance, and Nancy Ericsson and Cori Keller for photographic assistance. Thanks to all whose photographs are in these pages. Thanks to Nion McEvoy and the crew at Chronicle Books for believing in the concept. To the designers, Lori Barra and Andrew Faulkner of TonBo designs, eternal gratitude for our synchronicity—my vision realized.

In the final boarding process there are a few people who deserve an extra thank you for their help beyond the call of friendship: Mary Ann Helmholtz and Saïd Nuseibeh, who kept Ruth and me on track; Margaretta Anne, Julia Warren, and Kate Davison Mitchell, who have helped me through so much with their daughterly wisdom and love; and Sim Warkov, whose caring support and understanding never wavered throughout the extremely intense and demanding time it took to complete the manuscript.

Finally, I want to say it straight: This is Ruth's book. I have done all I could to follow up on Ruth's every word, every person, every nuance, every story, to fulfill every request to make this as much of a personal memoir for her as possible. She asked me explicitly to take on the role of author. I accepted. I dedicate every detail of *Ruth Bernhard: Between Art and Life* to Ruth with love and kisses.

MARGARETTA K. MITCHELL
Berkeley, California

1936	Pacific Institute for Music and Arts, Los Angeles, CA
1939	Jake Zeitlin Gallery, Los Angeles, CA
1939	PM Gallery, New York, NY
1953	Kurland Gallery, Pacific Grove, CA (Group)
1953	Institute for Cultural Relations, Mexico City, Mexico
1956	Gump's Gallery, San Francisco, CA
1958	Oakland Museum, Oakland, CA
1962	Museum of Modern Art, New York, NY (Group)
1963	Simbab Gallery, Boston, MA
1967	Focus Gallery, San Francisco, CA
1967	Metropolitan Museum of Art, New York, NY. *Photography in the Fine Arts.*
1968	M. I. T., Cambridge, MA. *Light7.*
1970	M. I. T., Cambridge, MA. *Being Without Clothes.* (Group)
1970/75	Neikrug Gallery, New York, NY
1975	San Francisco Museum of Art, CA. *Fifty Women of Photography.*
1977	Witkin Gallery, New York, NY
1979	International Center of Photography. *Recollections: Ten Women of Photography.* Traveled to sixteen U.S. museums and Canada.
1980	The Friends of Photography, Carmel, CA. *Ruth Bernhard: A Retrospective* Exhibition.
1981	Photography West Gallery, Carmel, CA
1981	The San Francisco Museum of Modern Art, CA. *Photographic Reflections of the World of Illusion and Fantasy.* (Group)
1982	The Photographers' Gallery, London, England.
1982	de Saisset Museum, Santa Clara University, CA
1983	P. G. I. Gallery, Tokyo, Japan
1984	The San Francisco Museum of Modern Art, CA. *Photography in Calfornia: 1945-1980.* (Group)
1984	Museum of Art and Culture, Dortmund, Germany. *Das Aktfoto.*
1985	Tokyo Institute of Polytechnics College, Japan. Retrospective.
1986	Galerie Zur Stockeregg, Zurich, Switzerland. *The Eternal Body*, traveling exhibition.
1987	Vision Gallery, San Francisco, CA (1992–95)
1987	Forum Bottcherstrasse, Bremen, West Germany. *The Eternal Body.*
1988	Amerika Haus, U.S. Cultural Center, Berlin, West Germany. *The Eternal Body.*
1990	Museum Ludwig, Cologne, West Germany. *Masters of Light: Fifty Twentieth Century Masters.*
1991	de Saisset Museum, Santa Clara University, Santa Clara, CA. *Ruth Bernhard: The Eternal Body.*
1996	The Art Museum, Princeton University, Princeton, NJ. Retrospective. *Ruth Bernhard: Photographs.*
1996	New York Public Library, New York, NY. *A History of Women Photographers*, traveling exhibition. (1996–97)
1996	University Art Museum, California State University, Long Beach, CA. *Ruth Bernhard: Known and Unknown.* Traveling major retrospective.
1997	Highlands Inn, Carmel, CA. *Photography as Life and Art.*
2000	The Art Museum, Princeton University, Princeton, NJ. *Ruth Bernhard: Between Life and Art.*
2000	The Friends of Photography, San Francisco, CA. *Ruth Bernhard: Between Life and Art.*

beloved edward/darling ruth

Correspondence between Ruth Bernhard & Edward Weston

The first letter from EW in Santa Monica to RB in New York 1935

Bernhard—
You have excellent eyes. Mine can't harm you. I am glad they were stimulating. And you were too—to me. One day we will meet again. In New York?

Negative news from Wash. Ho, Hum— We still eat. Stew or Beans tonight?

I have not printed since you left. Be patient. Have Hope!

Cariñosamente, Weston

⁓

Santa Monica, California, c.1936

Bernhard will forgive Weston (?) for not answering at once a letter of such beauty. I don't forget you but my time seems to be given over to the very stupid consideration of "business," how to buy the next sack of beans! Just as well you did not stay to witness the gradual decline of the bean-pot. We surely will meet again someday.

Your "German accent" is lovely; don't lose it. I am happy to feel that our meeting meant something to you, to your work; it did to me.

When will I finish the portraits of Bernhard?? If they had been good negatives I'm sure that I would have printed them at once. I will try to muster courage soon; shut my eyes to defects and make the most of them.

Brett opens at Julien Levy's next Tuesday.

I wonder will the horses hang on to life until I reach N.Y.?

Weston

⁓

Carmel, California, c. 1939

Dear Bernhard
Being a modest and retiring—even bashful youth, I blushed repeatedly when I read your spread in *US Camera* for June. I found too much Weston in the text. But the reproductions are evidence that you withstood Weston influence—thank the gods! I was glad to see my *Doll's Head* presented. And *Bernhard* by EW reproduced well.

I am printing, printing, printing.
" " "
" " "
—and on and on —
Abrazos and all good things—
Edward—

Wildcat Hill
Carmel, California, c. 1951

Ruth darling—
I should know the back of your head—but I had to give up on acc't of all the canine beauties. It was mighty good to hear from you; will be even better to see you! Yes, please phone! You will be most welcome to put up here if you can take the primitive life, and share in-household cares with Dody. Dody is my apprentice (photographic only). In return for photo-lore, she "keeps house" and drives me on occasional trips. She lives in one of the upper rooms.

Please bring all kinds of news about my sweet dotter, Eleanora. Wish I could see her more often.

I've gone down hill some since we met in N.Y., acquired a few shakes.

Love to you, Edward—

⁓

(undated)

Beloved Edward,
We had an exhibit together at my place a few days ago—and of course everybody sees your influence in my work. It always surprises me that it is that obvious!

And to boot I sold two more prints from the portfolio. I am hiding the nude and cabbage leaf for myself—selfish girl!

Darling I wish I could be with you more often—you do wonders for me. Somehow we seem always to be "tuned in" on each other's wavelength—besides there seem to be hundreds of pictures I never saw and those I always hunger to see again.

Gogo is having a show during March— might manage to see it and of course go to Pussycat Creek—to count the new kittens.

Tell that bad Brett (the lion) that he is a mouse—he knows what I mean. And tell Dody hello for me.

Be good to yourself, Darling—see you soon. All my love, Bernhard

⁓

Hollywood, California
January 6, 1952

Dearest Edward,
It was wonderful to be with you again. I am deeply grateful for you in my life—and you keep adding to my treasure, Darling, Beloved Edward.

We didn't have a chance to stop in Santa Barbara. The rain drove us on and on—we made it in 8 hours instead of 2 days. Good on us!

Friends in New York saw the Grand Central show—never were more deeply moved was their comment. They had to call me up to tell me—as the closest link to you.

Can't wait to see you again—maybe March, if it suits you.

All my love, Bernhard

⁓

(undated)

Edward Darling—
Love this picture of you and family!

Am deeply disappointed not to have managed to live in Carmel for awhile—just love the country and my favorite people live there to boot.

All my love Sweetie, Bernhard

Hollywood

Bernhard—
—forgive this card! If I did not have cards to shower on friend and foe I just would not write. I almost said "could not." Anyway you wrote me a wonderful letter and I thank you from my depths.

Love from Edward 1-28-'52

⁓

Hollywood
February 11, 1952

Darling Edward,
It is thrilling to hold your words in my hand—no matter if it be a long letter or a shortie. I never have been able to part with a single word from you—one might say my heart knows them by words!

Leda Dubin and I had a long talk about you and it turns out that she loves and appreciates you with all her heart. It brought us more closely together—and it is good.

Liz and I are talking about visiting you again very soon. Got some new really depraved recipe to try out on you.

We are thirsting to see your movie—have a fine projector for it. Would you trust us with it for awhile? (That's one way to get another postcard!)

All my love, Bernhard

Hollywood, California
February 15, 1952

Bernhard—
Ruth darling—Your letter made me blush— even at 66! I can't take such a glowing acc't of my unworthy self.

My film, I mean my copy of "The Photographer," is away. As soon as it returns I will mail it to you. If time seems long, maybe I've forgotten, so jog my memory.

Loving greets to you and Liz—Edward.

⁓

Undated

Darling—out of sight is never out of heart [drawn in shape of a heart], as you must know—but I am such a horrible correspondent.

I gave everybody seedpods from your nasturtiums—for Christmas—I hope a little of you will rub off on them.

Lovingly Bernhard

⁓

Wildcat Hill
Carmel, California, January 15, 1953

Dear Bernhard—
You girls did me proud with the wonderful dates. I just wrote Leda. I have an old address of hers.

Expected to see you long ere this. I'm not much to see these days, not even to talk with!

Gogo is living nearby and gets photographic lessons from Brett and Dody (who just married). I don't teach anymore, not even in the dark-room. I have too many jitters and have lost my novice. I also need my brakes relined.

Writing is a task, when it comes out this way.

My love—Edward

Hollywood, California
January 19, 1953

Dearest Edward
As always—a word from you gives me great joy, although without any words you are ever present in the person I have become through knowing you.

You had every right to expect me long before this—I have been hoping and planning for it for some time. Just 2 month ago had a big surgery job—a complete motor change (very successful!) which I was badly in need of for some years. Have practically completely recovered—very soon will be able to come and stay a bit—if you want a face around. Wish you were feeling better—

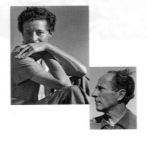

please don't write—words are not necessary as our geiger counters are tuned perfectly to the same wave length.

Saw and loved the film about you.

Talked to strangers at the beach yesterday—first thing we discovered we had you in common. Kathrin Gerber, friend of Brett's.

All my love Darling—Bernhard

❧

Wildcat Hill
Carmel, California, April 14, 1953

Ruth darling—
Exciting news about "our" exhibit, except that I don't know anything about it! Is it the group show at the gallery near or on Pebble beach? That was discussed with Miss (?). I'm no good on names anymore, but nothing was settled or final. I gave up group shows years ago, just got to wearing me out. You must be my personal representative. How many and who are going to be in this show?

Good to know that you are coming up, my love.

Edward

P.S. I would not try to get out of this show—especially if you and/or Brett would be in it—But I'm weary—very. —E.

❧

(undated)

Beloved Edward,
Never suspected it could be possible for me to have a show with you—makes me feel ever so extra super special! You are a sweetie to do it.

Don't know just when I can get there, certainly 2 or 3 days before opening date. Hope to stay for 10 days—and to visit with you often. My sister in law has moved to Huckleberry Hill—don't know if I can stay there—but I hope to be a bit closer to you this time got so much to tell you etc, etc —

Thank you Darling Edward—for too much to count on my toes and fingers—

Love, Ruth B

❧

Wildcat Hill, Carmel, California, c. 1953

—Ruth Bernhard—
Corte Madera, California

I'll expect you when we meet.

Hope I don't have a lot of weekend visitors, —a possibility.

Please bring Cozenforst!
Love from E—

❧

Wildcat Hill, Carmel, California, c. 1953

Ruth Bernhard
Corte Madera, California

Ruth dear—Xmas week-end is very much a family affair which I would not inflict on my best-friends. To complicate matters, Chen and his wife will probably be here from L.A. You decide, then every thing will be your fault!!! Your letter and poem here. I have not read the letter yet. If you decide to come, maybe you can get a camp site near by—Much love—Edward.

Let me hear from you. Wednes.

❧

Wildcat Hill, Carmel, California
December 21, 1953

—Bernhard—
Corte Madera, California

Bernhard (with that gem-like flame).
It was sweet of you to send the Slippers—only I can't get them on!

So what? Put them away until you come down and make suggestions! They are not too small, just can't get the neck on!
Love—E—

❧

Wildcat Hill, Carmel, California
March 8, 1954

Ruth Darling,
Or "Bernhard" depending on the mood!
Thanks for the checks. And exhibition news

The Portfolio must be getting thin.
Good news that you are working again.
Where is Gogo showing, and what?
I was invited to receive the degree of Doctor of Fine Arts, from Northwestern

University. I am supposed to go to Evanston for Commencement, but of course I can't. Strange, I was born a few miles from "Northwestern," Sixty-eight years after, I return.

Love, until we meet. Edward. 3-8-54

❧

Hollywood, California
April 2, 1954

—thanks for newsy note. Birthday has passed. "Doctor of Fine Arts" no longer a

possibility because I could not go on for the "Commencement."

I now have a young man with me (lives up in Bodie Room) to take care of my needs. Such as taking me to the doctors, or shopping—

LOVE—Edward. 4-2-'54

❧

San Francisco, California
December 13, 1954

Lover boy,
Like a miracle I always experience a rare and wonderful thing when I am with you: I have come home and time is standing still. You were feeling so rotten the last time, I hope the Doc was able to relieve your pains. It is just plain hell to feel so lousy—you should do some loud complaining to show that your halo is slipping now and then.

Forgot all about the big love greeting I had for you from Gogo. She wrote from Mexico about the work she was planning to do—and that she envied me my visits with you. Someone told me that she married, but no details.

Darling—do open the package from me right away no silly waiting until Christmas—

Who will be with you when Bob and Virginia are vacationing? Wish it could be me!

All my love, Bernhard

❧

San Francisco, California
July 29, 1955

Beloved Edward
I am a rat not to write more.

Have tried to get a transcript of my radio interview, but no luck. Jane Todd who admires you made it real easy for me to speak of you. I thought it would help people to understand what photography can be, but very seldom is. That like music, poetry and all creative work, it is the expression of the human being and the universe. Like Bach can be compared with Weston and Einstein—a seed is as great as the ocean and infinity, and so on and on. Being the modest boy you are—you would have blushed on all 4 cheeks!

I hear they have been treating you rough—what a rotten shame. I am coming to see you soon again.

All the cuttings I took back with me from your place the last time I was up are doing beautifully—I am thrilled about it.

All my love, Darling, and a big Hug!
Bernhard

Wildcat Hill
Carmel, California
c. June, 1955

—Ruth Bernhard—
San Francisco, California

Dear Bernhard—I missed hearing myself portrayed in the radio by you. I would have loved it—or would I? I recall, I think, that you mentioned something about it when you were here last time. But I guess there was too much side talk and chatter to make any impression on me. Can't you send me a copy?

Love—Edward
Do I guess right that your broadcast was on photog—in general?

❧

San Francisco, California
October 1, 1955

Beloved Edward,
It seems that my plan to visit isn't going to materialize as soon as I had hoped, but at least I can send you a check, which I know is always welcome. It was one of the framed ones Jack Weidell brought back from his visit with you—Ansel spoke to a bunch of "commercial boys." I was invited and took your pictures to teach them a lesson. Some were mystified, but most of them quite impressed. A few real young ones never had seen a real Weston before. But it was a woman who vibrated enough to want to own your print. Good for us girls!

I hope they are treating you right, Darling. As soon as I hear of someone going your way I'll pop in. Tell Bob Nash I say hello.

All my love, Sweetie.
Bernhard

❧

Wildcat Hill, Carmel, California
October 21, 1955

Ruth Bernhard
San Francisco, California

—the "always welcome" here and a—waiting the spending hour. Thanks!!!

But regrets that you could not come. Next time make it sure. . . Writing is just too difficult.

Fond Fervencis—
from me—Edward

index

Page numbers in italics indicate photographs.

Time goes so fast; life
asks so much - no wonder
friends get out of touch -
But in my heart, deep, true
unseen, friendship stays
for ever green -
 Love - Ruth Bernhard